California
BADMEN

Mean Men with Guns
on the
Old West Coast

By
William B. Secrest

Word
Dancer
Press
W

Sanger, California

Printed in the United States of America.

Published by
Quill Driver Books/Word Dancer Press, Inc.,
1254 Commerce Ave, Sanger, CA 93657
559-876-2170 / 800-497-4909
QuillDriverBooks.com

Word Dancer Press books may be purchased for educational, fund-raising,
business or promotional use. Please contact Special Markets, Quill Driver Books/
Word Dancer Press, Inc. at the above address or phone numbers.

ISBN 1-884995-51-9

**To order a copy of this book, please call
1-800-497-4909.**

Also by William B. Secrest
I Buried Hickok (College Station, Texas, 1980)
Lawmen & Desperadoes (Spokane, Washington, 1994)
Dangerous Trails (Stillwater, Oklahoma, 1995)
California Desperadoes (Word Dancer Press, California, 2000)
Perilous Trails (Word Dancer Press, California, 2002)
When the Great Spirit Died (Word Dancer Press, California, 2003)
Dark and Tangled Threads of Crime (Word Dancer Press, California, 2004)
California Feuds (Word Dancer Press, California, 2005)
California Disasters (Word Dancer Press, California, 2006)

Quill Driver Books/Word Dancer Press Project Cadre:
Doris Hall, John David Marion, Stephen Blake Mettee, Carlos Olivas
Cover and interior design by William B. Secrest

Library of Congress Cataloging-in-Publication Data

1. ab Secrest, William B., 1930-
 California badmen : mean men with guns / by William B. Secrest.
 p. cm.
Includes index.
ISBN 1-884995-51-9
 1. Outlaws—California—History. 2. Criminals—California—History. I. Title.

HV6452.C29S423 2006
364.1092'2794—dc22

2006033590

*"I desire to call your attention
to the case of Dye, the murderer
of Haines. He is now out on bail
and is a bad man... ."*

Letter of Wallace Hardison to Thomas Bard,
Ventura County, 1886

Table of Contents

Sources are listed at the end of each chapter.

Introduction

Bad men are still a blight on the world. Like so many things, however, the term has changed significantly over the years. "Badmen" is not one word today, but has reverted to its original two-word form and is seldom utilized. It is too vague and general a term, and today we call them "con men, gang members, killers, thugs" or even "dictators." We live in a continually evolving time and place where words constantly change and are added to or deleted from the vocabulary and dictionaries.

But, long ago, in Western terminology, the term "badman," spelled as either one or two words, held a specific significance. The term did not necessarily mean a man was evil, or an outlaw, although it could mean exactly that. Usually, however, a "badman" was simply a bad man to tangle with or to confront. Badmen were often gunmen; that is, they were in the habit of carrying pistols, or at least, they owned one. "Gunfighters" is the term used today, but that term didn't come into use until late in the nineteenth century. These men carried guns and didn't hesitate to use them, and they were called "badmen"—and those not familiar with the use of weapons had better stay out of their way.

Much has been written about the badmen of the Old West in the past hundred and fifty years. These gunfighters have become colorful and legendary figures due to their particular adaptation to Western novels, television and films. Indeed, the Western novel and Western films came into being at nearly the same time around the turn of the century. That the genre has been spectacularly overdone and exaggerated is obvious, but the core of the theme is true enough. Many examples of the genesis of the "Western" stand out in our actual history.

But, if the Western genre has been blown out of all proportion

to reality, that does not necessarily mean it is not true in its original and basic structure. There really were gunfighters and feuds, range and Indian wars, and cattlemen-farmer conflicts existed to a startling degree in the Old West.

No, the real problem with the "Western" as we know it is that all too often it is one-sided. Western novels and films nearly always take place in a West that excludes California—and the whole West Coast, for that matter. This situation has been modified somewhat in recent years, by writers casting about for new material, subjects and locales that have not been greatly overdone in the past. More important, there are authors and historians who have at last discovered and are exploring the great wealth of Old West material in California's colorful history.

Some years ago I questioned my good friend Joe Rosa about his excellent book, *The Gunfighter, Man or Myth* (University of Oklahoma Press, 1969). Joe, whose biographies of James B. "Wild Bill" Hickok and other works are remarkable for their unrelenting depth of research, is a highly respected historian in the Western genre. His gunfighter book was a carefully crafted evolution of the genre as we know it, and was generally well received by Western enthusiasts. To me, however, there was a flaw.

I asked Joe why he had left California gunfighters out of his book to the extent that the word "California" was not even in the index. Joe responded that he "was leaving that subject to me," or words to that effect. What I think this comment really meant was, like most of us in those days, he had been conditioned to not think of California as a part of the Western frontier.

Although the world is still enamoured of Billy the Kid, the Earp brothers, and Wild Bill, California writers have for some time been educating Western readers to the fact that frontier California was every bit as

colorful as Texas, New Mexico, and Arizona. Too, it has been pointed out that far from originating in the Midwest or Texas after the Civil War, a good case could be made for the so-called gunfighters actually originating in California during the early 1850s.

John Boessenecker, Roger McGrath, Harold Edwards, and others have led the way in the past twenty years in exploring and documenting the outlaws and lawmen of California's rich, frontier past. Currently, it is encouraging and interesting to note that Joe Rosa's *Age of the Gunfighter* and Richard Maxwell Brown's *No Duty to Retreat* both have many references to California's frontier days. And, it's about time!

Were there cowboys, Indians, gunfighters, range wars and bank and train robbers in early California? Of course! And what's more, they were every bit as colorful as those in frontier Texas, Arizona, Montana, and the rest of the West. Various historic California incidents actually eclipse anything that happened in other parts of the West. In a land dispute between the railroad and a group of settlers in the San Joaquin Valley, for example, seven men were shot down in the so-called Mussel Slough Tragedy of 1880. To the north, in Mendocino County, six men died or would die, while three others were badly wounded during an 1867 shootout between two feuding families. Yet, the furor goes on about that minor squabble at the O.K. Corral.

In the following pages a collection of little-known badmen are examined and brought to the forefront of our Western frontier history. **Billy Mulligan** is a particularly unique Western character whose career, both in California and New York, was a bizarre example of politics run amuck! His was a wild, fast life that ended in a blaze of gunfire that must have been the envy of all the hardcases in the Wild West!

The reader will be startled at the true story of the **Rancheria** killings. A group of bandits attack a town, gun down a half dozen citizens, but no one is captured and prosecuted. Dozens of suspects are

shot and lynched, however, in a bloodbath of unparalleled fury.

Sam Temple is a different kind of badman. Although in many barroom brawls, he only killed one man, but that one was a doozy!

A particularly unusual story is that of **Peter Olsen**. I defy the reader to try to guess the end of this strange frontier tale.

Joe Dye was fast with a gun, had many friends, prominent business associates, and a terrible temper. Those who knew anything of his past had no doubt but that he was destined to go out in a cloud of powdersmoke.

Although he came from a good family, **Bob McFarlane** could not seem to stay out of trouble. No! That should read "*would not* stay out of trouble."

These badmen all lived and died in frontier California. Not Texas, Wyoming, Missouri, or Arizona, but California. Tough, hard riding and unafraid, although largely unknown, these characters were real people who lived dramatic and usually disreputable lives before those well-deserved clods started hitting the lids of their caskets.

Now, relax, sit back, and take a look at another part of the West that has so often been ignored. Enjoy a good read about the riotous lives of a unique collection of mean men with guns on the old West Coast.

Acknowledgments

I have been gathering information on California badmen for many years. Other than a number of magazine articles, my first effort on the subject was a 1976 monograph of 47 pages called *Dangerous Men: Gunfighters, Lawmen & Outlaws of Old California*. My primary purpose was to show that there was a much broader West than that represented by Jesse James, Wyatt Earp, and Billy the Kid.

California has long been ignored as a source of our Wild West history and my skinny little booklet served notice that I for one was tired of this misrepresentation. To steal a phrase from Howard Beal in the film *Network*, I was "mad as hell and not going to take it anymore." I concentrated specifically on California subjects from that time on.

Over the years others have joined in this crusade, most of them more competent than I am. But that is the point, to get others to recognize the great void that ignoring California has left in our frontier and Wild West history.

My great pal John Boessenecker has long shared my own views on this subject and has ploughed well-wrought furrows in this fertile ground. I am very grateful for his help over the years. He is a skillful researcher, writer, and collector of Californiana, and every Western writer should be so fortunate as to have as knowledgeable a friend as John Boessenecker. Kevin Mullen, another extremely skillful historian and good friend, has also been very helpful in sorting out the Billy Mulligan story.

I must thank the Wells Fargo Bank History Room in San Francisco for its help over the years. Irene Simpson, Robert Chandler and others have always been most generous in sharing their wonderful collections.

Glenna Dunning of the History and Genealogy Department of the Los Angeles Public Library has also been very responsive to my requests for information, as has the Pomona Valley Historical Society.

John Tuteur, Napa County recorder, was helpful, as was the Napa County Genealogical Society. John Gonzales and all the other staff members of the California Room at the California State Library are always very helpful in serving the needs of their patrons. Joe Samora at the California State Archives has helped in supplying prison records and documents over the years.

Both the late Lorrayne Kennedy and Cate Culver, of the Calaveras Historical Society, were very helpful and appreciated. Jeff Edwards, that premier Tulare County historian, collector, and photographer, came through for me, as he always has.

Wendy Welker, archivist for the California Historical Society, was helpful in locating various illustrations.

In Texas, Bobby Bennett provided important aid in piecing together Joe Dye's family origins. Many thanks.

In New Mexico, Brian Graney and J. Richard Salazar of the State Records Center and Archives at Santa Fe were very helpful, as was Donald Burge of the Center for Southwest Research, University of New Mexico at Albuquerque. Robert H. Weber of the Socorro County Historical Society also provided valuable aid, as did the New Mexico State Library at Santa Fe.

Other libraries have helped substantially with my research, including the New York Public Library, the Merced County Library, and the California Room of the Fresno County Public Library. At the latter, where the author works several days a week, Bill Secrest, Jr. and his outstanding staff provided a wealth of research materials and opportunities. The Huntington Library and the National Archives have provided much aid, also.

My thanks to the J. Paul Getty Museum and Jacklyn Burns, assistant registrar of the Rights and Reproductions department, for permission to use two rare daguerreotypes of the Gold Rush town of Rancheria.

I am particularly grateful to Robert Ellison of Minden, Nevada, and Lee Edwards, both longtime friends, who frequently share research with me. Larry Cenotto of the Amador County Archives was very helpful in providing illustrations and expertise based on his vast knowledge of Amador County history. Phil Brigandi was exceedingly generous and helpful in sharing his wealth of knowledge on the "Ramona" story, garnered as a result of his long connections with the Ramona Pageant Association and the San Jacinto Museum. The Hemet Valley Chamber of Commerce generously provided research materials and leads many years ago when I first began looking into the story of Sam Temple.

My thanks to Robert G. McCubbin for his encouragement and generosity and his sheer presence in the Western history field. Most everyone in the Western field knows, and owes, Bob.

I want to thank the University of Oklahoma Press for permission to quote from its book *Oil, Land and Politics: The California Career of Thomas Robert Bard* by W. H. Hutchinson. My thanks also to Jane Kenealy of the San Diego Historical Society.

My always grateful appreciation to a wonderful wife who tolerates my historical avocation, helps whenever asked, but most of all does more than her fair share so that I have the time I need for my research and writing. I hope she knows how much she is loved and appreciated.

To all, and to anyone I may have inadvertently overlooked, my sincere thanks.

William B. Secrest

Chapter 1

A Gambling Gunfighter Always on the Prod!

The president's wife came to the window and smiled demurely. Mary Lincoln bowed and waved to the cheering crowd filling the street below in front of the Metropolitan Hotel. Besides the many civilian New Yorkers, the Empire City Regiment, commanded by Lieutenant Colonel William Mulligan, was present to add to the cheering. After Mulligan led the crowd in three cheers for the First Lady, Mrs. Lincoln presented the officer with two bouquets. Then, with a final wave, Mrs. Lincoln retired from view and the crowds began to disperse, as reported in the *New York Times*.

The First Lady had no idea who she was associating with, of course. To her, it was just one more public service—an acknowledgement of another body of brave men going off to war this summer of 1861. It would be interesting to know her reaction when she was later informed that Mulligan was a gambler, thug, ballot box stuffer and gunman who had been shipped out of San Francisco by the vigilantes in 1856. Worst of all, he was a Democrat. The President, however, had more serious things to worry about than the peccadilloes of his erratic wife.

Mulligan himself liked to say he was born in New Orleans, but according to his sister their parents were from Ireland and Billy's birth took place in New York City in 1828. Apprenticed to a cooper at an early age, young Billy never learned to read and write. He quickly discovered that the assembling of barrels and kegs, however, was not the road to riches nor in his area of interest. Besides,

Above:
San Francisco in Billy Mulligan's time.
Author's Collection

coopering was demeaning to one with so much other potential. He craved excitement and undoubtedly belonged to one of the gangs of young thugs that plagued New York at the time.

The slums of the great city were teeming with hordes of young men of all ages affiliated with clubs and organizations with names such as the Black Snakes, the Red Necks, the Plug Uglies, the Dead Rabbits, the Screw Bolts, and so on. Most boxers of the era were members of these gangs which, besides being made up of thieves, counterfeiters, shoplifters and burglars, were manipulated by the city's politicians to guarantee their election.

Young Mulligan began hanging out in saloons, absorbing the intricacies of prize fighting and gambling. He also learned the grungy details of ballot box stuffing and burning, voter intimidation, and other tactics of Tammany Hall, the Democratic political headquarters. He soon became skilled in his chosen way of life. For a price, Mulligan and his thugs could guarantee an election by stuffing the ballot box with fraudulent ballots or by simply scaring off anyone not voting for their candidate. Between elections, the tough, young Irishman picked up pointers on crime from his criminal pals in the dives of Five Points or the Bowery.

It was during one of his lean periods that Billy was picked up on a burglary charge and did some time in The Tombs, the New York City prison. It was the spring of 1847 and the Mexican War was being trumpeted by the battles of Vera Cruz and Cerro Gordo. This was a call to glory for Americans everywhere and in a burst of patriotic ferver, Billy escaped from both the city jail and New York proper and took sail for New Orleans with a group of pals.

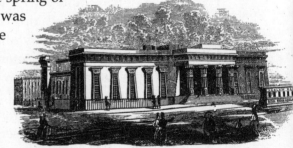

New York city jail, The Tombs, designed and named after an engraving of an Egyptian tomb in a popular book. *The New York Tombs, 1874*

In the Crescent City, Billy and his entourage enlisted with Captain Lewis's E Company, Louisiana Mounted Battalion. He signed up for a year on August 6, 1847, and although only nineteen years

New Orleans as it appeared to Mulligan and his pals upon arrival. *Author's Collection*

old, he was immediately promoted to corporal, probably through the bullying of his friends.

But Billy and his pals were too late. Captain Lewis's company was still organizing when the battles of Contreras and Churubusco took place in late August 1847. They were still in camp when Mexico City was taken on September 14, 1847.

Originally some eight thousand Louisianans had volunteered for the war, but only Captain Albert C. Blanchard's "Phoenix Company" was with General Zachary Taylor's troops in Mexico. In later years Billy liked to tell stories of his valor during the war, but the muster rolls of his unit show that he saw no action and was sick and not present for roll calls during much of his enlistment. Billy was also reduced to private, probably for these absences. Volunteer units were notoriously independent and while sitting around waiting for those orders that never came, the men were difficult to control and Mulligan especially so. Bored and disgusted, the men were jubilant when their enlistments finally expired.

Mustered out in July 1848, Billy gambled in New Orleans while looking for opportunities. When news of the great California Gold Rush burst upon the world in early 1849, Billy was inspired to consider a change of scene to the West Coast.

Twenty-one at this time, Mulligan was described by a friend as "low in stature, slight frame, active as a cat, the expression of a bull terrier, and as quick to an encounter, Mulligan was not a man to pick a quarrel with." As gamblers, he and his pals all dressed in the latest fashion and were always the center of attention. And, they

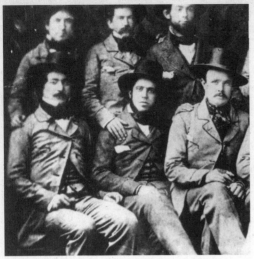

Seated left is "Dutch Charley" Duane and at right, David Scannell, two of the New York political imports. *Society of California Pioneers*

were always armed.

Billy and a coterie of gambler associates arrived in California in late 1849. In San Francisco, they met many of their New York cronies and no doubt had a grand celebration. Politics and government in California were being modeled after those of New York, and the Mulligan crowd was right at home. Billy's pals included James "Yankee" Sullivan, the former bareknuckle boxing champion, and Chris Lillie, another fighter who had the distinction of killing the first man in the American prize ring and who had served with Billy during the war. Tom Coleman, Ed Hopkins, Jim Hughes, and others were all New York gamblers and political thugs who, like Mulligan, saw much opportunity in this new land.

Everywhere he looked Billy recognized a former New York gang or fire company member. Bill Lewis was in town, along with David Scannell. "Dutch Charley" Duane was seen in a bar drinking with Martin Gallagher and Billy Carr, tough boatmen who hauled passengers and supplies from ship to shore in the bay. All but Duane were staunch Tammany Democrats who quickly became involved in city politics.

David Broderick, a Democratic politician and former New York saloon owner, was there also and had formed his own fire company, the first step to establishing a political power base. William "Wooly" Kearny, one of Broderick's political thugs, had a battered and scarred face that had frightened many a voter away from the polls. Mulligan, Sullivan and Chris Lilly all met with Broderick, who invited them to join his fire company and political group. All these New Yorkers had the same idea. They were getting in on the ground floor of a new territory and none of them doubted that, utilizing their Tammany tactics, they would soon be running things. Broderick had already been elected to a seat in the State Senate and aspired to national office.

Mulligan and his pals had never seen anything like San Francisco. Formerly a sleepy Mexican village called Yerba Buena, it was now a sprawling collection of adobe, brick, and frame structures surrounding an undeveloped plaza. Around this public square were saloons and gambling halls with the enticing names of El Dorado, Bella Union, and Empire House. The previous year the Parker House had rented for $110,000 yearly, $60,000 of this sum being paid as rent by gamblers on the second floor.

There was never-ending noise—auctioneers in lots and in the streets competed with hammering and sawing from new building construction and the melodies played on guitars and violins by musicians in the gambling halls. There was activity everywhere. Braying mules hauled supplies up from the waterfront, while noisy drunks reeled from saloon to saloon. Tents were scattered throughout the city and covered the surrounding brush and sand-laden hills.

Like all new arrivals, Billy and his gang were eager to visit the mines. They boarded a crowded steamboat bound for Stockton, then moved on to Tuolumne County. After a tour of Jamestown, Sonora, Columbia, and some of the smaller camps, however, they scoffed at all the hard work involved in mining. Looking around, they could see that the rough mining towns were filled with single, lonely men starved for entertainment. Boxing matches were immensely popular in the East at this time and the Mulligan crowd had much experience in this line. The New Yorkers began staging boxing matches

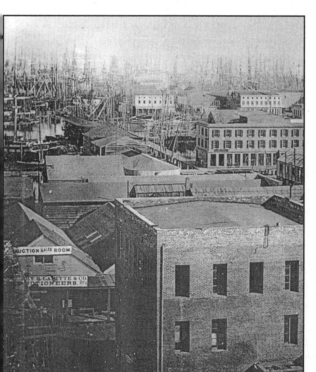

San Francisco grew fast in the 1850s. In the background can be seen a forest of masts representing ships abandoned as their crews joined the rush to the mines. *Author's Collection*

5

and by occasionally delegating the winner and betting accordingly, they could make a killing. The thousands of miners were just aching to bet their hard-earned gold. All of Mulligan's gang were experienced prize fighters and thugs who would make life very difficult

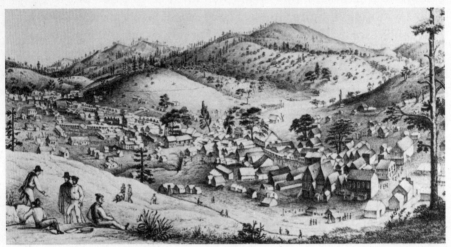

Sonora in the early 1850s. *California State Library*

for anyone who disputed the results.

Mulligan staged many prize fights in the Tuolumne camps, one historian calling him "the best showman ever in the mines." One of the matches was a decided flop, however. When heavyweight Alex Johnson was pitted against lightweight Billy Pool, the two stepped up to scratch and Johnson landed a devastating blow on his lighter opponent. Pool went down and out with a broken jaw and the fight was over. Several thousand disappointed spectators went grumbling back to their camps.

On February 10, 1851, Sonora storekeeper William Perkins was watching a dance in a new French hotel when suddenly a man with his face covered with blood came running in from the balcony. Chasing him was Billy Mulligan, who stopped and began talking to a friend. Both men were gamblers. "As Mulligan was explaining how the quarrel commenced," wrote Perkins, "a great uproar was heard below, and [William] Anderson rushed into the room with a revolver in his hand. Mulligan's pistol was out at once, and here, in a room full of people, most of them women, did these two ruffians com-

mence firing at each other." They fired some nine shots, according to Perkins, one of Mulligan's shots shattering William Anderson's knee. An old Mexican was killed during the melee and a young Mexican girl was slightly wounded.

The *Sonora Herald* of March 8 noted that Anderson had died two days earlier, probably of complications from his wound. Billy was not prosecuted since witnesses all testified that he had been attacked. Now, he was not only known as a "bruiser," but as a gun-toting killer—a gunfighter!

In December Mulligan and his toughs became involved in a mining dispute near Carson Hill, a short distance northwest of Sonora. A mining company, Hance, Morgan and Associates, was accused by several of the "associates" of selling their mine out from under them. The mine was quite wealthy and Finnegan and other erstwhile partners engaged Mulligan and his pals to forcefully oc-cupy the mine while litigation raged for many months. By the time a court order had been secured and the occupiers ousted, the Finnegan-Mulligan combination had taken out a huge amount of gold. There is little doubt that Billy and his thugs convinced Finnegan that they deserved the lion's share of the wealth. Well-heeled and not wanting to stick around for any more court proceedings, Mulligan and company promptly disappeared and headed north.

They visited Angels Camp, San Andreas, and Mokelumne Hill, celebrating along the way. At Coyote Hill Diggings, Billy engaged in a saloon argument with a character as fiesty as himself. Jimmy Douglass also had a reputation as a gunman, and it was decided to settle things with a duel. Both men carried Model 1849 Pocket Colt revolvers chambered for either five or six loads. They agreed to face each other at twelve paces and fire on command until one of them was hit. Being gamblers, they bet fifty dollars that the other would miss, but both men missed after several shots. Finally, on the fifth shot, Billy took a ball in the shoulder. Douglass was magnanimous in his victory and the two gunmen praised each other's courage at their dinner party that night. Mulligan's wound was more serious than originally thought and he was forced to leave the party early. It was the fall of 1851 when he was well enough for his friends to take him back to San Francisco.

The city had changed greatly during their absence. San Francisco had been destroyed several times by fire and now new brick and stone buildings were taking the place of the old structures. Even portions of the bay were being filled in, and wharves and warehouses lined the waterfront. They had also read in the press of the great vigilante uprising that summer of '51. Some of the worst criminals had been hanged and others shipped out of town. Most were Australians, but Billy and his gambler friends were uneasy.

Feeling his mortality in his still-aching shoulder, Mulligan invested in the Gibralter Saloon with Yankee Sullivan. Chris Lilly bought a cock-fighting pit, also, and all of them worked to insure the election of Democratic candidates. Billy could do as he pleased now and spent most of his time in saloons and gambling halls. He was soon in hot water again, however.

Yankee Sullivan in the days when boxing, crooked politics and gambling all went hand in hand. *Author's Collection*

On the evening of November 18, 1851, Mulligan had a dispute with a man named Rhodes in a Washington Street bagnio kept by a Mrs. Rose. Later, when Mulligan found Rhodes drinking at the bar of the Bella Union he walked up to him and renewed the hostilities. Richard Ross, one of the bar owners, came down the stairs at this time and rushed over to prevent any trouble. "I told Mulligan to go out, and not to have any difficulty in my house," stated Ross. "He started to go and someone told him that Rhodes had a pistol. Mulligan turned and came back to where Rhodes was and said something to him—think he said, 'God damn you, draw your pistol!'" What followed was a typical western shootout, as recounted in the *Daily Alta California*:

This took place in the large outer room, near the stove. Which fired first we cannot state, suffice it to say Rhodes fired some five shots, and Mulligan three or four. Meanwhile the parties retreated into the inner room, and here coming together, they clinched and fell. Both rooms were by this time nearly deserted. In the firing Rhodes was wounded in the finger, and Mulligan received two

wounds in the left arm. After the firing ceased, Mulligan and Rhodes pounded each other with the butts of their pistols. Here the police arrived.

Two officers hustled Rhodes off to headquarters. Two other lawmen grabbed the bloodied and fainting Mulligan, but he was seized by his friends and rushed upstairs into a private room and a physician summoned. When more police arrived they took a look at Billy and agreed that he should stay where he was. It was a close call.

At a hearing in the Recorder's Court, witnesses agreed that Rhodes was the assaulted party and he was discharged on November 29. A few days later Billy made his court appearance, wearing a bandage on his head and a sling on his broken left arm. He gave bail and eventually paid a fine and no doubt felt he should try to stay out of the way of bullets for awhile.

A few days later he was standing on the steps of the Union Hotel feeling glad to be alive. It was a short-lived feeling, since he suddenly found himself in the middle of a shootout by two characters named Crumely and Davis as reported in the San Francisco *Daily Picayune*:

Billy Mulligan in Hard Luck—When the fight came off this morning, at the upper end of Merchant Street, Billy happened to

The Bella Union on the plaza was at the hub of 1850s San Francisco.
Califoria State Library

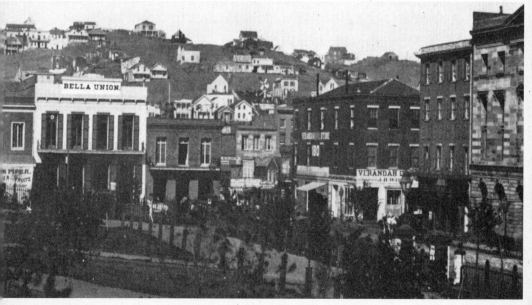

be in the vicinity, and, of course, got a shot in the leg which will lay him up for some time. He was taken into the Union and a surgeon was called who attended to his wound. It was sad to see the poor fellow, with an unhealed bullet-hole in his head, his arm broken by a pistol shot, suspended in a sling, both shots received in a recent broil, and writhing under pain of his newly broken leg.

The *Picayune* reporter did not have to worry about Billy, however. When there was an Indian scare in Southern California in mid-December, Mulligan was barely out of his bandages when he rushed to sign up with the San Francisco mounted volunteers. Jack Hays, the celebrated Texas Ranger and Mexican War hero, was appointed colonel of the two companies, and Mulligan was elected a lieutenant in gambler Dan Aldrich's detachment. Before the 300-man army could sail for San Diego, however, they were disbanded when word was received that the Indian scare had been highly exaggerated. Like Mulligan, many of the men in his company were gamblers and thugs, and peaceable San Franciscans were no doubt disappointed when the expedition was cancelled. Meanwhile, Billy went back to gambling.

By New Year's Eve, Billy felt himself healed enough to go on a drunken rampage with a crowd of gamblers. Billy, George Lane, Dan Aldrich, Frank Lee, and Alex Williams had begun drinking in the early evening, attended several parties, and then started carousing on their own. By the time they reached Dupont Street, they were ready for a frolic as reported in the *Alta* of January 3, 1852:

> The party after carousing around town, which everyone looked upon as innocent sport went into Dupont street and opened the ball by attacking the Globe Hotel. We are informed that they smashed in the windows, broke decanters and glasses, and wound up by clearing the house of occupants, proprietors and all. Satisfied with this, they proceeded along to Holmes' Boarding House, which they served in similar style. We are informed that a house in California street received a like treatment. A few of our citizens endeavored to quell these riotous proceedings, but pistols and knives were drawn and they were threatened with their lives and found their efforts entirely powerless. The police were on hand, but not in sufficient forces to avail anything .

Police officer Phineas Blunt wrote in his journal of the evening's excitement:

> Las night and today has been celebrated in the usual style for California, viz rum drinking, disorderly conduct etc., tonight a lot of rowdies say about 25 men went about creating all disturbances in their power, such as upsetting everything they meet with in the streets. Creating disorder in houses of ill-fame etc., (cracking-breaking) furniture etc. knocking down inmates. William Mulligan and other shoulder strikers were at the head of the crowd.

In a threat pertaining to the past *and* the future, the *Alta* grumbled ominously that "If our peaceable citizens are to be attacked in their houses, it is time for unmistakable evidence to be given, that these gentlemen must either alter their course or quit the city."

The next day Mulligan and his thugs were in the police court charged with the previous evening's rampage. The case was postponed for a week, but no further notice of the incident appeared and politician friends must have paid off the damage or otherwise squelched the matter.

That these thugs pretty much did as they pleased was evident in the January 7, 1852, journal entry of policeman Blunt:

> Tonight had difficulty with Charles Duane alias Dutch Charley. Also with John Barmore, Henry Drake and Sandy Rinton. All of them shoulder strikers, one of them offered to cut open [Police Officer] Cornelius Holland, another offered to cut the liver out of me because I had arrested one of them.

David Broderick had managed to secure a seat in the state senate in 1850, and Billy and his pals were called to Sacramento from time to time to help bully favorable votes for the party and for Broderick's political machine.

Mulligan never seemed far from trouble, however. On a Sunday evening in late February he was in Sarah Ewing's Dupont Street "boarding" house when ex-policeman Jim McDonald went on a drunken rampage. Bellicose and belligerent, McDonald threatened to throw a pitcher at one of the girls, who fled the room. Mrs. Ewing then came in to remonstrate with him, but left when McDonald

snarled, "It's none of your damned business." Becoming even more violent, McDonald pulled a knife and began slashing curtains and furniture. John Carroll and several others entered as a man named Dodge was pushing McDonald out the door after asking him to behave.

Sarah Ewing came back and was telling the others of the incident when McDonald suddenly burst back through the door. When he grabbed Ewing's arm, Carroll interfered, saying he should not treat a woman like that.

Billy Mulligan had been one of McDonald's party when they entered the house about ten o'clock. When Mulligan entered the room now, McDonald and Carroll were still arguing and Billy later recalled the action:

> McDonald then struck him in the neck and knocked him close over to the wall; Carroll got up and they both clinched; they fought about four minutes, during which McDonald bit a piece of Carroll's ear off; the latter seemed to be on his knees struggling to get up, and McDonald had his left arm around his neck; they had a struggle, when McDonald let go of him and started for the door. I looked at McDonald as he passed out of the door and saw a knife glittering in his hand. Carroll was not armed.

Mulligan refused to stop the fighting when asked to do so, but later told the bystanders that if he had known McDonald had a knife he would have interfered. A physician was called for Carroll while Mulligan and several others sought to locate McDonald. After discovering he was working as a guard on the prison brig anchored at Angel Island, the impromptu posse accompanied two police officers in searching the vessel. They found McDonald, but the prison officers refused to give him up without a warrant. After securing a warrant, Mulligan and the rest of the group deposited their prisoner at the city prison.

Carroll died from his wound on February 26. This was one of the few instances when Mulligan apparently acted in a reasonably responsible manner.

McDonald had many friends, despite his drunken lifestyle, and managed to escape punishment for the Carroll killing. He was later

reinstated on the police force and achieved the rank of city marshal a few years later. When he died in 1856, a thousand mourners followed the body to Lone Mountain Cemetery where Bishop Kip conducted the services.

Many of Mulligan's thug pals were paid back for their election "services" by quietly being put on the public payroll as a "clerk" or some such minor position where little or no work was involved. Others, with any ability, could be "stuffed" into a public office. When Billy's saloon was not reaping high enough profits, he accepted a job as a deputy tax collector. Apparently conscious of his responsibility, Mulligan's friends would later say he accounted for every nickel he took in, and perhaps he did. He well knew that a gambler's fortunes could change overnight.

David C. Broderick was the powerful Democratic political boss of old San Francisco.
John Boessenecker Collection

Politics were a terrible mess in San Francisco. Broderick led the antislavery branch of the Democrats, while William Gwin led the Chivalry, or slavery, party members. Deep divisions within these two party branches made for even more confusion. The American Party, Whigs, and Know-nothings further scrambled politics and made it easier for the spoilers and ballot box stuffers. Broderick knew well how mercurial in temperament his henchmen were, but they were vital to his winning elections. It was the way politics was done. Even Broderick, however, must have been startled at Bill Lewis's antics at a primary election on April 18, 1853, as reported in the *Alta*:

Destruction of the First Ward Ballot Box—One of the most high-handed outrages that can be committed in a free country was perpetrated yesterday at the Bay Hotel, the First Ward polls, by a man named William Lewis, a boatman. The circumstances, as we have heard them are as follows. There was no regular Whig candidate nominated in this ward, and Mr. Meiggs was the Democratic candidate. A number of those graceless scamps, the refuse of our population, whose whole business on election days seems to be to put every obstacle in the way of peaceable voting, then nominated an-

other gentleman by the name of Fleming on an independent ticket. During the morning Lewis waited on Mr. Meiggs and offered, for the sum of $500, to withdraw Mr. Fleming's name; this proposition was indignantly refused. Lewis then went to the polls and remained some time, under the pretence of challenging the votes.

Discovering that the Fleming candidacy was inevitably going to be beaten, Lewis, who was a large thug of the worst type, seized the ballot box and threw it over his head into the crowd, where his pals quickly kicked it to pieces. "This high-handed outrage," insisted the *Alta*, "should be visited by the severest penalties of the law." But, of course, it was not.

Mulligan, meanwhile, was caught up in another of his constant brawls. One evening in late June 1853, he was having a drink at the bar of the El Dorado when a drunken Herman Carroll staggered into the saloon and spotted Billy at the bar. Walking over, he began cursing Mulligan, calling him a "thief" and a "capper," among the more printable epithets. When Carroll assumed a fighting stance, Mulligan knocked him down and when he got up, Billy had a piece of metal with four short legs on it in the palm of his hand. A couple of swipes and Carroll's face looked as "variegated as a piece of New Castle coal." The *Alta* reported "Mulligan was discharged and Carroll told to 'vamos' back to the woods from whence he came."

The deteriorating political situation in San Francisco was nowhere better illustrated than on February 17, 1854, at a Democratic meeting at the Mercantile Hotel on Pacific Wharf. After adjourning the meeting, the politicians began the social part of the program which consisted of seeing how much damage they could do after seriously diminishing the liquor supply in the hotel's barroom. When the owner sent out a call for the police, Sergeant James Towle and two officers arrived. Although attacked and badly beaten while trying to make arrests, the officers, with reinforcements, finally

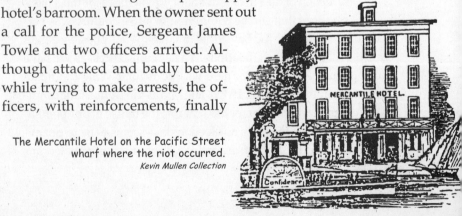

The Mercantile Hotel on the Pacific Street wharf where the riot occurred.
Kevin Mullen Collection

The San Francisco City Hall where police headquarters was located. The city jail was was located in the basement, with police offices upstairs. The El Dorado gambling hall can be seen next door, at the left.
Author's Collection

dragged James P. Casey, Jim Turner, Bill Lewis, Martin Gallagher, and others out of the place and herded them to police headquarters. The drunken rioters turned the station house into bedlam, as reported in the *Daily Herald* of February 19:

> Some of the imprisoned rowdies were making the night hideous with their bacchanalian songs and outrageous denunciations and epithets against the different city authorities, which feeling of resentment they even carried so far as to renew their violence upon the officers. At one time, in the station house itself, some of them rushed upon Captain North, threw him down and partially stripped him of his clothes, besides otherwise maltreating him. On the outside the scene was hardly less humiliating. In addition to crowds of the prisoners' companions who stood around discussing the matter with much vehemence, were a number of officials and aspiring politicians fraternizing with the rioters.

Returning to the hotel, the whole police force was assembled and went after the rioters who had now retreated to a ship in the bay. Sergeant Towle and others boarded the ship and arrested more of the gang and housed them in the city prison.

The officers had been badly battered in their efforts and were startled when at one-thirty in the morning Democratic Supreme Court Justice Alexander Wells burst into the cellblock with a writ and de-

manded the prisoners be released. Bloodied and battered, the officers were outraged as the smirking and jeering prisoners filed out of the building threatening the officers with retaliation. Later Judge Wells was seen drinking with the likes of Bill Lewis and Woolly Kearny at a favorite bar. Oddly enough, Mulligan is mentioned nowhere in the various newspaper accounts of the incident.

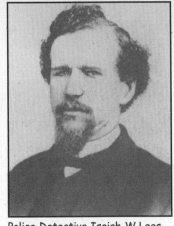

Police Detective Isaiah W. Lees took a brutal beating while arresting several political thugs. *Courtesy Bancroft Library*

Every man on the police force signed a petition stating they would quit in a body if the mayor did not sustain them in their action. Mayor C. K. Garrison quickly acted to calm the situation and managed to placate his lawmen, but the following Sunday morning a lone police officer was attacked.

Police detective Isaiah W. Lees had been at an early morning fire with his fire company, California No. 4. Afterwards, he was having a cup of coffee in a shop before going on duty when a drunken Woolly Kearny, accompanied by Fire Chief Charley Duane and several other thugs and political bullies, entered. Lees watched warily as Nick Perezo walked behind the counter and began deliberately breaking cups and dishes. When the officer jumped up and began scuffling with him, Kearny grabbed Lees by the throat. A tough ex-prize fighter, Kearny battered the officer, although Duane helped drag the drunken boxer outside where Lees handcuffed him. Lees's eye was rapidly closing from Woolly's blows, but he led Kearny and Perezo back to police headquarters.

The two thugs paid fines of $100 and $75, respectively, then went on their merry way. Anyone else would have been prosecuted for assaulting a police officer.

Although apparently not participating in the hotel rioting, Mulligan could not stay out of the news for long, as reported in the Stockton *San Joaquin Republican*, May 9, 1854:

> Affray—Last week a serious affray occurred at the El Dorado,
> San Francisco, between two notorious characters—Bill Mulligan and
> "Fat Jack," who had only just arrived from the states. The latter was

struck by Mulligan with a glass decanter over the head. The main artery of his right hand, which he put up to defend himself, was cut, and it was at first thought that it would be impossible to stop the running of blood. The artery was caught after some time and tied up. His head was also badly mashed by the blow.

The city's Democratic newspapers would often soft-pedal or ignore the antics of these "shoulder-strikers," or political thugs, and it was noted in one article that "the matter has been studiously kept secret, and no arrests have been made." And no wonder. Judge Edward McGowan, who had fled Philadephia as a suspect in a bank robbery, was judge of the Court of Sessions; Billy Mulligan was a deputy city treasurer; Charley Duane was the city fire chief; James Casey, an ex-convict from New York, was fraudulently elected a supervisor in a district in which he did not even reside; Christopher Dowdigan, another New York political thug, was a deputy sheriff, and the likes of Bill Lewis, Yankee Sullivan, Nick Perezo, and others were inspectors of elections and in charge of the ballot box. In a very real sense, the foxes were in charge of guarding the hen house!

When Chris Dowdigan became involved in a duel with Jim Hawkins of Tuolumne County, Mulligan offered his services as second to Dowdigan. Billy had known the deputy sheriff since their New York days and when they arrived at Hunter's Point, south of the city on May 19, 1854, he helped arrange the proceedings. Hawkins's second was one Philemon T. Herbert, an aspiring politician who had served a brief stint with Harry Love's rangers when they tracked down Joaquin Murrieta. All the men were Democrats, but Herbert was from Alabama and the dispute may have been sectional in origin The duel took place with rifles at forty paces, and at the second fire Dowdigan was wounded in the left arm. "After this," reported the *California Chronicle*, "the affair was arranged to the satisfaction of the parties."

Despite the late rioting at the Mercantile Hotel, the political situation was not improving. After an election in late June 1854, a long editorial in the *Herald* complained bitterly of the odorous state of local politics:

Since the memorable days of the Hounds, we believe there

has been in this city no such rampant ruffianism as was exhibited yesterday at the Democratic Primary Election. We really think if our citizens will submit to such villainous outrages and to the election to public trusts and responsibilities of the persons for whose promotion and advantage these outrages are perpetrated, the city deserves to sink into the depths of disgrace and infamy to which she has been for some time fast tending.

There were dozens of fights, knives, and pistols drawn, and at least one man was shot at the polls. Billy Mulligan was arrested for fighting at the Union Hotel polls, but learned later that he had been elected as a delegate from his Fourth Ward. That evening, Barney Mulligan bailed his brother out and they proceeded back to the Union Hotel bar to celebrate.

About ten o'clock, a man named John Watson burst through the saloon doors and began a noisy recitation of some of the outrages of the election. Charley Duane tried to calm him down and Watson started to leave, then spun about and drew a pistol and began firing into the crowd. Duane drew his own pistol, shouting for Watson to shoot at him and not at the crowd. Others had drawn weapons by now and some thirteen shots were exchanged. Watson took three of the shots, losing a finger in the process.

When the powder smoke cleared, Barney Mulligan was found to have been shot in the thigh, but no others, except Watson, were apparently injured.

On July 4, 1854, the city was treated to a series of Independence Day celebrations, including various balls and parties given by the different fire companies that evening. Charlie Duane was celebrating with David Broderick and Judge Ned McGowan at the Union Hotel bar when an up-country desperado named Jim Campbell entered and insulted Broderick. Broderick and Duane saw fit to ignore the remark, but in a short time Billy Mulligan entered dressed in his finest clothes for a fireman's ball. When informed of the insult, Billy peeled off his white gloves and placed them in his coat pocket. Handing his coat to a friend, Mulligan walked up to where Campbell was standing at the bar. As the badman turned around, Mulligan butted him in the face, then began viciously punching his groggy victim. When Duane tried to

intervene, McGowan told him to let them fight. "It was a fair fight between two boxers," McGowan recalled later, adding, "I thought it was better to let them fight it out." After a long recovery, Campbell was killed in a fight with another thug in September.

The California Democratic Party was still fractured by the split between Broderick's wing of the party and the anti-Broderick group of Southerners represented by Senator Gwin. Politically, it was a disastrous situation and getting worse.

In late July, the Democratic State Convention was held in Sacramento. It was held in a Baptist Church, but the divisions in the party were so acrimonious that both factions tried to seat their own chairmen. In the shouting and shoving that resulted, a pistol accidentally was discharged and politicians bolted from every door and window in the place. Needless to say, neither faction was invited back to the church and the two groups met the next day in two separate buildings. The splintered Democrats would take a beating at the next general election.

City primary elections were held the following month, and the *Alta California* was appalled at the election of gambler Dan Aldrich as Democratic candidate for city marshal. Billy Mulligan was also in the race, polling four votes to Aldrich's twenty-one. "There can be no hope," warned the *Alta*, "of electing those who have nothing to recommend them but the barefaced effrontery and impudence which emboldens them to crawl out of their groggeries, gambling hells, and places of a worse character, to present themselves for a nomination." Happily, at the October general election Whig John W. McKenzie, an experienced officer, was elected over Aldrich.

As the year 1855 dawned, Mulligan found himself in one scrape after another. During a visit to Sacramento in April 1855, he got into a slugfest with another tough named Tom McNab in the Sazarac Saloon, as reported in the Sacramento *Tribune:*

> No weapons except those provided by nature, were used, but they each got a severe drubbing. They made a perfect wreck of the saloon, demolishing about fifty tumblers, a lot of decanters, and any quantity of bottles of champagne, which they playfully broke over each other's head, for the sole purpose probably of hearing them pop. Samples of blood and gore were lavishy scat-

tered around upon the walls, and left upon the chairs and counter. After pummeling each other to an unlimited extent, the vigilant police discovered and arrested them. Mulligan was bound over in the sum of $100 yesterday to appear on Tuesday. McNab was too much injured to appear in Court. He will be examined on Monday.

By mid-May Mulligan was back in San Francisco where he and brother Barney, together with Bill Lewis and several others, broke down the door of a Clay Street bordello in which one Sarah Bacheler resided. All were drunk, of course, and when hauled into court it was discovered one of the drunks was Bacheler's lover. He had been thrown out and needed help being re-admitted.

The following month Billy joined Chris Lilly and Yankee Sullivan for an evening of cock-fighting and betting at Lilly's cockpit on Commercial Street. The three men had been friends for years in New York, Lilly also serving with Billy during the Mexican War. Sullivan, whose real name was reported to be James Ambrose, was born in Ireland in 1813 and was a former resident of the British penal colonies in Australia. He escaped to New York and after adopting the name Yankee Sullivan, became world heavyweight boxing champion. He had been a partner in Mulligan's boxing exhibitions in the Gold Rush country in 1851 and had recently served time in the Nevada City jail for promoting a brutal boxing match in that county.

Sullivan had not been well lately. The years of drinking and dissipation were catching up with him. The old fighter was temperamental, also, and as they watched the roosters fighting at one o'clock in the morning, Sullivan and Mulligan got into an argument. When Billy called him a "Sydney thief," Sullivan responded with a blow from his cane. The two men came together, but friends intervened as Mulligan yelled at Sullivan to meet him at Tyson's Exchange where they could be alone. Mulligan followed the boxer to Tyson's, where, reported the *San Joaquin Republican*, "Mulligan got the start, and Sullivan got the devil in the shape of a desperate thrashing." Another report stated that Mulligan had caught Sullivan unawares and delivered a powerful blow, then beat him mercilessly with his pistol, winding up the session by kicking Sullivan about the head and face when he was down. Apparently the authorities never

learned of the incident and Sullivan and his friends were too embarrassed to press charges.

San Franciscans were fast running out of patience with the hoodlum minions that controlled the elections and municipal and state offices and seemed to be picking their pockets at every turn. During the first five years of the city's existence, a debt of three and a half million dollars had been run up by politicians who had voted themselves outrageous salaries and given their friends pork barrel projects as payment for fraudulent election results.

For the past year a reform plan had been in the works in the state legislature. A Consolidation Act had finally been proposed that provided for controls on public funds and the combining of the city and country governments. Assemblyman Horace Hawes had piloted the bill through the lower house, but it became stuck in the senate when elements in the southern part of the county began talking about becoming a new county. Mulligan and his pals saw all this unfolding and searched for a way to make it work to their benefit.

In September, David Scannell was elected sheriff, helped into office through the efforts of Billy Mulligan, who was appointed deputy sheriff in charge of the county jail. San Franciscans winced at the appointment but, after all, the vicious Charley Duane had been fire chief for some time and had done a good job. Other thugs were in positions of authority and it had become increasingly clear

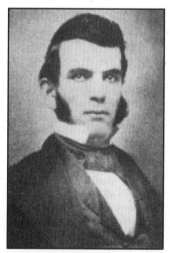

James King of William, the fiery editor of the *Bulletin*.
Author's Collection

that these problems had evolved because the citizenry had been cowed into not paying attention. That was about to change.

On October 8, 1855, the already crowded journalistic field of the Bay city acquired a new newspaper. The *Daily Evening Bulletin* would have been just another four-page tabloid among the many already in circulation, except for one thing. Editor James King had an agreement with his publisher that he was in absolute control of the editorial policies of the new journal. It was an agreement that would help seal the doom of many people.

James King—called James King of William to differentiate him from the many other James Kings in his Eastern home town—was a banker who had lost everything in the wild economy of 1850s San Francisco. The fledgling editor had already startled the city when he had declined to fight a duel at a time when such a refusal reflected greatly on his personal courage. King cared little for such reflections. He published a letter in which he stated that his wealthy opponent's family would be taken care of in the event that he fell on the dueling field. King, on the other hand, was quite poor due to his banking failure and had a wife and four children who depended on him for support. He refused to risk his family's welfare for the satisfaction of someone else's "honor." He was armed, however, and if attacked he would defend himself. King's letter resulted in newspaper editorials throughout the city hailing his courageous decision.

Almost immediately, King began attacking the rampant corruption in the city. His editorials raged against Palmer, Cook & Company, the banking concern that bonded most of the corrupt politicians of the state; the gambling interests in the city; prostitution; and even the king politician, David C. Broderick!

King's methods terrified the establishment and from day to day no one knew who would be attacked next. And, his newspaper sold like hotcakes. When he called for the removal of City Marshal Hampton North, who had claimed he could do nothing to curtail the brothels that infested the city, King responded:

> If the city council find that they have not power or lack the will to remove Mr. North or make him do his duty, we will have the records searched and learn who own the houses rented to these people; and we will publish their names, that the respectable portion of the community will know who to admit and who to reject from their firesides. It's no use trying to dodge the *Bulletin*, Gentlemen!"

The bordellos, many of which were scattered throughout the business district of the city, instantly scattered and were at least far less conspicuous than before.

Several attempts were initially made to bribe the new journal, but when King published the names and methods of the parties in-

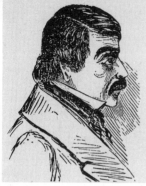

Charles Cora, the gambler who helped spark the vigilante uprising of 1856.
Author's Collection

volved, the efforts were quickly abandoned. Nothing—no one—was safe from King's probing pen.

On the evening of November 17, 1855, a gambler named Charles Cora shot and killed U.S. Marshal William Richardson. The two men had a personal disagreement in a theater the night before when Richardson objected to Cora and his prostitute mistress sitting behind his party during the performance. When friends sought to ameliorate the situation in the Blue Wing Saloon the following night, Cora shot and killed Richardson during a confrontation after the two men stepped outside.

The city was shocked by the incident and Cora was thrown into jail, indicted for murder, and scheduled for trial in early January 1856. The wealth of the gambling fraternity and Cora's wealthy mistress enabled them to buy the best legal talent (and witnesses) in the state. Few in the courtroom were surprised when the Cora jury announced they were deadlocked and a new trial date would be set.

On a scale of one to ten, editor King's fury was a burgeoning sixteen when he penned the following editorial:

> Hung be the heavens in black! The money of the gambler and the prostitute has succeeded, and Cora has another respite. Rejoice, ye gamblers and harlots! Rejoice with exceeding gladness. Your triumph is great.

King was particularly outraged because Billy Mulligan, known to be a friend of Cora, was in charge of the city prison. A former member of the 1851 vigilantes, King admonished over and over again that while no one wanted those days to return, they surely would if justice could not be obtained in any other manner. And if Cora were allowed to escape while in custody of the sheriff and Mulligan, then the genie was out of the bottle, penned the irate editor:

> Hang Billy Mulligan! That's the word! If Mr. Sheriff Scannell does not remove Billy Mulligan from his present post as keeper of the county jail, and Mulligan lets Cora escape, hang Billy Mulligan,

and if necessary to get rid of the sheriff, hang him—hang the sheriff! Merchants of San Francisco, mechanics, bankers, honest men of every calling, hang your heads in very shame for the disgrace now resting on the city you have built!

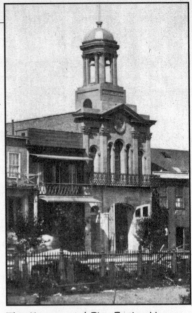

The editor was making it very clear. If San Franciscans continued to accept the lawless situation, they would deserve the continuing consequences of murder in the streets, stuffed ballot boxes, and bought politicians. Apparently King's fears of Mulligan aiding Cora were groundless. On November 22, a man named Hacket had called at the jail and asked to see Mulligan. When he asked the deputy if he would release Cora for a consideration, Billy threw him into a cell and

The Monumental Fire Engine House on the Plaza, from where Tom Riley sallied forth to whip Billy Mulligan. *Author's Collection*

later turned him over to the police. Whether Mulligan had acquired a sense of responsibility or he was remembering some of editor King's flaming editorials is not known.

Deputy or not, Mulligan could not pass up an opportunity for a good fight. As two members of the Monumental Fire Company, Tom Riley and a friend, were going off watch at two in the morning, they met Mulligan and several cronies on the street. Billy made some insulting remark that caused Riley to pause.

"I know you, Mulligan, and it would not do to repeat that remark."

"You ought to get to know me better," grinned Mulligan as he began peeling off his coat. Riley flung off his coat also, as reported in the *Bulletin*, January 28, 1856:

Billy came up to the scratch, and placed himself in attitude, when Riley knocked him into the middle of the street. Billy came up again, and was again knocked down; came up a third time, and closed—both fell, Riley uppermost, with his finger in Billy's mouth.

Although Mulligan's pals began kicking his opponent and otherwise trying to upset the situation, Mulligan got a severe trouncing and was carried from the field. Aside from several severely chewed fingers, Riley was uninjured. The victor was known as a hard-working, peaceable man and for once Billy got what he deserved.

The *Bulletin* gave a long account of the encounter, while other reports were brief or non-existent. The politicians and their thugs must have been nervous about the situation that was developing. Mulligan and his cronies sensed a dangerous mood in the Bay city, and there seemed little they could do about it.

Jim Casey, the illiterate ex-convict from New York, another of the Democratic political thugs, had established his own newspaper in December 1854. Christened the *Weekly Sunday Times*, Casey called himself the editor, but actually hired journalist John C. Cremony for the post. Now he could lambaste his enemies, including the *Bulletin*, and blackmail and browbeat various merchants for advertising revenue.

Billy Mulligan was impressed. If Casey could publish his own newspaper, it couldn't be that difficult. In March, 1856 the premier issue of Billy's *Sunday Varieties* appeared. A man named James W. Walsh was hired to edit the new organ. As might be suspected, an 1858 history of California newspapers published in the *Sacramento Union* referred to Mulligan's journal as "decidedly disreputable in character."

James P. Casey, the illiterate ex-convict who changed the course of San Francisco history. *Author's Collection*

As bad as the situation appeared locally, Mulligan and his minions had come up with a plan that would solve all their problems. They would write off San Francisco. Give it to editor King and his do-gooders. Mulligan and his gang would create, control and plunder a new county.

The Mulligan brothers, Chris Lilly, Bill Lewis, and others had been carefully watching the Horace Hawes consolidation bill which had been stuck in committee for some time now. The Hawes bill would enact controls on how municipal and county funds could be

spent. It would mean the end of the plundering of the county treasury, which had been pillaged in the amount of three million dollars during the past five years.

The Mulligan crowd had noticed the effort by residents in the southern part of the county to create a new county. San Francisco

was too far away, they argued, and they wanted a new county seat closer to home. Mulligan's group now began badgering senators to not only support the Hawes bill, but add the provision for a new San Mateo County. Today it seems incredible that this group of thugs had so much power, but remember, they had elected many of these same legislators and did not hesitate to threaten and blackmail others. Benjamin G. Lathrop, the new county's first clerk, later recalled the transaction:

Billy Mulligan as sketched by Thomas Nast during the Heenan-Sayers fight in England. *Author's Collection*

In the legislature of 1856, Horace Hawes famous consolidation act was passed, but before it could be put through Hawes had to make terms with the thieves, by adding a clause of his act cutting off about nine-tenths of the county of San Francisco, establishing what is now the county of San Mateo. Chris Lilly and Billy Mulligan, two leading chiefs of the roughs, agreed to accept that much of the county provided it could be arranged to organize a county government within one week after passage of the act.

The Mulligan gang had been determined to defeat the consolidation bill or pull its teeth. Fearing they would fail in both, they insisted that in return for establishing the new county, for which there was a genuine demand, they would allow the bonding of city officials and a fixed ceiling would be placed on expenditures. The stage was now set for a May 12, 1856, election of the new county's officials.

The gang set up thirteen precincts and appointed three men as supervisors of the election. Chris Lilly's San Rafael House saloon was named as one precinct, with two others at Crystal Springs and the village of Belmont. Ex-governor John McDougal lived in the lat-

ter precinct and went along with the scheme so long as Belmont was made the county seat. These three precincts would be made to bring in enough votes to carry the election. The gang's slate of candidates included Bernard Mulligan for sheriff, with Lilly's bartender, Robert Gray, for county clerk.

As might be expected, the election was a monstrous fraud. Clark, the county clerk candidate, managed to kill a man in a drunken brawl at Lilly's. The *Bulletin* of May 14 announced Bernard Mulligan had been elected sheriff and Gray the clerk-recorder, along with the gang's other candidates. The truth quickly came out in a flood of protests from outraged voters, as noted in the *Sacramento Union*:

> San Mateo Election—The San Francisco *Chronicle* publishes an extract from a private letter in which the following facts are stated in regard to the election in that new county:
>
> In fact, our election was a mockery, and an insult upon common decency and honor. Our ballet boxes were stuffed beyond parallel. Crystal Springs, 240 votes with 50 voters; Belmont polled 340 votes, while there are not over 30 voters in the precinct; and at Lilly's, where there are 40 voters, 500 votes were polled. Men whose names were not on a ticket and who were not known as candidates, were elected; and some of the successful candidates received 217 votes more from the three precincts than there were voters in the county. I am disgusted and ashamed to own myself a citizen of so young a county so deep in rascality and sin.

An investigation proved all of the above, and more, and a new election was scheduled. Mulligan and his gang had badly miscalculated just how brazen they could be and get away with it. But by this time they were in even deeper trouble.

On May 14, 1856, the *Bulletin* printed an editorial commenting on a recent shooting scrape between James Casey and a man named Bagley. King suggested that, even if Casey was a bad man and an ex-convict from New York, that was not reason enough for Bagley to try to shoot him. King did not have to mention Casey's Sing Sing record, as this was already known. Still, a highly incensed Casey burst into the *Bulletin* office and demanded to know why King had brought up his prison record. After a brief exchange of

words, King told him to get out, with Casey mumbling about defending himself as he left.

That evening King left his office at five o'clock and began his evening walk home. As he walked past the Montgomery Block and started to cross the street, the editor heard a voice and turned toward it. He had barely identified James Casey pointing a revolver at him before the explosion came that staggered him.

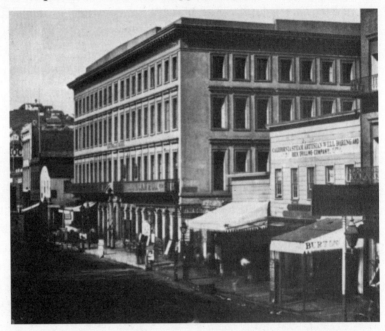

King was shot in front of the four-story Montgomery Building, shown here in 1856, the year of the killing.
Author's Collection

As Casey was hustled off to the county jail in a hack with a howling mob in pursuit, James King was helped into a nearby express office where a group of doctors tried desperately to save his life. Huge crowds waited in the street for any news, and his wife stayed at his bedside around the clock until he died, six days later.

A boisterous mob surrounded the county jail as soon as Casey was admitted. Everyone knew that Scannell and his deputies, who had been stuffed, or appointed into office, were "shoulder-strikers" and Broderick thugs who were now in charge of the jail. As Casey was ushered down the cellblock, Charles Cora glared at him through the bars, while the boisterous throng outside continued to grow.

Sheriff Scannell, Billy Mulligan, and other deputies were mute

and wide-eyed at the situation in which they found themselves.

"Casey," muttered Cora, "you've done us both in!"

Meanwhile, William T. Coleman, who had led the 1851 vigilantes, was conferring with other former members. All agreed that it was time to make a stand, and the old vigilante bell on the plaza began to ring. The Richardson and King shootings, along with the San Mateo voting frauds, were more than an outraged public could stand. Newspaper notices called for all the old Committee of Vigilance to assemble at a Sacramento Street hall, and soon long lines of prospective members were being signed up.

When King died, some 2,500 armed vigilantes marched to the jail, positioned a field piece, and demanded that Casey and Cora be handed over. Groups of lawyers, politicians, and public officials bolstered the Scannell forces, but they were but a minnow confronting a whale. The two prisoners were released to the custody of Coleman's forces and marched back to vigilante headquarters where both were given prompt trials. As a long train of mourners followed the slain editor's body to the cemetery, Casey and Cora were hanged from two adjoining windows of the vigilante headquarters on Sacramento Street.

The vigilance committee now controlled the city of San Francisco! As expected, the politicians, office-holders, government officials, lawyers, and judges were generally allied against Coleman and his men, although some Democrats were conspicuous in the grim ranks of the vigilantes. When Governor J. Neely Johnson tried to assemble an opposition force, there was little support. Even the federal government refused to become involved. Most of the city press fully approved of the takeover, and any dissenting newspapers quickly discovered their advertising being withdrawn.

Banker William T. Sherman, an officer in the state militia and later a prominent Civil War general, was opposed to the vigilance committee, but clearly understood the frustrations fueling the uprising. In a letter to a banking partner in Saint Louis immediately after King was shot, Sherman penned that "had the populace got Casey that night and hung him, I would have rejoiced."

Immediately after the hanging, the committee began arresting the ballot box stuffers and thugs who had for so long controlled the city elections. They took no chances with people like Charley Duane,

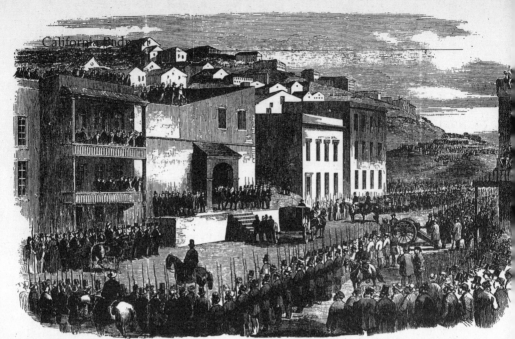

The vigilantes take custody of Cora and Casey at the county jail. An engraving from a daguerreotype. *Author's Collection*

Billy Mulligan, Bill Lewis, Woolly Kearny, and Martin Gallagher, and six or eight vigilantes were detailed to retrieve them one by one. At the sign of any resistance, a swarm of additional troops appeared as if by magic. Yankee Sullivan, John Crowe, Reuben Maloney, and lesser lights such as Lewis Mahoney, a notorious cattle and horse thief, were given free room and board at the vigilance committee's Sacramento Street rooms. Some twenty of these captives were given a hearing, after which charges against them were read and they were told they would be sent from the city.

Were the vigilantes justified in their high-handed actions? That question is still debated today. But even Charley Duane, who vehemently opposed the committee, in later years admitted the justice of the vigilante cause:

> I do not dispute the fact that there was some ground for the Vigilance Committee here in 1856. Politics had become so corrupt that it was impossible to have anything like a fair election. It was a regular thing to elect men as supervisors [who controlled city finances] whose names had not even been mentioned at the polls on election day, just as Casey had been elected.

Chris Lilly and various minor thugs were warned to leave the city, which they were glad to do. Judge Edward McGowan, suspected as an accomplice in the murder of King, disappeared also. Yankee Sullivan, thinking he was being returned to the penal colony in Australia, committed suicide in his cell on May 31.

The vigilantes recognized that it would be best to ship out the prisoners late at night to avoid any trouble; so the first six of the worst offenders were scheduled to leave at two o'clock in the morning. Late on the night of June 5, 1856, squads of vigilantes conducted the manacled prisoners down to the wharf. Here they were helped aboard a tugboat which would take them to the ship. For some reason all the prisoners thought they were being sent to Australia. A reporter for the *True Californian* sat down with the prisoners on the tug and published this illuminating report:

> Duane declared that the turn that affairs had taken was peculiarly unfortunate for him, as he had just got matters arranged in such a way as to secure to himself the office of City Marshal, at the next election. And while talking about election, they all declared that they had had many a hearty laugh among themselves after the polls were closed, to hear the folks talk about such and such a man running so well, or being so remarkably unpopular, when it was all managed by *hocus pocus* by the "stuffers."
>
> When the tug parted from the *Carrier Dove*, without leaving these fellows on board of her, they were very much relieved. Soon the steamer came alongside of the bark *Yankee*. Bulger, Gallagher, and Carr were ordered on board the bark, after having been relieved of their irons.

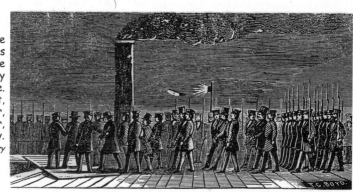

At two o'clock in the morning the prisoners are escorted to the wharf, each flanked by a stern vigilante. Duane is first, followed by Gallagher, Mulligan, Carr, Bulgar, and Woolly Kearny.
California State Library

The others did not exhibit any signs of either fear or shame. Duane talked about as usual, but now and then broke out with a complaint or an oath. Mulligan admitted that he was too bad to live in any city—yet "he had 'spotted' those who sent him away,"—laying his finger on his nose.

The reporter wrote that both Mulligan and Duane were determined to come back "as soon as there was any law in the damned country." Passengers lining the decks of several ships that were leaving port looked at the situation slightly differently and, aware of what was happening, "broke out with a tremendous cheer."

Duane, Mulligan, and Woolly Kearny were placed on the *Golden Age* for Panama, while another group was sent to Hawaii. Others who skipped out to inland cities were informed that death awaited them if they returned to San Francisco. Al-

Park Place in New York City as it was when Mulligan was returned to the city in 1856.
Author's Collection

though many illegally elected officials remained in office, the ballot box, and other thieves and killers had been successfully dealt with and municipal authorities again resumed control. Their job done, the Committee of Vigilance disbanded after a huge parade in late August 1856.

Following several detours and escape attempts, Charley Duane eventually made it to New York, still vowing he would return to San Francisco. Mulligan arrived in New York aboard the *Illinois* in July and promptly began fulfilling his pledge to "get even" with the vigilantes. Learning that three vigilantes were in town on business, Billy, Jim Hughes, and several other thugs promptly found their

quarry at the Girard House. In a dispatch from the *New York Tribune*, the *Bulletin*, July 30, reported:

> Soon one of the men crossed the street from the hotel towards Hope's Grocery, when Mulligan rushed at him and struck him a powerful blow. The gentleman, seeing the odds against him and not wishing to soil his hands by touching such a scamp, scampered off and has thus far not appeared to prefer a complaint against the assailant. It is expected that a large number of the vagabonds who have been expelled from San Francisco will come to this city.

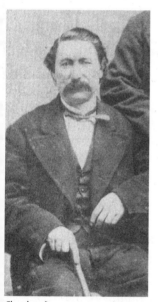

Charley Duane was a vicious thug and killer, but there were some things he would not do.
John Boessenecker Collection

William T. Coleman arrived in New York on business in September 1856. Mulligan attempted an attack, but was thwarted and the vigilante leader suffered only minor damage. Coleman was arrested that same month on a complaint of Reuben Maloney, who sought that Coleman be held for one hundred thousand dollars. In early October, both Mulligan and Duane instituted hefty lawsuits against individual vigilantes and ship captains. Clearly, those who were banished from the West Coast were going to make great nuisances of themselves and perhaps get rich in the process.

Duane promptly hooked up with his old Tammany Hall cronies, lawyer Dan Sickles and Tom Hyer, the noted prize fighter. Duane had not learned anything from his San Francisco experience and was still determined to return. His two friends urged him to wait until the presidential election was over so he could return with a government position and the vigilantes would not be able to touch him. This idea appealed to him and he bided his time.

While Duane was reading in the Metropolitan Hotel lobby one day, Rube Maloney, another of the exiled California thugs, walked in. The two men went down to the barroom where Billy Mulligan and several others greeted them. Maloney joined the group while

Duane waited at the bar, unsure of what was going on. Finally, Maloney asked him to come join the group, as they had a proposition for him. After being sworn to secrecy, Charley was invited to join a plot to assassinate Coleman, who was still in the city on business. Duane reported years later that when the group looked to him for a response, he stood up and said, "If a hair on Coleman's head is harmed I will expose the whole plot."

Surprisingly, Billy Mulligan jumped up and stated he would stand with Duane. Although still in favor of "giving Coleman and every other vigilante a sound thrashing," Mulligan would not take part in any assassination. With this, the plot was effectually broken up and Billy went back to his "thrashing" entertainments.

When a former vigilante named Chrysler arrived in town, the belligerent Mulligan promptly sought him out, as reported by a correspondent in the *Bulletin*, September 30:

> The gentleman was beset in the street by Billy and his satellites, but he was near the Astor House, where he was staying and took refuge there. It was only a change of scene, Mr. Mulligan followed him into the office, and having ascertained by inquiry that the Californian was not armed, he began to "pitch in." Those who were present promptly interfered; a gentleman took Billy by the collar and laid him out on the floor, recommending him to lie there until he could behave like a man. A waiter ran for a policeman, but before the official appeared, the late candidate for the office of Marshal of the city of San Francisco had escaped.

Following Mulligan's attacks, Billy and Duane both instituted suits against members of the committee and the ship captains who had carried them from the state. In November 1856, Duane claimed damages of $100,000 due to his expulsion, while Mulligan sued for a paltry $25,000, feeling no doubt that he would have a better chance of collect-

ing a smaller amount. Other expelled thugs instituted lawsuits also, but the vigilantes fought them in the courts, considering it part of the price of getting rid of them. Duane's suit was finally whittled down to fifty dollars, while Mulligan received nothing. On several occasions, however, sympathetic courts did award Duane and other deported thugs a few thousand dollars.

New York had always had more than its fair share of political thugs, gamblers, gangs, and the vicious "shoulder-strikers" who stuffed ballot boxes and controlled elections. When many of them went to California during the Gold Rush, they were not missed. Now, some of the worst were back and they were not appreciated, as was noted by a New York correspondent in the San Francisco *Bulletin*:

> Why, in the name of common sense and the filial reverence you owe us, does your Vigilance Committee make a Botany Bay for your rogues in our city? Why don't you send them to Utah, or Japan, or the river Amoor, or the Gilipagos? If you will send them here, why don't you send us a little Committee along with them?

For a time, due to Mulligan's relentless attacks, visiting vigilantes became a scarce item in New York, and Billy could devote himself full time to gambling, boxing and politics. When he located another vigilante, James F. Warner, on July 2, 1858, he gleefully confronted him on Broadway and punched him in the face. Notified the following day that another ex-vigilante had arrived, Mulligan and several pals found the luckless Hiram Webb at the Metropolitan Hotel and attacked him, as reported in a letter to the *New York Times*:

> Your account of the assault, last evening, upon Mr. Webb by the notorious "Billy Mulligan" at the Metropolitan Hotel, scarcely did justice to the two energetic policemen who were called in to see fair play. Whilst the victim was standing in the presence of his murderous assailant, and calling upon policemen to arrest Mulligan, that gentleman was permitted to walk off unmolested by these two officers, upon the ground that

MULLIGAN TO BE TRIED.—We are most happy to learn that Judge RUSSELL has reviewed his decision in the case of BILLY MULLIGAN, and determined to try that disturber of the public peace at the present term, instead of deferring it until September. We presume that no one will be disposed to question the propriety of Judge RUSSELL's continuing to discharge the functions of his office, even though he is under an indictment himself, while he sits on the trial of such persons as Mr. MULLIGAN. If he had appeared yesterday and allowed the testimony of Mr. WEBB to be taken *de bene esse*, the trial would have been put off until September.

New York Times, June 24, 1858.

without a warrant they had no right to make an arrest, notwith-
standing Mr. Leland, the proprietor of the Hotel, ordered the arrest,
and a dozen gentlemen present saw the assault, and Mr. Webb's
wounds giving the very best evidence that he had been beaten.

The plain truth of the matter is, that Mr. Mulligan was pro-
tected by two or three men of his own stamp and the officers *dared
not* make the arrest.

Mulligan put up a $1,000 bail for the Warner assault, but did not
choose to appear, as requested by the court, when Webb's testimony
was to be taken in the district attorney's office. Judge Russell was not
happy and scheduled Mulligan's trial for the next day in the Court of
Sessions. He showed up for this appearance, but when he was called
upon by the court, he was nowhere to be found. It seems he had fled
across the Hudson River where he enjoyed himself at Hoboken's At-
lantic Garden with a bunch of pals. Mulligan's attorney covered for
him as best he could, arguing that to fulfill his bonds, his client was
only required to show up in court. The judge thought otherwise and
although his bail was ordered forfeit, the case was postponed until Sep-
tember.

Billy, meanwhile, did show up for the Warner trial that took place
in early December 1858. Insisting that the San Francisco Vigilance Com-
mittee be made the villain in the trial, Mulligan quickly discovered the
ploy was a two-edged sword.

The defense counsel, Richard Busteed, made the fitness of pro-
spective jurors dependent on their sentiments concerning the vigilan-
tes. It was a bad idea, as reported in a New York dispatch to the San
Francisco *Bulletin*:

The answers of a few of these challenged jurors were not of a
nature to pour balm upon the still lacerated spirit of Master Mulligan.
One stated bluntly that, in his opinion, "the Vigilance Committee
did just right in banishing (Mulligan) and his fellows from Califor-
nia; that a similar committee would be a good thing for New York;
and that Mulligan ought to be sent back, not to California—the ju-
ror would not be so cruel to that State—but to the Feejee Islands."
This statement of opinion was followed by some hearty applause,
under which the defendant seemed to wince a little.

After various prospective jurors had been discarded for similar sentiments, the trial got under way. It was a simple case. James Warner, a divorced man, was trolling for a female companion that night when he had been accosted by Mulligan. Billy scared off Warner's first "date," then followed as the ex-vigilante picked up another street-walker. Again, Mulligan rushed up, telling Warner to release his hold on the woman and stop abusing her. When Warner called him a "dam-nable nobody," Billy delivered a powerful blow and Warner retired to his place of business. That Mulligan was merely an interested spectator try-ing to rescue two women from the lecherous Warner was attested to by the two local Cyprians involved that night. Both had been brought up from Blackwell's Island prison and verified the thug's story. When Warner and two police offic-ers testified that neither Catherine Smith or Mary Anne Leonard could tell the truth if their life de-pended on it, it was too little and too late.

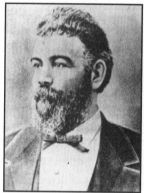

John Morrissey was another New York thug who became the world heavyweight champion. *John Boessenecker*

In summing up, lawyer Busteed castigated the San Francisco vigilantes at great length, not-ing that they had performed one good service: "they had sent back to this Metropolis, from which he was too long absent, the renowned Mulligan, to be once more the champion and the defense of insulted virtue." The only question re-maining was, who laughed loudest at Busteed's summation, New Yorkers or San Franciscans.

Mulligan was pronounced "not guilty" after Judge Ingraham prompted the jury as to the manner in which Mr. Warner selected his evening companions. Billy was heartily con-gratulated by his thug colleagues as he left the courtroom. In Septem-

Morrissey and Mulligan raise their arms in victory over Heenan in a contemporary print. *Author's Collection*

ber, Mulligan had plead guilty in the Webb assault case and paid his fine.

In October, Billy seconded the current champion, John Morrissey, in a heavy-weight title fight with John Heenan, the "Benecia Boy" in Canada. It was a brutal slugfest, with Heenan breaking his hand early on but continuing the fight. He managed to break Morrissey's nose and batter him considerably, but the champion came back to knock Heenan cold in the eleventh round. According to newspaper accounts, Billy made a handsome sum wagering on the fight.

On April 5, 1859, there was a large benefit for the widow of a popular ward politician held at Hoyan's Theater. Exhibition boxing matches and liquor made for a raucous evening and afterwards Joe Coburn and Pat Mathews discussed the entertainment in Florence's Saloon. It was midnight when an argument evolved into a brawl and Mathews blacked both of Coburn's eyes before stalking out and looking for a

more formidable foe. At Dick Platt's Bleecker Street saloon, Mathews ran into Mulligan, referred to in the *New York Tribune* as the "martyr of the San Francisco Vigilance Committee." After exchanging a few snarls, the two thugs went at it and were quickly surrounded by a throng of cheering spectators.

"For about fifteen minutes," reported the *Tribune*, the "gentle" Mulligan and the "amiable" Mathews sprawled upon the floor, chewed each other's noses, and gouged one another's eyes to their heart's content and to the unallayed satisfaction of the spectators. Mulligan, getting decidedly worsted in the encounter, was finally removed by his associates."

Apparently, Mulligan was first to cry "enough." A tally of dam-

ages listed both men as having black eyes and the tip of their nose bitten off, besides sundry cuts and bruises. Billy's eyes were gouged to the extent that there were "doubts of his ever recovering his eyesight. For the sake of a quiet and well-ordered community, let us hope for the worst," commented the *Tribune.* "But in all probability, they were separated rather too early for the public good." Such events were joyously reported in the San Francisco press, of course.

In 1859, John Morrissey resigned his championship for an interest in a saloon and gambling house. He had been champion since 1853 when he had beaten Yankee Sullivan. A thug and drunk, Morrissey was a product of the burgeoning cult of boxing which had been embraced by the criminal class, street gangs, gamblers and the political thugs who controlled elections. But Morrissey was very popular and valuable to the Tammany political bosses. Mulligan and Morrissey had at one time been great friends, but it was said that Billy had once run Morrissey out of a saloon and this may have been when their relationship soured. Others maintained Mulligan had been blackmailing Morrissey and this was the cause of their enmity.

Late on the afternoon of January 2, 1860, Mulligan walked into Morrissey's gambling house at 676 Broadway. He and Morrissey had been involved in a dispute the previous night and Billy sought out an old man named Daney who also had an interest in the house. Insisting that he break any connection with Morrissey, Mulligan told Daney he would do no more business in New York if the partnership was not severed. Morrissey stepped up at that point and ordered Mulligan from the house. Mulligan refused, saying he would leave when he was ready. Morrissey repeated his order and when the badman again refused, Morrissey left and returned with police officer Anthony W. Oliver. When Billy asked for the officer's authority, Oliver showed his badge and stated, "This is my authority."

"I don't recognize your authority," exclaimed the shouting Mulligan, "and anyone putting a hand on me does so at their own peril!"

Mulligan now pulled his pistol and pointed it at Oliver, saying he would defend himself. At this point, reinforcements were summoned and Billy saw that further resistance was useless. Several of

ficers escorted the San Francisco "martyr" to police headquarters where he was met by his lawyers and bail obtained. Mulligan knew he was in serious trouble this time.

When Morrissey retired, John C. Heenan, the celebrated "Benecia Boy," assumed the heavyweight mantle. British champion Tom Sayers had been casting about for a worthy opponent and agreed to a bout with the new American titleholder. Knowing full well he was on bail and could not leave the country, the arrogant Mulligan signed on as a Heenan handler and set sail for Liverpool aboard the *Asia* on January 4, 1860. James Cusick, another of the thugs cast out by the San Francisco vigilantes, was Heenan's trainer. The impending fight had stirred up much interest in both countries. The *New York Illustrated News* and George Wilkes's *Spirit of the Times* each sent reporters and artists to cover the event. The celebrated artist Thomas Nast and two engravers accompanied the *Illustrated News* contingent, determined to be the first to record the heralded match. Nast would make on-the-spot sketches and his two engravers would convert the scenes to wood blocks while on the return trip so as to be ready for printing immediately upon landing in New York.

As in America, prize fighting was illegal in Britain and the

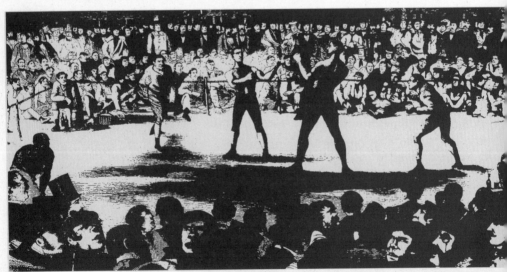

This view of the fight shows Mulligan (right) crouching just behind the towering Heenan. It shows him as he is always described—a fierce, no-holds-barred scrapper ready for anything. *Harper's Weekly, May 5, 1860*

site had to be changed many times, with Heenan later complaining that he had "been chased out of eight counties." A huge crowd was expected and a final site was selected near the village of Farnborough. The date was April 17, 1860.

The Benecia Boy was larger than Sayers, but the two fought a bloody battle, utilizing all the tricks of those

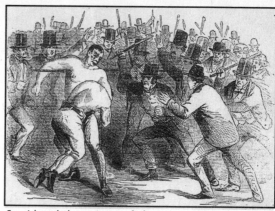

Considered the greatest fight in boxing history, this shows the closing scene as spectators and police break into the ring. *Wilkes' Spirit of the Times, May 5, 1860*

early days of the ring. Although kicking, hitting below the belt and striking a man who was down were against the rules, throwing him down and falling on him "accidentally" was a favorite means of weakening an opponent. An intimidation stunt used by Mulligan and other thugs was to menace a fighter and his handlers with constant threats and the subtle display of pistols and knives.

John Morrissey had made the trip also, and he had counseled Sayers on how to defeat the Benicia Boy, but to no avail. The bruising battle lasted forty-two rounds and was broken off when constables burst into the ring and stopped the contest. At the time, Heenan had a choke hold on Sayers and was pummeling him. The fight is still considered the most celebrated nineteenth-century prize fight and both men were awarded championship belts. Heenan was acclaimed as a tremendous hero when he returned home.

Mulligan was no doubt glad to get back to New York that summer. His excuse for leaving was probably that arrangements had already been made for the overseas trip, and Heenan—the American champion—depended on Mulligan to help defeat the British champion. In mid-August there was a huge benefit for Heenan at Jones' Wood where thousands gathered and paid to see an exhibition bout by Heenan and contests by various other bruisers. Mulligan, Cusick and other thugs helped keep order until the bouts commenced. Despite the country's euphoria over Heenan's British showing, Billy still had to face his trial in late November.

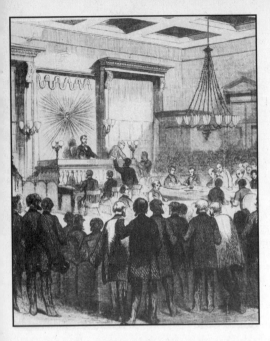

Mulligan's trial was held in this room in the courthouse at City Hall Park.
Harper's Weekly, February 1857

On November 20, 1860, Mulligan made his court appearance, accompanied by Richard Busteed and two other lawyers. There was the usual hassle trying to find unprejudiced jurors, but by afternoon the trial was underway. The prosecution's case centered around Mulligan refusing to leave Morrissey's gambling hall when ordered to do so. He also refused a policeman's demand that he leave, and drew a pistol and threatened the officer. Both officer Oliver and Morrissey testified as to the incident, after which it was announced they had no more witnesses.

The defense then called up a string of witnesses whose testimony lapped over into the next day. The court refused Mulligan's request to remain out on bail and he was relegated to the city jail, or the Tombs, for the night. That evening Billy had plenty of time to reflect on his misspent life, but he probably didn't. He was more concerned with the outcome of his hard-fought trial.

The case was continued for the next two days and when the jury brought in a "guilty" verdict, there was consternation among Mulligan's friends in court. To make matters worse, there would be no bail while waiting for word on an appeal based on a faulty indictment. On December 2, Mulligan was in court with his attorneys for sentencing. The offense was a felony, calling for a sentence of between two and ten years. Judge Gould sentenced him to four and one-half years in Sing Sing state prison. Pleading that his sentence should be delayed until he could testify in another court case, Mulligan was disappointed when Judge Gould also turned down this request.

The New York press had a field day with the event, the *Brooklyn Eagle* reporting:

The fashionable bully Billy Mulligan—the wild, tremendous, roaring, tearing, fighting Mulligan—that has battered the countenance of some quiet citizen on an average once a week for the past five years with perfect impunity—was on Saturday sentenced to the States Prison for four years and a half for merely attempting to shoot a policeman. Of course the fashionable ruffianism of New York is disgusted, but the newspapers all chuckle over it, and seem to regard it as a great triumph that a big ruffian has at last been sent where he ought to have been years ago.

Before being shipped off, Billy had acquired permission to be married to his long-time consort, a woman named Mary Lewis. Of course the San Francisco press loved all this, particularly Billy's new marital status. On December 25, 1860, the *Daily Alta California* had great fun describing the happy event:

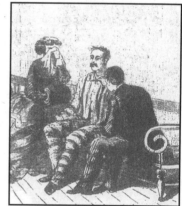

Mulligan was frequently visited by his new bride, but the woman was only a means to an end. *Harper's Weekly, 1861.*

> Before starting [for state prison] he was married to Mrs. Lewis, a boarding house keeper on East Houston street. Now, as Mulligan's associates were not of the most virtuous sort, as the locality where Mrs. Mulligan resided is not a very respectable or virtuous part of New York, and as the term boarding house keeper is a very general term—and has been claimed more than once in the police courts, and elsewhere, to mean an occupation somewhat questionable—it is a fair inference to suppose that our quandom San Francisco rowdy has married a woman of doubtful reputation.

A more respectful recollection of Mulligan's nuptials was recorded by Charles Sutton, the long time warden of the Tombs. Sutton described his new boarder as a "professional blackleg":

> During his incarceration in the Tombs he was frequently visited by a handsome young woman who was possessed of some money and considerable jewelry—diamonds, etc.—which she sacrificed to meet the expenses of Mulligan's trial. On the evening

preceding his departure for Sing Sing she called upon him and in so many words offered to marry him. He consented. The knot was tied by Judge Brennan, who at that time was on the bench. The next day they started on their wedding tour for Sing Sing, the bride manifesting a devotion such a woman only knows.

On December 8, 1860, Billy's usually elegant attire was exchanged for stripes at Sing Sing. It was reported that when Billy's hair and mustache were shaved off, the badman cried bitter tears at his humiliation.

New York's Sing Sing prison was the largest of the state prisons and was a massive, sprawling complex of cellblocks and outbuildings overlooking the Hudson River at Ossining, New York. Billy kept in constant touch with his lawyers and told his wife to stay in touch with them, also. All felt certain that an appeal would be successful. His lawyer, James T. Brady, discovered that the original indictment had stated that Mulligan had actually fired his pistol at officer Oliver, when in fact it had been proved he had only pointed his pistol at the policeman. It must have seemed like a year before news arrived in mid-February that his appeal was being considered.

A new trial was granted the following month as noted in the *Times*, March 19, 1861:

> Arrival of Billy Mulligan. Billy Mulligan, in company with his wife, arrived in this city last night, in charge of an officer. He was taken out of Sing Sing on a writ of error, and a new trial granted him.

The ex-convict was admitted to $5,000 bail. The case had been so thoroughly vented in the courts already, however, that the case never went to trial. "He may reasonably be expected to be seen disporting himself on Broadway the first fine afternoon," reported the *Times*, "with all his old-time elegances, saving and except that hirsute appendage, the removal of which by his late keepers, from his upper lip, is reported to have seriously lessened the rigidity of that facial feature."

After the fall of Fort Sumpter in April 1861, Mulligan had, of course, kept up with the war news. Now there were always soldiers on the streets, parades of recruits, and constant rumors and news of impending clashes. It was war and Billy got caught up in

the excitement of it all. Or, perhaps he saw a grand chance for plunder. Military units were being formed all over the country. Touting his Mexican War service, and with his political connections, Mulligan would have no trouble acquiring a commission from those who owed their election to him. And, a nation cobbling together an army as quickly as possible did not always look as closely at those "cobbled" as it should.

As outlandish as it appears, Mulligan found himself with a commission as a lieutenant colonel with authority to raise a regiment of volunteers for service in the army of the Union. Few details of this unit have been found, but don't you just know that Mulligan and his cronies set up their recruiting station in their favorite saloon.

After electing officers for his unit, Billy began enlisting men, forming them into companies and platoons and drilling them in army tactics. As soon as he could procure uniforms for a few platoons, the pompous Mulligan began showing up anywhere he could find an admiring audience. During an evening in June 1861, he and some of his men showed up under the hotel window of the president's wife, Mrs. Mary Lincoln, who was in town for some shopping as reported in the *New York Times*:

> Mrs. Lincoln made her appearance at the window and acknowledged the compliment by bowing and waving her handkerchief. She was greeted with three cheers and every demonstration of enthusiasm. Mrs. Lincoln then presented to Lieut. Mulligan two handsome bouquets. This gentleman gracefully acknowledged the gift. Can your readers who have heard of Billy Mulligan, imag-

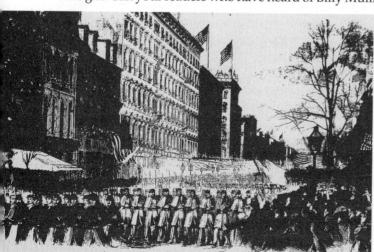

A New York regiment marching down Broadway during the war.
Harper's Weekly, March 4, 1861

ine a richer scene than this? And wouldn't they like to know who is responsible for this gross insult to the wife of the President?

"Who will be disposed, hereafter," closed the article, "to deny the truth of the declaration, 'when the nation boils the scum rises uppermost.'"

Mulligan and his troops waited throughout the summer for assignment to an army unit, but none was forthcoming. After the action at Bull Run in July 1861, Mulligan must have been frantic to get into action. He was a fighter. It's what he did. He undoubtedly knew in his drink-fogged mind that if he could just see some action he would distinguish himself and become a bigger celebrity than ever. He must have pestered his political connections incessantly about an assignment to a regular army unit, but always he was put off. Little is known about this period of Mulligan's story, but it is known that when word got out about his background no officer wanted an albatross like Billy around his neck.

A few newspaper articles of the time seem to suggest that Billy was actually making an effort to behave responsibly. A New York correspondent sent the following article that was published in the *Sacramento Union* on November 30, 1861:

> Billy Mulligan, the bruiser, is Colonel of the Fremont Cavalry, raising in New York city, and has been before the Police Court to procure the imprisonment of his Quartermaster, named Hall, who, having been removed for malfeasance, was making trouble among the men. Billy behaves quite like a gentleman; and when Hall called him a liar, before the court, Billy showed an equanimity of temper not usually credited to him, telling Hall that he would not dare to say so, if he (the Colonel) were in the street, and had his uniform off.

Mulligan had grown tired of waiting for an assignment on the eastern front. After the battle of Wilson's Creek in Missouri, he had accompanied a group of his men to Saint Louis, hoping to attach his unit to that of General John Charles Fremont. According to a dispatch from Saint Louis to the *New York Times*, Mulligan "came here to offer his sword to Gen. Fremont, having, I believe, made the general's acquaintance in California; and hence, as in all such cases, entitled to a

position in the Body Guard, or a fat contract." Fremont's sun, however, "was just going down." After losing the battle at Wilson's Creek, Fremont had lost his command and was recalled to Washington. The frustrated Mulligan and his men returned to New York.

The *Sacramento Union* article no doubt reflected some kind of face-saving gesture, as there was no hope of Mulligan being attached to the discredited Fremont. Back in New York he would have been a laughing stock if anyone had dared to laugh. The truth was that Mulligan's past was being aired in government circles now and there was no way a thug, gambler, ex-convict, and gunman was going to be given any authority in the military. During the same month the *Sacramento Union* reported Mulligan was "released" from the army,

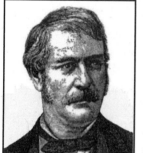

a man named George Wilkes was taking credit for having the badman discharged from the military.

As editor of the *Spirit of the Times*, a New York tabloid with wide distribution, George W. Wilkes was a powerful man. He was an influential Democrat and while touring Gold Rush California in the early 1850s, Wilkes had met Mulligan in San Francisco. For whatever reason, the men became chummy, probably because a Mulligan could be quite useful to a newspaperman. "Wilkes is capable enough to gain a good position among gentlemen and scholars," stated an article in the San Francisco *Bulletin*, "and how it happened that he and Mulligan were ever cronies is unaccountable."

George Wilkes, editor and founder of the *Police Gazette*, and bitter enemy of Billy Mulligan. *Author's Collection*

When Mulligan's old political associate David Broderick was killed in a California duel in 1859, George Wilkes found himself the recipient of Broderick's will. The two men had been friends and business associates since the 1840s, Wilkes being a tutor and mentor to the younger Broderick. Since Broderick was quite wealthy, mainly due to interests in San Francisco property, there had been allegations that his will had been forged. In the squabbles and court challenges that followed, sides were taken and enemies were

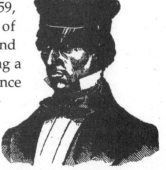

John Dooley, alias Laurence, as depicted in Wilkes's publication. *Wilkes' Spirit of the Times, September 20, 1862*

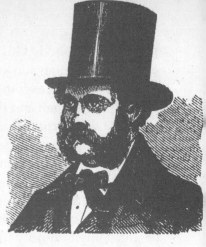

Mulligan's portrait as published by George Wilkes.
He promised to print a full length view , but Billy
apparently moved West before he did so. *Wilkes'
Spirit of the Times, September 27, 1862*

made. Two of the enemies were Wilkes and Billy Mulligan, who crowed that the will was a forgery to anyone who would listen.

On September 20, 1862, George Wilkes wrote and published a long article in his tabloid excoriating the legions of "Mulligans" that had plagued New York for decades. Expending a long column on this class of characters, Wilkes railed:

> These fellows, whom the police have not inaptly nicknamed "Strippers," are among the best dressed figures of the street, and, though five minutes questioning by any magistrate would reveal the fact that they are without visible means of living the miscreants are not only saucy, but aggressive, and it is only by an excessive diffidence of carriage that gentlemen can escape their sneers, or by hurried footsteps and downcast heads, that the virtuous females of our city can pass by them without insulting intercession.

After making stinging accusations of these thugs as being petty thieves and blackmailers who hung out in the city's gambling halls, Wilkes also charged them with "numerous instances where citizens have recently been knocked down, maltreated and robbed by these dandily dressed brigands (for they all affect to be pugilistic) and many a murder might also be laid at their door." Wilkes next related how he had met Mulligan and his pal Johnny Laurence at the Fashion horse race course the previous week. Laurence was referred to as an "English pickpocket named 'Dooley,' alias John Laurence," who kept a low, cheating gaming house in the city.

The two thugs had "dogged" Wilkes and several friends at the race course, trying to catch them off guard and involve them in an assault. Laurence was making a loud, spurious claim that Wilkes owed him some money in an attempt to gather a crowd, under cover of which an assault could be made in the general melee.

The Wilkes group was able to avoid a situation where they could be attacked, but in order to force Mulligan to avoid him in the future, Wilkes had written the following article. He had closed his harangue with a blistering biography of Mulligan, citing several murders he had engaged in during the Mexican War, his expulsion from San Francisco, and his motives for raising his recent ill-fated army regiment:

> On coming out of the State Prison, he endeavored to raise a regiment in connection with several fellows of his own kidney, and who we knew had been in association when Washington was first threatened, to go down there and assist in its plunder by the [Confederate] enemy. We informed the government of these facts, gave the antecedents of Mulligan and Company, and were substantially the author of the order which General Scott subsequently issued to the governors of States directing that in all future nominations of staff officers, they be sure to select *"men of good, moral characters and known loyalty."*

To make it clear that he meant business, Wilkes published a portrait of Laurence and Mulligan and let it be known that he had access to the New York police Rogues Gallery and he would not hesitate to publish likenesses of these thugs when necessary. Suggesting a New York vigilance committee might be in order to get these thugs out of town, Wilkes recommended his advice to the "strippers," concluding his lengthy diatribe by noting Billy's latest escapade :

> We especially commend [our advice] to the murderer Mulligan. Arrested as late as Friday night in a house of ill-fame in Houston street, and taken to the Eighth Ward Station on suspicion of robbing one of the incautious guests, he should felicitate himself upon this new es-

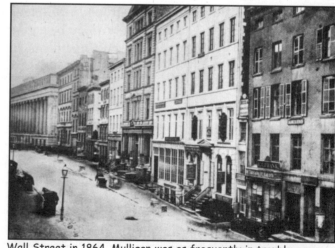

Wall Street in 1864. Mulligan was as frequently in trouble in the East as he was in San Francisco. *Author's Collection*

cape from justice and get out of town. The community is sick of such vile characters as he and will not tolerate their presence in the streets much longer.

On October 17, Wilkes printed a long, unflattering article and portrait of Mulligan. The editor had seemingly made himself invulnerable by assuring Mulligan and his cohorts that they would be the principal suspects in case anything nasty happened to him. Unfortunately, the tables were turned when Johnny Laurence slapped a libel suit on Wilkes and his publication.

The case went to trial on December 19, 1862, but it promptly assumed the ludicrous stature that it deserved. Mulligan was present at the trial as a witness for Laurence. When a defense counsel asked a juror whether he had read the article in Wilkes's *Spirit* "about Billy Mulligan and other gamblers," Mulligan leaped from his seat, as reported in the San Francisco *Bulletin*, January 16:

> Advancing toward the counsel [Billy] demanded in a loud tone that he should desist from making use of his name in that manner. The court for a moment seemed to be paralyzed, but seems to have gathered courage enough to venture upon an order to the bully to take his seat. This order Billy declined to obey.

Mulligan's outburst, of course, only helped validate the truth of Wilkes's article. The defense counsel easily proved Laurence was a professional gambler and won the case. For dessert, they paid Mulligan back in spades for his "insolence" in court by reading Wilkes' biography of Billy in his article. Mulligan decided that it might be a good time to move on.

Charley Duane and other political thugs had returned to the coast without incident and Mulligan felt it should now be safe for him, also. After settling his affairs in New York, he booked passage back to San Francisco. The San Francisco *Daily Morning Call*, February 2, 1863, chronicled Mulligan's tranquil return to California. It was a low-key triumph:

The grave of Yankee Sullivan as it looks today in the Mission Dolores cemetery. *Author's Collection*

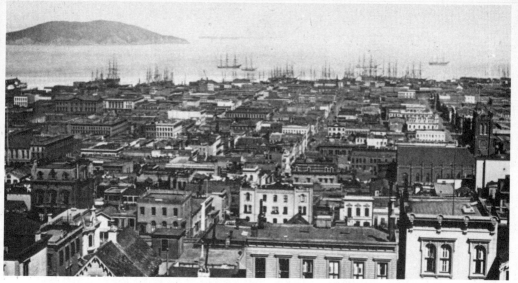
San Francisco still had plenty of badmen in the 1860s and now they had Mulligan back in the mix again. *Author's Collection*

Billy Mulligan—This individual, who, years ago, when taking his departure from San Francisco, was accompanied to the steamer by a large number of our most respectable citizens, returned on Sunday, and, strange to say, has created no excitement amongst his former admirers.

Actually, excitement was the last thing the badman wanted to create. Mulligan must have been walking on eggs the first few days after stepping off the boat. After all, he had been told not to return under penalty of death! Now, he found the salad days of the Gold Rush were gone as were old friends. Senator Broderick had been killed in a duel with Judge David Terry. Martin Gallagher, the burly boatman and Democratic vote hustler, had been stabbed to death in a saloon. His old pal Yankee Sullivan had committed suicide in his vigilante cell, while Chris Lilly had been murdered in Central America. Other pals shipped out by the vigilantes had disappeared.

Charley Duane was back, however. He and his brother John were strutting around town again. Mulligan did not have to buy his own drinks for the next few days as he reminisced with a few cronies and hangers-on about the good old days. Still dressed in the fashion dictates of the day, Mulligan ate at the St. Francis Hotel and otherwise kept up a good front.

Billy must have wondered at the growth of the city. Large brick and stone buildings were everywhere, while the streets had been extended west, out into what was once scrubby countryside. The atmosphere of the city had changed, and no amount of drinking could bring it back. In some ways the vigilantes were still in control, many holding offices of importance. Ex-vigilante Martin Burke was police chief and Mulligan stopped and chatted with some of the officers he knew.

It was not long before Mulligan was his old, cocky self. When he was picked up on a charge of attacking a young girl, the evidence proved to be negligible and he was released. There were other minor difficulties, usually resulting from his constant drinking. When he heard news of his brother Barney in Nevada Territory, Billy packed a bag and caught the first steamboat for Sacramento.

Barney Mulligan was a much more stable personality than his brother, even though Billy had sometimes dragged him down to his level. Barney had mined in the Sierra gold camps, worked in Sacramento for a time, and then joined the rush to Nevada Territory's Virginia City in the early days of that great camp. When word of the new

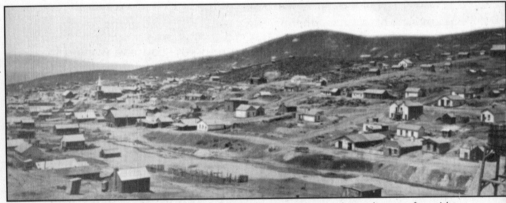

The boom town of Austin, Nevada Territory, drew the usual compliment of gamblers, miners, and desperadoes. Billy Mulligan didn't help matters much.
Author's Collection

discoveries in the Reese River District caused a stampede in January 1863, Barney joined in. Located some 180 miles east of Virginia City on the overland stage road, Austin was an overnight boom town.

When a new strike was made a few miles north at Amador,

Barney staked some claims there. In running for the office of mining recorder of the district in December 1863, he had a dispute with Tom Coleman, probably over the election. It was this dispute that brought brother Billy on the run. Details of the quarrel are sketchy, but Billy well knew Coleman's history. When the two men met in Jim Leffingwell's Austin saloon, Coleman pulled his pistol but Billy told him not to shoot while they were in a crowded room. That night arrangements were made for a duel to take place the following morning.

This is probably the same Tom Coleman of Billy's early Gold Rush days. He had honed his gunfighting skills as a steamboat runner on the Sacramento wharves. In the 1850s and '60s, competition for passengers among riverboats was intense. Steam-powered riverboats were the most comfortable and swiftest means of travel in California before the railroads began covering the state in the late 1860s. When competition became too keen, the California Steam Navigation Company, and the opposition line, began hiring runners to hustle passengers aboard their boats. When the runners themselves became too competitive with each other, toughs like Tom Coleman were hired and the situation became worse. Coleman was mixed up in several street fights and in late March 1862, was involved in the shooting of Edward Lloyd, one of the notorious Lloyd brothers. Afterwards, Coleman went to Aurora and other camps and there was talk of other shootings.

Billy, Coleman, and some two hundred friends and onlookers rode in a caravan the five or six miles to Amador where the duel was to take place. Mulligan was the challenging party, giving Coleman the choice of weapons. He selected revolvers at ten paces with the option of advancing toward each other after each shot. With the words "Gentlemen, are you ready? Fire!"—at the word "Fire" both combatants were to shoot indiscriminately. A telegram from Austin to the Marysville *Daily Appeal*, gave full details of the duel:

> Both the principals exhibited the utmost coolness and unflinching nerve, though it was evident that Mulligan had somewhat the advantage, as his every movement showed evidences of his being an expert, while Coleman appeared somewhat awkward and clumsy.

After taking their positions on the ground, Mulligan shook hands with his brother and retired. Bradshaw gave the word, and both pistols were discharged, almost simultaneously. At the first fire, however, both shots fell short. At the second fire, Mulligan's shot broke the second finger of Coleman's right hand, which occasioned him some difficulty in cocking his pistol, though he maintained his position without flinching, and continued firing all his shots, which seemed to fall short, however, as Mulligan did not receive a scratch. It is thought Coleman's fourth shot went off prematurely, as the ball struck near the feet of Captain Duncan, throwing sand in his face. Mulligan's fifth shot took effect in the fleshy part of Coleman's thigh, inflicting a slight flesh wound. His last shot was made with such deliberations that it seemed almost impossible that he should fail to kill his antagonist, but the ball went wide of its mark.

Mulligan cocked his pistol evidently thinking he had another shot, but seeing Coleman hesitate he said, "Are you out, sir?" Coleman replied, "I believe I am."

Mulligan wanted to reload the pistols, but the seconds would not permit it. The poor shooting and shots falling short would seem to indicate the duel had been fixed. But there was no comment if such was the case. The authorities made no attempt to prevent the fight and no arrests were made. The local Austin press, the *Reese River Reveille*, reported, "Since the meeting a complete reconciliation has taken place, and now those so lately seeking each other's lives are the dearest of friends."

Although the local press played up his newfound friendship with Coleman, Billy was shopping around for a plaything and meal ticket. It took him a while, but he finally found both in a local brothel owner named Madame Patrone. Billy had treated his New York wife, Mary Lewis, shamefully. She had married him and sold most of her jewelry to pay for his appeals and other legal bills. According to George Wilkes, Mulligan had rewarded her with a good beating just before he had deserted her and left for California.

It is not known just how long the Patrone–Mulligan liaison endured, but apparently she caught on to his act before long. Nursing a mean drunk was not the Madame's idea of a relationship. The *Reveille*, August 2, 1864, reported:

> Arrested Last Night.—Madame Patrone was arrested last night on the affidavit of William Mulligan, charged with threatening, quarrelling with, and traducing him. The trial will take place this morning at eleven o'clock, before Recorder Harrington.

This had to be embarrassing to one of the more noted badmen of the time, but the thick-skinned Mulligan never let it show. He made a demonstration of his own and was picked up for disturbing the peace. When a witness failed to show at the hearing, it was put off until that evening, but the jury failed to agree on a verdict and Billy was discharged. Earlier in the day the Patrone case was dismissed, also in a hearing before Justice Logan. The fact that no witnesses were called suggests an outside settlement was arranged.

The mining camps had palled on Billy by this time. When Nevada Territory was made a state on October 31, 1864, he was on his way back to San Francisco. He took a room at the St. Francis Hotel in February, announcing his return to town by being picked up in the middle of the month for carrying a concealed weapon.

Mulligan was drinking steadily and heavily after his New Year celebrations of 1865. He was thirty-six years old now and living the same reckless existence as in the past. He had nothing to show for his life, but a past shrouded in shameful acts and whiskey-induced brawls. He had feelings of foreboding. Something was wrong, but he could not put his finger on it. His friends were not much help. Their answer to his morose thoughts was always the same: "Have another drink, Billy." By that summer he was a rum-soaked wreck and suffering from bouts of delerium tremens. When the badman was coaxed into visiting a physician named Henry, the doctor later recalled that "he was one of the most dangerous and unmanageable patients he was ever called upon to prescribe for."

It was not surprising when Mulligan had an argument near his hotel with an acquaintance named Walter McGarry and threatened him with a cheese knife. "Arrested by officer Chappell and held to bail by Justice Wells, the charge against Mr. Mulligan is "assault with a deadly weapon," reported the *Daily Alta California*. Unfortunately, he was promptly out on bail.

Two nights later Billy went to police headquarters and asked to spend the night in jail. "They are after me," he complained to

Officer Richard Monks. "I feel like I'm going to die tonight." He was babbling about the vigilantes seeking him again. Monks felt he was "in a state of mind bordering on insanity from excessive drinking" and he felt he was doing Mulligan a favor by letting him stay in the jail that night. The officer sat with him a while, joking and trying to calm him down. In the morning, July 7, 1865, he was released and returned to his room at the St. Francis Hotel.

About nine-thirty, a Chinese laundryman came running into the office of W. P. Brown. He said a shot had just been fired into his laundry on the corner of Dupont and Clay streets. The two men determined the shot had been fired from the second story of the St. Francis Hotel across the street. Brown rushed over to police headquarters a few blocks away and asked to see the chief. Captain of Detectives Isaiah W. Lees met with him, mentioning that Chief Burke was ill that day. Lees was due in court that morning, but told Brown he would send an officer over to investigate.

Officer Charles McMillan was sent over to interview the laundryman and the two men agreed on the source of the shot. All indications suggested the shot had come from a room occupied by Billy Mulligan and the officer knocked on his door at the head of some

In 1886, the corner of Dupont and Clay streets was in San Francisco's Chinatown. The St. Francis Hotel was located here in 1865. *John Boessenecker Collection*

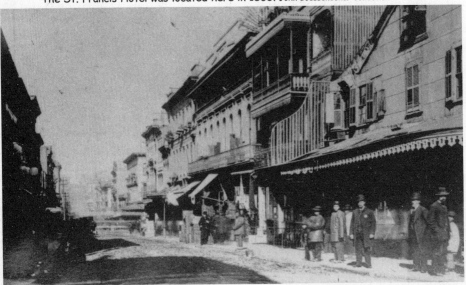

narrow stairs. Talking through the door, Mulligan said the shot had been accidental. "I cannot help that, Billy," responded the officer, "but I have been sent by Captain Lees and if you won't come out I will kick in the door." Mulligan said he had better get someone else to kick down the door as he was going to shoot anyone who tried.

McMillan then sent for Lees, who came and talked to Mulligan but without results. He then left for court after detailing several other officers to aid McMillan. Looking through the transom, one of the officers saw that Mulligan had put the bed and several trunks against the door. Knowing the armed man was now barricaded in his room, the officers began formulating plans of attack. Officer Jake Chappell tried to enter Mulligan's room through an adjoining window, but he hastily retreated when Billy fired at him and missed. Captain Lees had returned from court by now and was supervising the operation.

Captain Isaiah Lees supervised the Mulligan seige. *Author's Collection*

Lees consulted with several of Mulligan's friends, urging them to talk him into surrendering, but no one cared to do it. It was afternoon by now.

Procuring a drugged drink prepared by a nearby pharmacy, Lees placed it before the door where it was quickly snatched up by Mulligan. The detective captain continued talking to him through the door, but the drink had no effect. About two o'clock, Jack McNabb, a notorious character recently released from state prison, appeared and said he would go up the outside stairway and talk to his friend about surrendering. From a window Mulligan saw McNabb coming up the stairs and went out on the balcony to confront him. There was a brief exchange of words, but when McNabb continued up the steps, Mulligan fired and the ex-convict staggered back down the stairs. He was taken to a nearby physician, but died within the hour.

There was a huge crowd on the street now, adding to Mulligan's fear that the vigilantes were again after him. Captain Lees next sought

permission from the district attorney to use muskets if necessary, but was told it was bad policy. Lees obtained muskets anyway, after Mulligan shot and killed a bystander on the street, a passing fireman named John Hart.

The stand-off had continued too long. Lees now stationed Officers Pike and Mortimer Hopkins with muskets at a window across the street from Mulligan's room, instructing them to shoot to disable, rather than kill. Watching carefully for their opportunity, the officers caught fleeting glimpses of Mulligan before he suddenly appeared in a hallway.

"I raised my musket," stated Officer E. W. Pike, "and it missed fire. I did not see him again for five minutes. He stood facing us a moment in the hall. I saw him come downstairs looking north at Mr. Hopkins and myself; he looked right across the street; as soon as he saw us he darted to one side in a jog and pointed the pistol directly at us; he had it cocked and pointed at us when Mr. Hopkins fired." Mulligan went down.

Across the way, the badman was found stretched out full length in the hallway of the balcony entrance. Trying to avoid the large pool of blood, Dr. S. H. Harris found the desperado had been shot through the forehead, the ball exiting through the back part of the head. He had died instantly. Brains and blood spattered the walls.

Mulligan's death shocked the city and made headlines around the country. In New York the announcement depended on the political alignment of the newspaper, but few were sorry to hear of his demise. The *New York Times* first printed a brief telegraphic report, then on August 10 ran something a little more to the point:

> The Death of a Dog—This Mulligan was a representative man of his class; a class that should have died with him. There is a romantic notion that most great criminals have certain secondary virtues, such as bravery, magnanimity, etc.; but this creature was a stranger to any such weaknesses; he was, from first to last, an umitigated fiend. He lived too long by twenty years; the gallows was cheated of its due by just about that length of time.

The coroner's jury on the following day found the dead badman had been shot and killed by officer Hopkins under orders from his

superiors. Police officer Jake Chappell had been present at Mulligan's death and during the proceedings Mulligan's sister created something of a "sensation" when she shook her finger in Chappell's face.

Married to Andrew Harrigan for over ten years, Billy's sister, Margaret, had two children and may have accompanied her brother to the West Coast from New York. She testified that the dead man was born in New York and was thirty-six years of age.

The following day, the *Times* reprinted the very long accounts that had appeared in the San Francisco *Daily Alta California*. While maintaining a modicum of respect for the dead, the *Alta* could hardly ignore the past of this thug who had plagued the community for so many years. In commenting on the funeral cortege of six carriages carrying the dead man's friends and his sister, the newspaper pointed out, "There was an evident feeling of relief in the mind of the community that it was at last rid of a thoroughly bad man."

A more subtle and sobering tribute to Mulligan and his class was reported in the New York *World* on August 1, 1865:

The San Francisco press ran long and detailed articles on Mulligan's death. The incident was covered in most other California newspapers also, as noted here. *Stockton Herald, July 8, 1865*

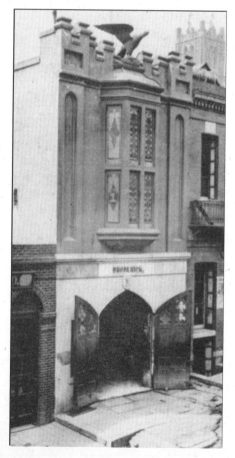

Mulligan's death was no surprise to many, but his colorful past and political activism assured large crowds when his body was exhibited in the Broderick No. 1 fire company

An effort has been made among his friends and admirers to get up a meeting with a view of passing a series of resolutions complimentary to the deceased. On Wednesday evening a meeting was to have been held at the Hone House, but for some unknown reason it fell through, but two or three of the sporting fraternity being present.

Enclosed in an expensive rosewood casket, Mulligan's body had been displayed in the Broderick firehouse before being taken down to the embarcadero for the steamboat trip to his final resting place. Barney accepted the casket on the Sacramento wharf.

With a small coterie of friends and gamblers, he delivered the remains to the City Cemetery just south of town. Sacramento's Centreville Race Course was next to the cemetery and for some reason Barney buried his slain sibling within the enclosure of the track. Today there is no record of his grave. The old race course disappeared many years ago along with any trace of the last resting place of one of the most desperate and little-known badmen of Western history.

Writing to the Sacramento *Union*, a San Francisco correspondent paid his own special tribute to Mulligan in a ballad to desperadoes and badmen throughout the West. The author well knew that Mulligan's pals had been trying to obtain a verdict of unjustifiable homicide in his death and so refrained from signing his "tribute."

Crowded the street with terrified men—Is it a wild beast pacing his den!

Silent and still as the evening glooms, Death lurks him there in those desolate rooms.

Ever and now see the blue smoke lift, While out from the windows a bullet sings swift.

Back falls the crowd with hurrying feet—Two corpses just have been borne down the street.

Not a human soul those walls may dare, For the terrible form that is raging there.

Never was tiger in jungle more feared—All are ready to slay, but none dare beard.

Hedged is the tiger on every side—Muskets are cocked and their mouths gape wide,

Ready to launch their sleet of lead If the horror within but shows its head.

But all is still, and the crowd stands vext, For the question is open: "Whose turn is next?"

A ping, and a thud—you can tell by the sound, When the rifle bullet its murk has found:

Hearing it once you will know again When the whistling lead has crashed through a brain!

"Is it He? Is it He? Or has one victim more Gone to join the ghosts that wail before?"

The answer comes, as the smoke lifts away: "Dead! shot to death like the beast at bay!"

Oh, curious crowd, come gather you near, In the hush of these halls there is nothing to fear

Teeth tightly set like the clench of Fate, Lips still white with the foam of hate.

Shattered the skull and spattered the brow; Would the mother who bore him know him now?

Never a priest to cheer the flight Of the soul as it went out into the night!

Even now at the bar, arraigned, he stands, With witnessing ghosts and his own wet hands.

Cradled in crime, nurtured in strife. The desperate end of a desperate life—

Oulawed, and hated—hiding from day; Shot to death at last like a beast of prey.

Oh, surely, in view of this terrrible death, We may whisper one word of compassionate breath.

Believe me, each tear on a freshly turned sod Is a prayer that appeals to the mercy of God

An ocean of tears might be weak to save; But—one woman wept at this desolate grave!

The End of Billy Mulligan

CHAPTER 1 SOURCES

Boessenecker, John. *Against the Vigilantes; The Recollections of Dutch Charley Duane*. Norman: University of Oklahoma Press, 1999.

Boessenecker, John. *Gold Dust & Gunsmoke*. New York: John Wiley & Sons, Inc., 1999.

Eisenhower, John S. D. *So Far From God: The U.S. War with Mexico, 1846–1848*. New York: Random House, 1989.

Johnson, Kenneth M. Ed. *San Francisco As It Is: Gleanings from the Picayune*. Georgetown: The Talisman Press, 1964.

O'Meara, James. *The Vigilance Committee of 1856*. San Francisco: James H. Barry, Publisher, 1887.

Stanger, Frank M. *South from San Francisco: San Mateo County, California, Its History and Heritage*. San Mateo: San Mateo Historical Society, 1963.

Sutton, Charles. *The New York Tombs*. New York: United States Publishing Company, 1874.

Secrest, William B. *Lawmen & Desperadoes*. Spokane: The Arthur H. Clark Company, 1994.

Brooklyn Eagle, December 3, 1860.

California Police Gazette, September 2, 1865.

Carson *Daily Appeal*, September 9, 1865.

Daily Reese River Reveile, August 2, 4, 5, November 30, 1864.

Demorest's New York Illustrated News, May 1860.

Frank Leslie's Illustrated Newspaper, May 12, 19, 1860.

Harper's Weekly, June 22, 1867.

Marysville *Daily Appeal*, April 23, 27, 1864.

New York Times, June 24, July 9, 12, 16, 29, 31, September 8, 21, December 17, 18, 1858; April 6, October 4, 1859; August 14, October 20, November 21, December 3, 1860; February 15, March 19, 20, December 1,1861; December 20, 1862; August 11, 1865.

Sacramento *Daily Union*, May 17, 22, June 11, July 11, 19, 20, 1856; November 30, 1861; August 6, 1864.

San Francisco *California Chronicle*, May 20, June 20, 1854.

San Francisco *Daily Alta California*, November 19, 20, 21, 29, 1851; January 3, 4, 1852; April 19, June 29, 1853; August 1, 6, 8, 18, 1854; May 16, 1855; August 20, 1858; May 2, October 29, 1859; December 18, 29, 1860; January 20, 1863; July 4, 8, 9 10, 19, 1865; October 19, 1884.

San Francisco *Daily Evening Bulletin*, January 28, July 7, 30, September 30, November 15, 1856; January 14, May 2, 13, 14, 31, 1859; October 17, 1862; January 16, 1863.

San Francisco *Daily Examiner*, July 8, 1865.

San Francisco *Daily Herald*, February 24, 25, 26, 27, 28, 1852; February 18, 19, June 20, 1854.

San Fancisco *Daily Morning Call*, December 25, 1881.

Stockton *San Joaquin Republican*, November 26, 1851; May 9, 1854; April 10, June 20, 1855.

San Francisco Post, July 27, 1878.

Wilke's Spirit of the Times, May 5, June 2, 1860; September 20, 1862.

Boessenecker, John. "Billy Mulligan: Gold Rush Gunfighter," *California Vignettes*. Brand Book, San Francisco Westerners, 2001.

Secrest, William B. "There Once Was a Badman Named Mulligan," *Real West*, August 1984.

Mulligan, William. Muster Rolls, 1847–1848, Co. E, Mtd. Batt'n, Louisiana Volunteers, Mexican War, National Archives.

U.S. Federal Census, 1860, San Francisco, California.

Chapter 2

Who Pays the Terrible Price of Revenge!

Drytown, Cal. Aug. 8th, 1855

Dear Sir:
It becomes my melancholy duty to inform you of the death of your brother, Eugene Francis. This Rancheria is a small mining village, there being but one store and one tavern in the place. On night before last, about ten o'clock, some ten or twelve, and some say there were twenty Mexicans, rushed into the store and tavern, both at the same time with pistols, knives and commenced an indiscriminate slaughter.

And so begins a letter by Nathan Parsons to the Eastern family of one of the victims of what has gone down in California history as the "Rancheria Massacre." In a time of poor race relations in the mines, this incident was the epitome of a bitter enmity that grew out of the Mexican War and still lives with us today. Although the initial event was atrocious enough, it merely set the stage for the wholesale tragedies that were just over the horizon.

Sandwiched between El Dorado and Calaveras counties, Amador County came into being on May 10, 1854, fashioned principally from Calaveras County. Mining camps were already sprinkled liberally all over the new county at its formation. Villages and towns with names like Big Bar, Butte City, Misery Flat, Jacalitos—and Rancheria—were filled with bustling miners, speculators, and mer-

Above:
Rancheria Creek as it appeared in 1967.
Photograph by the author.

cantile establishments during the early days of the great California Gold Rush. But there were badmen, also, as reported in the Sacramento Daily Union, October 2, 1854:

EXCITEMENT AT RANCHERIA.—Two Men Shot.—The Sheriff and his Posse Fired Upon. On Thursday evening, at Rancheria, an American by the name of George Neese, was shot by a Mexican. His wound is severe but not dangerous. The Mexican fled, and was taken at "The gate" [Jackson] yesterday morning by a party from Rancheria. Information of the affair reached this place shortly after, with the additional statement that the prisoner was about to be hung by his captors. Sheriff Phoenix, with Deputy Sheriffs Chauvin and Perrin, and a small posse of citizens, immediately started out, and at Rancheria they retook the prisoner from the crowd who had him in charge. As they started for Jackson with him, some forty or fifty shots were fired, and the prisoner was wounded in four different places. Neither the officers or any of their force were hurt, who succeeded in bringing the prisoner to Jackson where he was lodged in jail, and

A view of Rancheria as it appeared at the time of the bandit raid. *The J. Paul Getty Museum, Los Angeles: a half-plate daguerreotype by Robert Vance [View of California Mining Town with Rancherie House, Unidentified Hotel, and Sweata & Francis Bldg.] 1853-1855.*

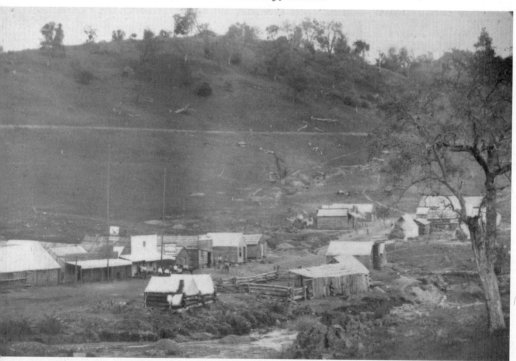

his wounds, which are dangerous, if not mortal, were promptly attended to.

The sheriff was not only fearless, but prompt in his prosecution of law breakers. In mid-December, Sheriff Phoenix is noted as being in San Francisco with three prisoners destined for the state prison at San Quentin. One of the trio, Francisco Kues, was convicted of assault with intent to kill and may be the gunman noted above.

The rich placers of Rancheria Creek had largely petered out by the early 1850s, although miners were still working when there was water. Quartz mines had been located nearby, along with ranches and other settlers so that the small mining camp remained as a stage stop and supply center with a population of somewhere around fifty inhabitants. At the 1854 election, only thirty-five votes were cast, but these included only the men, of course. A resident of the time reported a dozen houses, including the store and tavern, or hotel. There was also a dance house in the Mexican part of town.

By this time, higher upstream, another village had been established which was also known as Rancheria. To differentiate between the two, this was known as Upper Rancheria while the original village was now called Lower Rancheria.

Summers in the California foothills were always quite warm, but by August, cooling fall weather was just around the corner. August 6, 1855, however, was particularly hot, as Deputy Sheriff George Durham rode over the oak-studded, ochre-colored hills. The lawman must have looked forward to a cool beer as he walked his horse down Dry and Rancheria creeks collecting the Foreign Miners' Tax. He had gathered a quantity of dust from the Chinese camps when he was accosted by a group of Orientals who complained that they had just been robbed. Other Chinese camps reported robberies, also. After interviewing the victims, Durham estimated the bandits had netted something over $4,000 in their foray. The plundered parties described the outlaws as ten or twelve Hispanics, but with several Americans in the group, also. The robberies were reported in the Sacramento *Union*, as well as the Sacramento *State Journal*, which reported:

Yesterday morning, the 6th inst., a party of Chinamen were

attacked about three miles below this place [Drytown] by a gang of Mexicans and Chilenos, and it was said a few Americans were among the number, and succeeded in getting about $1,500 in gold dust from the hard-working Johns.

Durham was concerned and that afternoon he rode into Lower Rancheria where he warned store owner Eugene Francis that bandits

Drytown in 1922 probably looked much the same as it did during Gold Rush days. *Author's Collection*

were in the area and he should guard against being robbed. Riding over to Drytown, the deputy passed a camp that looked suspiciously like that of the bandits. In town Durham pressed Constable Cross into service to help collect taxes from the Chinese miners at Milton's ranch. While the two officers conversed, an excited resident came in and said a Spanish woman had told him the town was full of bandits.

Visiting a house on Chili Flat where the supposed robbers were eating their evening meal, the two lawmen found the place seemingly empty except for a Mexican woman. When they asked about her dinner guests, she pulled a door curtain open enough for Durham and Cross to see several figures in the darkened back room. Running behind the house, the officers spotted their fleeing quarry and both groups began firing. When the bandits withdrew to some high ground, Durham and Cross retreated to reload their pistols and secure reinforcements.

As the outlaws retreated in the direction of Rancheria, the two officers began putting together a

Chinese miners kept to themselves and were often victimized by robbers. *From J. D. Borthwick's* Three Years in California

posse and rounding up all the weapons in Drytown. Uncertain of just what the outlaws were up to or what they would do next, it was thought best that the town should be guarded while a messenger would be sent to Rancheria to raise the alarm. It was nearly ten o'clock at night by now and Bob Cosner and a friend volunteered to make the ride. Avoiding roads, they began their ride of nine or so miles.

Horace Burlow lived in a small cabin just behind the main buildings in Rancheria. During the day there had been some kind of squabble among a few of the local Mexicans and some Indians who lived nearby. When Burlow heard some scattered pistol shots in the evening, he rushed to the door to see what was happening:

Robert Cosner rode to warn Rancheria, but was too late
Amador County Museum

> When the firing was heard in the evening I had just finished writing a letter. I went at once to the door and saw three distinct flashes through the back window of the hotel. Directly after, a Mr. Johnson called at my door and inquired what I thought of the proceedings, stating that in his own mind he believed it was a robbery and that your brother must be among the fallen. At my request he went to the door of each of those houses near to mine but could not ascertain that a single person was in either of them. After a little consultation I gave him one revolver and taking another myself, we started in the direction of the hotel. When about half way I heard the voice of Mrs. Dymond's [Dynan] little girl some distance in the rear of the house crying for its mother... .

Bob Cosner and his companion arrived about this time, only to find that they were too late. After fleeing Drytown, the outlaws had gone directly to Rancheria where they had liquored up at the Mexican fandango house, then gotten into a drunken squabble with some local Indians. Learning there was considerable money in the Rancheria store and hotel of Eugene Francis, the bandits planned a concerted attack on both the store and the Rancherie House, a two-story structure next door.

It was around ten o'clock at night when one of the gang yelled out, "Hurrah for Mexico!"and the nine or ten bandits simultaneously stormed through the front doors of the store and Rancherie House. None of the inhabitants in the store were armed and they had no chance at all to defend themselves. Dan Hutchens, the clerk, was shot down behind the counter where he collapsed and died. Startled, Francis was shot in the arm, but he grabbed an ax and was shot again as one of the bandits snatched the ax from him and chopped at him as he lay on the floor, nearly severing his left leg. He was shot several more times before the desperadoes turned and began looting the place. As the others plundered shelves and drawers, one of the bandits spotted the safe and began chopping at it with the bloody ax. Although horribly wounded, Francis began crawling to the back door.

As this scene of carnage was underway, the Rancherie House next door was similarly assaulted. Again the screaming bandits had burst through the doors and started shooting at anything that moved. Mike Dynan was gunned down at the bar, while two card players, Uriah Michener and Sam Wilson, were shot dead at their table. As the wounded Dynan kept under cover, or perhaps tried to see to the safety of his two children upstairs, his wife managed to drop her daughter from a window before she was shot and stabbed in the back. The dying Mrs. Dynan now managed to follow her child out the window.

At the store next door, several of the bandits were chopping at the safe trying to get it open. They finally gave up and stuffed some powder in the lock and blew it open, taking out an undisclosed amount, probably something around $2,000. Meanwhile, it was noticed that Eugene Francis was not where he had been left on the floor. Several of the bandits followed the trail of blood out the back door where they began searching for him in the dark. They

A photograph identified by the family to be Michael Dynan. *Amador County Archives*

stumbled over the body of an Indian who was sleeping off his afternoon celebration. When they discovered the Indian was not the wounded storekeeper, they quickly knifed him to death.

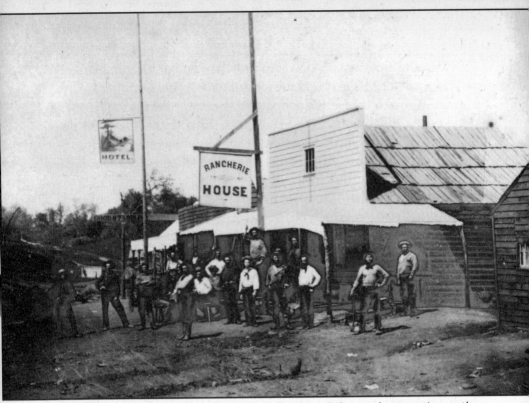

A collection of locals pose in the street at Rancheria. Taken at the same time as the previous view, the Dynan Hotel is shown next door to the Francis "Rancherie House." Both places would have had a saloon and let rooms. *The J. Paul Getty Museum, Los Angeles: half-plate daguerreotype by Robert Vance (Street Scene in La Rancheria, California) 1853-1855.*

A moment later they noticed Francis lying nearby, face down. Again the deadly ax arched down, chopping into the storekeeper's back. After searching him, the bandits returned to the store.

A local Hispanic had been told to round up enough horses for the gang and put them in a corral across the street. After hurriedly reloading their pistols at the store, the gang took everything of value they could carry and mounted their stolen horses. Galloping out of town, they again yelled "Hurrah for Mexico!" and disappeared into the darkness of night.

Burlow and Johnson heard the two-year-old Dynan girl crying as they neared the scene. They next found the dying Mary Dynan under the window and did what they could to make her comfortable. They did not know where the outlaws were at this time. Parsons, in his letter to Eugene Francis's brother, continued at this point:

Francis, it seems, fought like a tiger; he was found lying be-

neath an oak tree. He was carried to the house where we had two doctors examine his wounds. There were two balls [bullets] in his face near his eyes, also a deep cut in his back, either of these three wounds were sufficient to cause death... In addition to these he had a ball through his left arm, his right hand was cut very badly and his left leg below the knee was shivered all to pieces...

Bob Cosner and his friend had arrived from Drytown by now and they did what they could to help with the dead and wounded and organize a posse. Hutchens, the store clerk, was dead and Francis died about dawn. They had been clsoing up when the attack began. In the tavern of the Rancherie House, two men and Mrs. Dynan had been killed, along with three men being wounded. The Indian sleeping outside was dead also. None of the three Dynan children were injured.

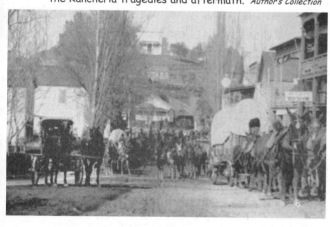

The town of Sutter Creek played an important role in the Rancheria tragedies and aftermath. *Author's Collection*

"You may think it strange," explained Parsons, "that fourteen men could surprise a place like this, and rob and murder the inhabitants, but when you consider that there were only about twenty of us men, and they came when most of us had retired for the evening.... If we had five moments warning this never would have happened, but it is done and cannot be helped."

A letter written from Jackson on August 8 gives some idea of the tumult and conflict of emotions that now raged throughout the area:

The excitement has continued today, unabated, and God only knows where it will end. All the persons murdered by the robbers night before last were buried today in one grave. It was certainly a heart-rending spectacle, and many a stony heart gave way, and tears would flow. The five Americans were buried in one grave,

Alfred Doten visted Rancheria shortly after the massacre. *Author's Collection*

side by side, and the Indian was taken care of by members of his tribe at Rancheria.

How many Mexicans have been caught and hung it is impossible to say. Seven, to my knowledge, have been hung, and how many have been killed by the scouters, no one knows but themselves, and they won't tell.

The Indians, to pay for the murder of one of their tribe, have killed three Mexicans today. Last night the guard left at Sutter tore down every Mexican house in town, and ordered all the Mexican population to leave today, and they are mostly camping in this town tonight, under the protection of our officers, but tomorrow they will have to leave.

Messengers were sent to the county seat at Jackson alerting Sheriff Phoenix and requesting the cornoner's services. At five o'clock the next morning messengers arrived at Drytown with news of the Rancheria slaughter. The sheriff and a large posse were quickly in the field, while smaller groups sought the bandits in every direction. A report was circulated that four Frenchmen had been killed and robbed on the Mokelumne River during the flight of the bandits from Rancheria. On August 7, Alfred Doten, a miner near Volcano, wrote in his journal:

At noon seven men, mounted on horses and armed to the teeth, passed this way—they stopped a very short time at Vance's store, to get a bite of something to eat and then hurried off again in the direction of Fiddletown— these are a portion of some 40 men who are out today in search of some twenty scoundrels who last night at Lower Rancheria at a tavern murdered six men and a woman.

Accompanied by some friends, Doten rode over to Lower Rancheria on

The Rancheria Tragedies.

The *Jackson Sentinel* extra, dated Aug. 15th, gives the following particulars of the meeting held in that place on the 11th instant; also farther intelligence of the hanging of a Mexican implicated in the recent murders

At an early hour on the 15th, the *Sentinel* received the news that one of the Rancheria murderers was arrested at Columbia and conducted to Moquelumne Hill A number of citizens started over and found the villain in the hands of Mr. Houtaling, of Volcano, and some of the Calaveras officers. They arrived in town about 10 o'clock, with the prisoner in a buggy. Geo. Durham, Esq., was in the buggy with the prisoner, and, when opposite the *Sentinel* office, the immense crowd took possession of the horse, buggy, prisoner and all, conducted him to the "hang tree," and, when there, a party of citizens were appointed to examine him. An American being by who spoke excellent Spanish, interpreted what the Mexican said to the crowd.

His confession under the tree did not amount to much, as it was in direct opposition to what he had the night before confessed to Officer Clark, of Calaveras. He said he was not concerned with the band of desperadoes who murdered the citizens of Rancheria, but he knew all who were connected with it. Their names, as he gave them, are Macias, California, Bonito and Manuel. He stated that he was in Drytown when the band passed through there; was working at the house where the land pirates stopped, and through fear was compelled to get them some

An excerpt from the *Jackson Sentinel* copied into the San Francisco press. *Author's Collection*

August 10 and heard the stories of the inhabitants. There was little doubt that some Mexican and Chileno citizens of Rancheria had participated in the bloody raid. A great many miners had come in from the surrounding country. "The news had spread," wrote Doten, "and at daylight mounted rangers started out from all the neighboring towns in pursuit of the murderers—They took three of them but a short distance from the scene of the murders—One of them had Mrs. Dynan's jewelry, and the other had her husband's watch—they took them back to Rancheria and Judge Lynch hung them all at once to the limb of a big oak tree." An extended account of these events by a correspondent of the Sacramento *State Journal* was published a few days later:

> After the coroner's inquest was held, the mob, who had by this time arrested about thirty-six Mexicans, proceeded with them about one hundred yards east of the town to an oak tree and here a motion was made to hang all thirty-six of them, but through the exertions of several gentlemen, a jury of twelve was selected from the crowd, and three Mexicans who gave their names respectively as Pertervine, Trancolino and Jose, were found guilty of murder, and after half an hour's time being allowed to prepare themselves, they were hung on the tree, under whose shade their trial had been conducted.

William Clark, a resident of Drytown, was a voice of moderation in the first lynchings and was himself threatened. *Author's Collection*

> The testimony elicited was strong against them; one citizen swore that he (witness) saw defendants run from the Spanish dance house to the store, and saw them about the store at the time the murders were committed, and that they (defendants) joined in the chorus of "Hurrah for Mexico!" One of the defendants was identified as being connected with the late, notorious Joaquin [Murrieta].

> While the trial was being conducted, the outraged community turned out en masse and burned the Spanish dance house, and every Spanish house in the place. The flames made such headway [that] it was at one time feared the whole town would go to ashes.

>After the three were hung up, the citizens of Rancheria passed a resolution that no Mexican shall hereafter reside at the above place; and every Mexican who shall be found at Rancheria after seven o'clock this evening should be requested to leave, and receive one hundred and fifty lashes in the bargain.

When Rancheria's Mexican residents were expelled from town, they took refuge in nearby Mile Gulch until they decided what to do. They only had with them what they could carry from their now destroyed homes in town. The nearby Indians, angered that a member of their village had been killed by the bandits, now attacked the fugitives in Mile Gulch. As they fled, some eight Mexicans were killed, no age or gender being spared. All that prevented a worse massacre was a fleeing Mexican's trunk falling from a mule's back and distracting the Indians with the plunder inside. It was said that some of the fugitives were killed and thrown into mining holes, while others were left where they fell and later devoured by hogs.

William O. Clark, of Drytown, had argued for a legal trial for the prisoners, but he was quickly shouted down and accused of being friendly to the Mexicans. When he too was threatened with hanging, he was forced to give up his efforts. Clark and his wife did what they could in the situation, as related by a correspondent of the San Francisco *Herald*, August 10, 1855:

>In this place [Rancheria], I cannot award too much praise to the ladies in this vicinity, who proceeded immediately to the scene, and did all in their power for the wounded men. I must also add, that Mrs. Diamond [Dynan] left three children motherless, the youngest being only two months old, who were taken in charge by Mrs. Clark and another lady whose name I could not learn.

A well-educated young Spaniard named Borquitas was visiting in the area and offered his services as an interpreter. Arriving at the scene, he conversed with some of the prisoners and became convinced they were innocent. When he tried to speak up, he was shouted down and was also threatened with hanging. A man named Roberts, who had designated himself the hangman, was particularly violent and while jerking out his pistol managed to acciden-

tally shoot and kill himself. While all this was going on, Borquitas faded into the crowd and disappeared.

The strangling clutches of the mob reached out even beyond Amador County. On August 19, the Stockton *San Joaquin Republican* published a long article describing how a prominent Spanish rancher, Laoreano Jilier, his foreman, and two vaqueros were arrested after disembarking from a Sacramento steamboat at San Francisco. On their arrival, an Amador deputy sheriff who happened to be in town was advised that Jilier was carrying a large amount of money in gold coins. Somehow the officer equated this with the Rancheria murders and robberies. With no more "evidence" than this, the deputy arrested the four men and placed them in the city jail until the next boat left for Sacramento. In the recorder's court, the judge promptly discharged the prisoners for lack of evidence, but the deputy immediately re-arrested them on a murder charge, claiming to have seen Jilier's foreman in Rancheria. A local banker, William T. Sherman, had done business with the rancher in the past and he and others easily convinced Judge Freelon of the prisoners' innocence. The gold coin carried by the rancher was from the sale of a herd of mules.

"Now," wrote Don Jilier to the San Francisco *Herald*, "the object of the Sheriff of Amador County and of his Deputy, was to take us up to Amador County and had they succeeded, no doubt that by this time we should have been hung, as the spirit of the sheriff and his deputy clearly showed, and two more innocent victims would have been added to the list." As it was, the rancher had to pay court costs to the amount of $520.

Chinese Camp in 1857. A mile away at a small settlement called Campo Salvado, Sheriff Phoenix was killed. *California History and Genealogy Room, Fresno County Public Library*

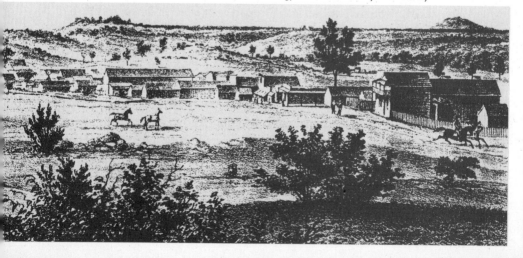

Despite the terrible excesses now being publicized in the press, there was progress in the pursuit of the fugitive desperadoes, but at at a terrible price. Immediately after the tragedy at Rancheria, Sheriff Phoenix and Sheriff Clark, of Calaveras County, led a posse in search of the murderous gang. Heading south they stopped at Campo Salvado, about a mile from Chinese Camp. Here, while they were in a saloon seeking information, a group of Mexicans appeared at the door,

Street scene in old Sonora in 1856, just a year after Sheriff Phoenix's body was taken there for burial. *Author's Collection*

one of whom was recognized by Phoenix. The *San Joaquin Republican*, August 14, reported the action that followed:

> The Mexicans also recognizing the party in pursuit, immediately fled. Phoenix sprang forward and attempted to arrest one of them, although one of his own party advised him against making the attempt—to shoot the desperado down, and not to attempt to take him alive. The Mexican jumped over a picket fence, and turning, shot the sheriff through the heart. In the general melee which ensued, one American and two Mexicans were wounded, after which the latter broke for the chapparal. One of their party took refuge in a house, from which it was impossible to dislodge him without great difficulty. On setting fire to the house, he rushed out with a revolver in each hand and commenced a promiscuous fire— discharging ten shots at the Americans. One of the latter shot him through twice; this, however, did not seem to affect him much at

the time, but afterward, becoming too weak to stand, an American stepped up and ended his existence with a blow from an axe.

Sheriff Solomon, of Tuolumne, accompanied by a large party, started out yesterday in pursuit of the Mexicans. The most intense excitement prevailed in the vicinity of the outrage. It is to be hoped that the villains committing these damnable outrages will be secured, and brought to summary justice. Let the whole tribe be driven from the land.

The shootout had allowed the others in the gang to escape, and the officers took their dead and wounded to Sonora. Sheriff Phoenix was buried under Masonic auspices in the local cemetery, while a large meeting of citizens was held. A committee was appointed to patrol the town and surrounding countryside and to arrest all suspicious Mexicans "who cannot give a good account of themselves." Another committee was organized to solicit contributions to pay the expenses of the patrol.

That night the patrol, led by John Ward, followed two suspicious Mexicans who had arrived in town. When the two men entered a Mexican woman's house, Ward knocked and asked if any men were there. When the woman said "no," Ward pushed the door open to find one of the men aiming a pistol at him. Knocking the weapon down, Ward pursued the man when he jumped through the window. Although lame, Ward kept after him until the fugitive

Deputy Sheriff Ben Thorn, of Calaveras County, was active in the pursuit of the Rancheria killers. *John Boessenecker Collection*

turned and shot at him several times. He then gave up the chase.

With the populace in a high state of excitement, a force was appointed to guard the town. The newspaper in nearby Columbia reported that "A feeling to exterminate the Mexican race pervades the whole community." By midnight, nine suspicious characters had been rounded up and by daylight a dozen were in custody. When a resident of a small nearby village reported some suspicious characters in the Mexican quarter, a posse promptly investigated as reported in the Columbia *Clipper*:

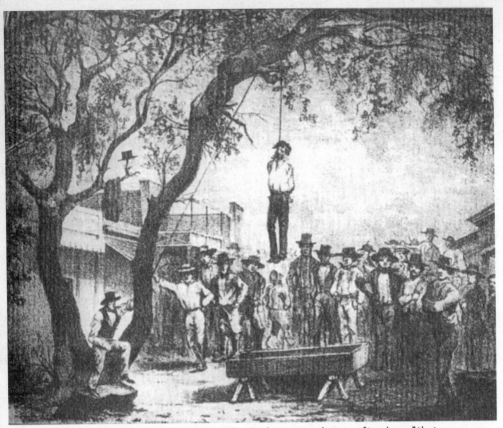

The lynching of Rafael Escobar on the Jackson tree that so often bore "that peculiar kind of fruit." Reportedly this contemporary lithograph was based on the work of a local daguerreotypist named D. A. Plecker. *Huntington Library*

They discovered a man rolled up in a blanket under a tree. Mr. Floyd went to him and gave him a shake, at the same time presenting a pistol at his head, he told him to arise and in doing so, two large six shooters were found in his possession, one under his head and the other by his side, cocked. Another man was taken at Lorings's Fandango house.

At eight A.M., Tuesday, Sheriff Clark, of Calaveras, Deputy Durham and others of Amador, arrived from Sonora with a prisoner supposed to be connected with the gang. They were requested to look at the party we had in the jail to see if they could recognize any of them. As soon as they set eyes on Rafael (the one who was found so well armed) they exclaimed that it was the scoundrel who murdered Mrs. Dimon [Dynan] and child at Rancheria, and he was handed over to them, and they hastened to Jackson where

he will go up—on the old oak tree that so many have been suspended from.

This man, Rafael Escobar, was brought over to Mokelumne Hill and delivered to some Amador County and Calaveras County officers and citizens. Deputy George Durham brought him to Jackson in a buggy, but when opposite the *Sentinel* newspaper office an "immense crowd" surrounded him and took charge of the prisoner who was then escorted to the "hang tree," on the main street of town. An American who spoke excellent Spanish interpreted the captive's confession. The *Jackson Sentinel* of August 15 reported the proceedings:

His confession under the tree did not amount to much, as it was in direct opposition to what he had the night before confessed to Officer Clark, of Calaveras. He said he was not concerned with the band of desperadoes who murdered the citizens of Rancheria, but he knew all who were connected with it. Their names, as he gave them, are Macina, California, Boito and Manuel. He stated that he was in Drytown when the band passed through there; was working at the house where the land pirates stopped, and through fear was compelled to get them some supper, but he was not aware of their intention to attack Rancheria. He said when he was arrested he had two revolvers upon him, and could have killed several of the Americans if he had been so disposed [He was captured while asleep]. He said he was in the power of the Americans, and knew he must die, and wished to have his face washed and hair combed, which favor was granted. He then said he would like to have a Priest to confess himself; this being refused, he called for a "brandy punch," which was given him.

Deputy Bob Paul was another officer under Calaveras Sheriff Charles Clark involved in the pursuit of the Rancheria killers. *John Boessenecker Collection*

The Mexican was run up and held there for a short time, then lowered, when great difficulty was encountered getting the rope loosened from his neck. It was finally cut loose; in the meantime he suffered excruciating pain, rolling his eyes about, throwing his head and body about at random and making loud gur-

gling noise from his throat. When the rope was taken from his neck he revived and asked for brandy and water, and said he would like to talk, but it was no use, as the people would believe nothing he said. At this moment an American, who was present when he confessed to Officer Clark, stepped forward and stated that the Mexican had told Mr. Clark, in his and the presence of other Americans, that he belonged to the gang, and was at Rancheria—that they had all taken an oath to die rather than expose each other, and that he knew all connected with it well, and many other things amounting to the fact that he was as "deep in the mud as the rest were in the mire." The Mexican denied saying so, however.

The crowd, who could not hear half that was said, again became impatient, and cried out "run him up," which was immediately done, and he at this moment, twenty minutes after twelve o'clock, hangs suspended by the neck from the memorable limb of the old "hang tree."

There was little doubt, at least, that Escobar was one of the Rancheria bandits. In Sonora, Constable John Leary had recognized him as being a former associate of the notorious Joaquin Murrieta, who had been killed in 1853. A few years earlier, Leary had thwarted Murrieta's attempt to free his brother-in-law whom Leary had arrested.

Other serious suspects were being rounded up, also. A man named Manuel Castro was captured at Texas Bar on the Calaveras River, after a desperate shootout with a posse. He was probably mortally wounded in the back, but spoke good English and readily confessed to being a member of the gang being sought throughout the Gold Rush country. He described robbing the Chinese miners before the raid, as well as the murders and the safe robbery at Rancheria. The San Francisco *Daily Alta California* reported the capture:

The lonely grave of Eugene Francis, far from his Eastern home and family. *Amador County Archives*

Prisoner said his party were on this side of the Calaveras at the time

An ancient oak tree near the site of Rancheria marks the lonely cemetery of the Dynan family where the husband, in time, joined his murdered wife.
Amador County Archives

he was taken; one of the party was an American, a man about twenty-five years old, with red hair and whiskers; called his name Gregorio; the names the Mexicans went by were Bonito, Waro, Rafael, Macemanio, Trinidad, the other two he could not recollect. The American made up the party.

Castro was another likely member of the gang. Word was received from Ione Valley that a group who were hunting up suspicious characters in that area were advised that two prime suspects had caught the Sacramento stage at Quincy's Ranch. One was named Guadalupe Gumbo and the other, Ormarago. On September 1, 1855, the *San Joaquin Republican* reported:

> The Mexican who shot Sheriff Phoenix, of Amador County, and who was well known, had been surrounded, but just as his pursuers were about seizing him, he drew a pistol and shot himself dead.

This brief, newspaper account hardly does credit to the drama that actually took place. It seems that shortly after the death of Sheriff Phoenix, an old Mexican from Algerine Camp told the officers that the man who had killed the sheriff had come to his house and asked for refuge. He was badly wounded and wanted aid, but the old man knew better than to get involved with any of the Rancheria bandits. When he told the wounded desperado the Americans would kill him if he assisted him, the outlaw said he would kill him if he refused him

aid. The old man then hid him in a mine shaft and informed Deputy Durham where he was. When the deputy and several others visited the site and called out the hidden man's name, there was no answer. A clump of brush was stuffed into the tunnel, then set on fire. After calling to the fugitive several more times, there was a pistol shot within the tunnel. The wounded outlaw had killed himself. He was later dragged out and found to be badly wounded and would not have lived long in any case.

Gradually, the terrible time passed. A conservative estimate of the death toll must be twenty or twenty-five, but there is no way to know for sure. Men must live with the terrible things done in the heat of passion. Some would be ashamed. Others, defiant. For many, the revenge for Rancheria was no more than a war—a "war to the knife and the knife to the hilt." Those murderous bandits had murdered a woman! A WOMAN! This could not be tolerated. To some it was the way of the world that in a war the innocent are going to suffer. That was the way it was!

An irritated Amador County correspondent of the San Francisco *Herald* regretted "that so much misapprehension should exist as to the real course pursued by the people of that county toward the Mexicans since the Rancheria murders." The writer insisted that whites had interfered when the Indians had attacked the Mexicans in Mile Gulch; no Mexican had been executed without satisfactory evidence of participation, or previous knowledge of, the attack; "most" of those executed made confession of their own guilt. All weapons confiscated from Mexicans were sold and the proceeds returned to the owners.

This was all very comforting, but it was not the tone of the dispatches written from the scene of action. While condemning mob lynchings and the lack of faith in the law, the San Francisco *Alta California* took a pragmatic view of the terrible events:

> With what face can we ask people to emigrate hither when our journals are filled with the news of such crimes as these? The law is powerless. People have no confidence in the courts and in aggravated cases trust not to them. This evil people have long groaned under, and it has been hoped time would work a change and improvement. Yet, a reform and a purity convention has just

nominated the most obnoxious, objectionable of our judges for re-election. How can we hope for reform when such men are apparently endorsed by the people.

The *Alta* editor was digressing to the burgeoning problems of San Francisco, where ballot box stuffing had become a fine art. The great vigilante uprising of 1856 curtailed the Bay city's problem, but the Gold Rush country was another matter. Sheriffs' offices, usually understaffed at this time, could hardly hope to cope with a crime of such scope as the Rancheria attack. They did a phenomenal job, however, and caught many of the outlaws, only to lose them to lynch mobs. The large posses scouring the country for the murderers was a natural action taken to prevent the escape of the outlaws. Without the restraining influence of a lawman to accompany such groups, however, the maddened mobs were almost certain to run amuck. And they did, even when officers were present. A horrendous crime had stimulated an equally horrendous response and the revenge for the Rancheria massacre haunts the hills of old Amador to this day.

CHAPTER 2 SOURCES

Andrews, John R. *The Ghost Towns of Amador*. New York: Carlton Press, Inc., 1967.

Boessenecker, John. *Gold Dust & Gunsmoke*. New York: John Wiley & Sons, Inc., 1999.

Cenotto, Larry. *Logan's Alley*, Vol. 1. Jackson: Cenotto Publications, 1988.

Doble, John. *Journal and Letters from the Mines: Mokelumne Hill, Jackson, Volcano and San Francisco, 1851-1865*. Ed. by Charles L. Camp. Denver: Old West Publishing Co, 1962.

Doten, Alfred. *The Journals of Alfred Doten*, 3 vols., edited by Walter Van Tilburg Clark. Reno: University of Nevada Press, 1973.

Mason, Jesse D. *History of Amador County, California*. Oakland: Thompson & West, 1881.

Jackson Sentinel, August 15, 1855.

Sacramento *Daily Union*, October 2, December 14, 1854.

San Francisco *Daily Alta California*, August 8, 10, 11, 13, 14, 18, 1855.

San Francisco *Daily Herald*, August 9, 10,15, 16, 17, 19, 20, 21, 1855.

Stockton *San Joaquin Republican*, August 9, 10, 14, 18; September 1, 1855.

Burlow, Horace. "Rare Original Letters Relating to the Horrible Rancheria Massacre in 1855," *Pony Express Courier*, March, 1938.

Execution of Rafael Escobar [on August 10, 1855, at Jackson, Amador County, California]. S. F. Fishbourne Lithographic Soc., 1855.

Murder Inspires a Beautiful and Timeless Story!

"**I was driving one day with a friend** up the San Jacinto mountains, from Hemet. We were enjoying the beautiful section of wild wood through which the road winds, here and there catching glimpses of the foaming waters of the creek dashing over boulders on their way to the valley. As we approached a watering trough, conveniently placed on the road side, we heard the jingle of bells, which teamsters on these narrow mountain roads always place on their horses, that those traveling in the opposite direction may early arrange for passing at a convenient and wide enough stretch of road."

George Wharton James was recalling an incident in one of his fascinating books on the Southwest. He was prowling through Southern California at this time, looking for interesting material and people to bring his next book to life. A prolific writer, James was born in England and migrated to the United States in 1881. A messy divorce case dictated his relinquishing the ministry as a career and he eventually developed into an entertaining writer, lecturer and photographer of the Southwest.

"As this team came in sight we saw it was loaded with lumber. The horses, eight in number, were fine animals, one of them, particularly, being a stallion of good breed, fine build and graceful proportion. My companion at once whispered to me: 'That's Sam Temple, —Jim Farrar."

James must have shuddered at this observance. Thousands of readers knew the name "Jim Farrar" and James was no exception.

Above:
A modern view of Juan Diego Flats where Ramona and her husband lived. *Courtesy Phil Brigandi*

He studied the man carefully as he was introduced and described him perhaps differently than he would have if he had not known his identity. "A heavy-featured," he wrote, "strong-jawed, thick-nostriled, broad-browed, coarse-lipped, keen-eyed, self-indulgent face, crowned with a head of coal-black hair, dominated a strong muscular body of some five and a half feet in height." Although the date of the meeting is not reported, James probably met him around the turn of the century when Temple was nearly sixty years old. Actually, in his youth, the teamster was quite handsome and garnered attention wherever he went. Most strangers shied away from him because of his history, but whatever his past, Sam was one of the few local people, if any, who could claim to be the model for a character in a world-famous novel.

A native of Massachusettes, writer Helen Hunt Jackson was married twice, settling in Colorado Springs, Colorado, with her wealthy second husband, William S. Jackson. Helen began writing in the 1860s, selling some poetry in 1866, and publishing her first novel ten years later. When she attended a talk by several Ponca Indians at Boston in 1879, she was startled to hear the Native American view of their own history.

Intrigued by what she had heard, Mrs. Jackson began looking into a litany of Indian complaints around the country and discovered a horror tale of murder, dispossession, unfulfilled treaties and broken dreams. Outraged at the perfidy of the government, she researched and wrote a book on the subject which was published as *A Century of Dishonor* (1881). It was a harrowing indictment of white treatment of Indians, documented by official reports and eyewitnesses that left little to the imagination. Mrs. Jackson felt so strongly about her subject that she sent cop-

Helen Hunt Jackson just wanted to help the Indians, but her novel did much more as it captured the imagination of the country.
Courtesy Ramona Pageant Association

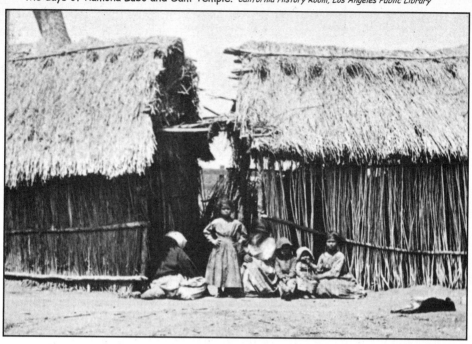

ies of her book to every member of Congress at her own expense. The reactions to her book were disappointing, but it resulted in her being sent to California by the government to investigate the condition of California's mission Indians. Published in 1883, her report was well received but she felt it, too, was ineffective. She determined to write a novel that would secure sympathy for the plight of the Indians, while capturing the imagination of the country, as did Harriet Beecher Stowe's *Uncle Tom's Cabin* (1852).

During her 1883 trip to Southern California, Mrs. Jackson visited many cattle ranches, missions, Indian rancherias, and villages. She interviewed a great many whites and Indians. She talked to the Coronel and Couts families, whose roots went back to the 1850s in Southern California history. She interviewed Indian reservation agents and nearby ranchers who employed Indian workers. She absorbed local color by visiting at such early-day San Diego County towns and ranches as the Guajome rancho, the Palma House at San Jacinto, the Del Valle family's Camulos rancho in what is now Ventura County, and various other sites.

Sam Temple hauling a load of lumber out of the San Jacinto Mountains. A photo probably by George Wharton James. *From James' Through Ramona's Country*

At the urging of her supportive husband, Mrs. Jackson retired to a hotel in New York City and began frantically writing her epic novel, finishing it in three months. Something seemed to be driving her on. There was no deadline, yet day after day she churned out her penciled tale, interspersed with letters to California seeking even more research material. Unknown to Mrs. Jackson, she was indeed working on a deadline—a time frame defined by the grim reaper.

Her novel, *Ramona*, was published in 1884, a year before her death. It told the story of a beautiful half-Indian girl, the Ramona of the title, and her Indian husband, Alessandro, who sought happiness and survival in two worlds. Skillfully written and richly detailed from Mrs. Jackson's Southern California research, the tragic tale immediately found a wide audience. But, although very successful as a popular novel, and in sales, *Ramona* did not succeed in the manner hoped for by its author. After reading reviews in the *Atlantic Monthly* and other publications, she sadly wrote to a friend, "Not one word for my Indians! I put my heart and soul in the book for them. It is a dead failure."

Actually, it was a wonderfully alive success, but not in the way she had intended. It did not ameliorate or call attention to the plight of the American Indians as was her burning intention. Her strength was declining rapidly, now, and she moved to California for that final year of her life, hoping the climate would restore her health. The growing cancer would not be denied and she died in San Francisco on August 15, 1885.

While *Ramona* is a novel, Mrs. Jackson's research

enabled her to weave her tale into an intertwining mixture of fact and fiction. She had witnessed scenes of ranch living, sheep shearings, and cattle roundups and could accurately describe them. She had talked to Indians who described how they had been displaced from their land under the guise of the law and read reports of Indians being murdered on the flimsiest of pretexts. As the years passed, it became part of the mystique of the novel for critics and readers to attempt to separate the truths from the pure fictions of the plot. Others stepped forward over the years claiming to have had a part in influencing the plot of the book. Which brings us back to "Jim Farrar" who was one of the characters in *Ramona*.

The great tragedy of *Ramona* takes place when her husband, Alessandro, returns from a horseback trip to their small home in a secluded valley of the Cahuilla Mountains. Cruelties of the whites and hardship had disturbed Alessandro's mind, and at times he behaved irrationally. Upon his return, Ramona noticed her husband was

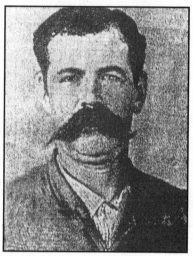

An old newspaper print shows Sam Temple (Jim Farrar) in his prime. *Author's Collection*

riding a strange horse. He said he must have made a mistake when he saddled his horse early that morning in San Jacinto. Knowing the white ranchers' attitude toward horse thieves, Ramona was terrified and urged Alessandro to return the horse immediately. Her husband was too tired, however, and promised to return the animal after a few hours of sleep. He had been sleeping for a short time when Jim Farrar, the horse's owner, rode over the crest of a hill and down to Ramona's home. Seeing his horse tied to a nearby tree, the furious Farrar called Alessandro from the house and shot him down in cold blood. He then rode off as Ramona tried to staunch the flow of blood from her dying husband's mortal wounds.

This incident in the novel is based on an actual event that took place in March 1883. The Indian woman was named Ramona Lubo and her husband was Juan Diego. The killer in the novel, Jim Farrar,

was based somewhat on the real killer, also, a rowdy and colorful early California badman named Sam Temple. This is his story.

If we can believe the 1850 Knox County, Tennessee, census, Samuel W. Temple was born about 1841. His mother, Mary Jane Temple, was apparently a widow, and Sam had two younger sisters. Little is known of his early life, but various sources report he was of Cherokee, negro and English ancestry. Sam claimed that his father was a judge, but this is uncertain. He also stated that he had fought as a Confederate in the war and a "Sam W. Temple" did serve in Company C, 41st Virginia infantry. He reportedly went to Montana after the war, then migrated to California about 1876.

Sam had probably been a sometime ranch hand, miner, and teamster in Montana, and in California he worked for years hauling lumber out of the mountains rimming the San Jacinto Valley, southeast of Los Angeles. He was a handsome fellow who worked hard and spent his share of time in the local saloons. There is ample evidence that he was a tough character who gloried in a brawl and took his liquor straight and hard. An old-timer recalled that Sam liked to "fill up on 'forty-rod' [whiskey] and ride his bronco into every store in town, shoot out the lights in the sa-

An early photograph of Ramona Lubo, probably taken on the Cahuilla reservation.
John Boessenecker Collection

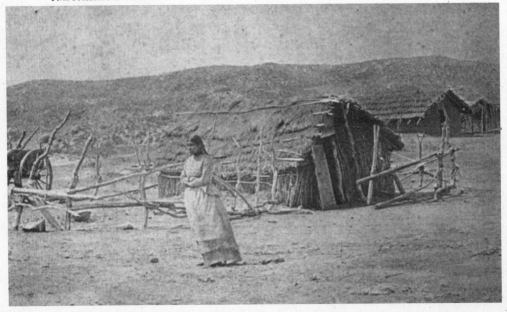

loon, and in many other ways amuse himself to his heart's content."

There is no doubt but that Sam Temple would today just be another colorful frontier character if it had not been for that one, defining moment in his life when he killed Juan Diego. Most men would regret that type of celebrity and do anything to minimize it in the public mind. But not Sam. From all accounts he was a bully and braggart and wallowed in his notoriety. While nearly everyone agreed with this description, those closer to him would modify it by describing him as "a good fellow when not crossed, a happy-go-lucky sort whose meaningless oaths are imbedded in every rock of the mountain side."

One of Temple's early notices was in the summer of 1878, when he was called to testify before a coroner's jury concerning the death of a Mexican named Refugio Baca. A San Jacinto rancher named William Palmerston had been murdered at his ranch on the evening of July 5. His wife fought off the killer, then fled to a nearby ranch for help. Putting together various reports along with the coroner's investigation, it seems that Baca had stopped at the Palmerston place asking for food and lodging for the night. While Mrs. Palmerston prepared their meal, Baca came up behind his host and "split his head open," according to a report in the *San Diego Union*.

J. B. Kennedy, the local justice of the peace, and his constable, Aurelio Ortega, tracked the killer to the San Jacinto Mountains, where Baca was captured at a sheep camp. Brought back to San Jacinto, which consisted at that time of Kennedy's store and a few other buildings, Baca was given a brief hearing, then ironed to the floor of an adobe building for the night. Constable Ortega was then detailed to guard him.

At this time the San Jacinto Valley was part of San Diego County and it was likely any trial would be held at the county seat. The murder was a most brutal one and the grieving widow had easily identified the defendant who had attacked her. There were those gathered around the local saloon bar that night who exhorted how needless the trip to San Diego was when the murderer had been positively identified by Mrs. Palmerston. No expensive trial was needed, but there was work to do that night. After a few more drinks,

a member of the group was sent over to borrow Constable Ortega's pistol to shoot a prowling coyote. The unarmed constable was helpless when a crowd of masked men suddenly entered the room a short time later and removed the prisoner.

The next morning, Baca was found hanging to a nearby cottonwood tree. Justice Kennedy put together an eight-man coroner's jury, some of whom also served as witnesses. Sam's testimony was pretty much the same as the other witnesses, oddly so, in that the statements were all so similar they reek of being discussed for alibi purposes. Sam testified as follows:

Q. In what condition did you find deceased?

A. We found him hanging to a cottonwood tree with a roap about an inch in size around his neck. He was about 10 feet from the ground and I think he was dead.

Q. Do you know how he came there?

A. I think judging from tracks, etc., that he must have been taken there by a body of men and from the looks of the man I should suppose he was hanged by them.

Q. Was he choaked or his neck broken?

A. Choaked I should think. (signed) Sam Temple

Justice Kennedy telegraphed the San Diego sheriff informing him of the lynching. If any of the officials were concerned that Sam and some of the other witnesses had participated in the lynching, nothing was apparently recorded. There were no other witnesses, as no one really cared and no action was taken.

In later years various friends of Temple liked to mention Sam's love of his horses and enjoyment in telling stories and singing to children. An acquaintance, Martin Aguirre, explained Sam as "a pleasant man when not drinking, but when he drank too much, he turned mean." The "good fellow" side of Sam is underscored by a pioneer's reminiscence of his performance during a party at a primitive San Jacinto hotel in the early days:

The crowning feature, to call it that, was a regular floor-

pounding jig by Mrs. Pierce (the landlady) and Sam Temple.

At first glance, Sam's better side is also illustrated by an article in the Riverside *Press & Horticulturist* on March 18, 1882:

> Assault and Battery—Judge Conway's court was occupied on Thursday last by the examination of Sam Temple for assault upon a Chinaman at the railroad camp east of town. As near as we can learn the facts of the case are as follows: A water cart with a boy driver was employed to deliver water to the camp, and was instructed to deliver it to the cook house first, and what was left to give to the Chinamen. At the time of the assault the boy was making his usual trip to the cook house when a lot of Chinamen stopped him and attempted to take the water from him. The boy resisted, but the Chinamen were too many for him, when Sam Temple seeing the row stepped in to assist the boy. The Chinamen then attacked him, and he, using a pick-handle, made sad havoc among them, badly cutting some of their number about the head, and

Known as the "Ramona" of Mrs. Jackson's novel, Ramona Lubo is shown here in later years sitting in front of her home, which looks much as her adobe house did at the time of her husband's murder. *California Room, Los Angeles Public Library*

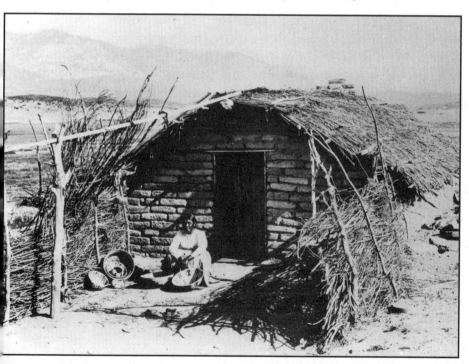

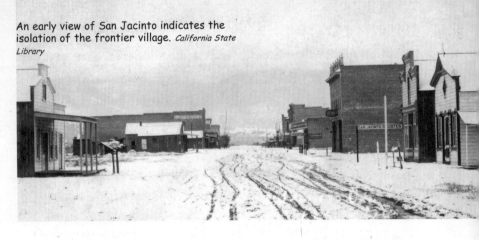

An early view of San Jacinto indicates the isolation of the frontier village. *California State Library*

driving them all off. For this the Chinamen had him arrested and his trial took place as stated. A number of witnesses were examined, and the above facts elicited, whereupon Judge Conway discharged the prisoner, finding no cause of action.

As laudable as Sam's action appears to be, the cause of the trouble was the white workers having first crack at the water and the Chinese receiving what was left. Even more indicative of Sam's motive was the fact that Sam was recalled by an acquaintance as being "dedicated to his prejudices. He held contempt for Indians, the Chinese and any other aliens, as did many others during those days." When all is said and done, the fracas would seem to have been primarily an excuse to attack the Orientals!

Sam lived in San Jacinto while engaged in teaming during the 1880s. Founded around 1870 on the sprawling Estudillo land grant, the village soon had a collection of such businesses as all frontier towns needed to survive: a blacksmith shop, saloon, a mercantile store, and Henry Hewitt's hotel. Hewitt was the leading merchant for whom Old San Jacinto's main street was named.

Stories of Sam's saloon brawls are often undated, but they are many and varied and he probably lost as many as he won. Frank Reynolds operated a stage line out of San Jacinto and was part owner of a local saloon. He arrived in town one day and was warned by several friends that Temple was drunk and threatening to kill him. He no sooner walked through the saloon door when Sam made a dive for him and the two men had a wrestling match in which Temple

was subdued and warned to behave. Sam then offered to buy him a drink, exclaiming, "You're the best man in San Jacinto."

"I wouldn't say that," responded Reynolds. "I'd as soon kill you as a rattlesnake."

And it was not only men who put Sam in his place. Mrs. J. C. Jordan was housekeeper and in the early days helped operate Hewitt's hotel, later rebuilt as the Palma House. Besides being a hotel, the place was a store and saloon with a public corral where horses could be kept. Meals were also served and Mrs. Jordan had no trouble keeping busy. Asked by a visitor if she knew Sam Temple, Mrs. Jordan replied: "Knew him," she responded, "nobody better."

Traditionally, Mrs. J. C. Jordan was the pattern for another of the novel's characters, "Aunt Ri."
Author's Collection

He used to stay at my house a great deal, and put his horses in our corral. He was a big bully and everybody was scared of him, but one day he met his match in a little woman. Oh, he'd got to quarreling with some man or other in my kitchen, and I wanted Mr. Jordan and some other men to go in and interfere. I didn't want any rowing and bloodshedding in my kitchen. They were all afraid, so I went and threw open the door and stamped my foot at Sam and said: 'See here, Sam, don't you dare get up a fight in my kitchen. Be quiet or get out.' Sam got out."

On March 23, 1883, an Indian stopped at the San Jacinto hotel and put up his horse in the hotel corral. His name was Juan Diego and he lived with his wife and several children in a small valley in the mountains east of town. The family had some goats and sheep, along with a few fruit trees, and they farmed some of the surrounding land. It was a barren, wind-swept piece of property and the family lived there because the land was so poor that no whites would be inclined to take it away from them.

It was sheep-shearing time and Juan had been looking for work

in the valley. He was unsuccessful, but he had covered a great deal of ground and he stopped at Hewitt's San Jacinto hotel for a brief rest before heading up the mountain to his home. Mrs. Jordan saw how tired he was and suggested he get some sleep before returning home. Some years later Mrs. Jordan recalled that evening:

> We used to call him 'Crazy Juan.' He wasn't really crazy; he was smart enough. He used to get spells. No, not crazy spells, but it seemed as though the devil got into him, and yet he was generally harmless. Everybody knew him and trusted him. There was no real harm in him. When Sam Temple came in that morning and told me some one had run away with his horse, and I saw Juan's mean little pony there in its stead, I told him I'd bet anything that Juan had taken it when he had a spell on. Sam swore he was a _____ horse thief and he'd follow him and kill him. And so he did. But he didn't ought to have done it. Juan would surely have brought the horse back if he'd waited a little while.

Perhaps Mrs. Jordan should have rushed to the local justice of the peace and alerted him to Temple's threat. But she did not. She was well aware of Juan Diego's "spells" and perhaps thought Temple would take this into consideration at the proper time. She was also well aware that Temple was a loud-mouthed braggart. No one could think the situation was worth a shooting. Meanwhile, Temple was pushing his horse up the trail to where Juan Diego, his wife, and three children lived.

A young niece of Juan Diego was visiting at the time. Mrs. Cinciona Norte told her story in 1931 and there seems to be little reason to doubt her account. Hers is the only version of the shooting that could be considered less biased than her aunt's or Temple's accounts:

> I was living with Ramona and Juan at their home on Cahuilla Mountain. Juan had wooed and won Ramona at the Indian

village of Cahuilla and after their marriage had taken her far back into the mountains to a little adobe hut he had built with his own hands.

Ramona's family, the Lubos, was prominent in the affairs of the Cahuillas. Four children were born to Ramona and Juan in that little adobe hut to which she went as a bride. Three of Ramona's children were named Lupo, Matilda and Mary, respectively. I do not remember the name of the youngest.

It was during one of my visits to the home that Juan was killed. Ramona and I were alone with the children at the time of the shooting. We did not speak to the white man who fired the shot. In fact, we had no opportunity to do so because he rode away immediately.

The remains of Ramona and Juan Diego's home about 1900.
From James' Through Ramona's Country

My uncle was working in his garden. I was walking with one of the children a short distance away when I saw a white man riding up on his horse. A moment later there was a shot. I turned and ran back toward the house. My uncle was lying face down in the garden with Ramona bending over him. He was dead.

Ramona's account has Juan sleeping when Temple rides up and shoots her unarmed husband as he stepped outside the door. She says nothing about his working in a garden prior to Temple's arrival. Since Ramona's various accounts were filtered through an interpreter, some latitude can be allowed. The fuzzying of some details in the Norte account is understandable, also, although she doesn't claim to have seen the actual shooting. The fact is, Mrs. Norte may have merely assumed her uncle was working in the garden when she saw him lying in it.

Both women's accounts are augmented by the report from the Cahuilla Indian Reservation. After the shooting, Ramona left her niece with the body and, taking her youngest child with her, walked to the Cahuilla reservation to tell her people what had happened. There was no government official present at the time, but Ramona

told her story to the local Indian officials and the Indian school teacher, Mary Ticknor. Horrified, the teacher immediately wrote to the Indian agent in San Bernardino. Brief and to the point, the letter reads:

S. S. Lawson:
Dear Sir.—The Captain and officers [Indian] are here to have me write to you.

Saturday, the 24th, Juan Diego was murdered. It appears Juan stole a horse at San Jacinto from a man named Temple. He followed Juan. When he arrived Juan was sleeping. When the dog barked he went out without any arms. Temple had hitched his horse a little distance from the house, and he met Juan with a string of profane oaths and a shot, and when he fell kept on shooting until he had fired four shots; then took his horse and left.

I went to see the murdered man. It was a sickening sight. He was shot in the forehead, nose and wrist with a shot gun, and in the cheek [chest?] with a shot gun.

Juan's wife says he had nothing to protect himself with. The murderer says he came at him with a knife. I think the wife tells the truth.

Temple himself rode right back to San Jacinto and looked up Samuel V. Tripp, the local justice of the peace. Sam knew just what had to be said and done. He confessed to killing Juan Diego, but insisted it was only done in self-defense. Justice Tripp took down Temple's statement as follows:

Justice court document in Sam Temple's case for the killing of Juan Diego. *Courtesy Ramona Pageant Association*

People of the State of California vs. Samuel Temple

Mch 24th A.D. 1883
Personally appeared before me Samuel Temple and makes the following statement (namely) that he has this day committed

His "Jim Farrar" celebrity established, Sam Temple and Judge Tripp hauled court furniture outdoors to recreate Sam's justice court appearance. *Courtesy the San Jacinto Museum*

justifiable homicide committed upon an Indian supposed to be one Juan Diego and under the following circumstances (viz) that he the said Temple followed the tracks of a horse stolen from him last night from the corral of Hewitt & Jordan in San Jacinto and that the tracks led to the house of said Juan Diego and that there he saw his horse and upon inquiring whose horse it is, Juan Diego approached him with a knife in his hand and replied it is mine. And further Temple asked where did you get the horse. I got him in San Jacinto all the time approaching in a threatening manner, whereupon Temple alleges that he ordered him to stop, stop, and the Indian did not heed the order whereupon Temple says, I shot him with [my] shotgun which I carried and as the Ind. did not yet stop coming I shot again and I had to use the butt end of my gun before he fell and I took my horse and returned to San Jacinto.

Sworn and subscribed to before me this 24th day of March A.D. 1883.

S. V. Tripp, Justice of the Peace

Tripp set a hearing for Monday, March 26, releasing Sam on his own recognizance.

On the morning of March 25, Judge Tripp assembled a local coroner's jury consisting of William and George Blodgett, William Stice, J. C. Jordan, Frank Wellman, and Will Webster. Both Jordan and Wellman were friends of Temple's. The jury then proceeded to Juan Diego's home as reported in the San Diego *Sun*, April 5, 1883:

Upon arriving at the ground they found the spot where the

body had been removed and the clothing burned as a heap of hot ashes indicated. As the body could not be found in the locality, the jury were discharged. That evening Capitan Fernando sent a message for Mr. Tripp requesting him to visit the village of Agua Caliente, six miles distant, which he did and saw the body of the Indian. It was recognized as that of Juan Diego, and had two ghastly wounds, one in the breast from a charge of buckshot and a pistol shot through the forehead. Justice Tripp ordered the Capitan to have the body buried immediately.

Sam Temple (sitting) and his pal Frank Wellman. Wellman was a witness at Sam's hearing and was later killed by his Mexican wife in self-defense. *Courtesy the Ramona Pageant Association*

Tripp's hearing took place as scheduled, but was put off and continued until the following Saturday when the coroner's jury could again be assembled. These men were the only witnesses, Ramona not being called even though Indians could testify in court at this time. Henry Hewitt, the hotel owner, served as Temple's defense attorney. With several of his friends on the coroner's jury and no one appearing against him, Sam's hearing was pretty much a stacked deck.

Sam told his story many times in later years, sometimes elaborating on the incident as to details, but always basically the same: The Indian was a horse thief who had attacked him with a knife after he called out several times for him to stop. He was forced to shoot him in self defense. Insisting that Juan Diego, with a shotgunned hole in his chest, still continued his attack, Sam had to pull his pistol and shoot him several more times in the head. All indications are, however, that Sam pumped those revolver shots into a

dead man on the ground. Will Tripp, Judge Tripp's son, said as much in a 1921 interview:

> Reaching the Diego cabin he called to Juan, and shot him down in cold blood as he emerged from the door. Not satisfied, he continued to perforate the body with bullets long after life was extinct.

With no one to appear against his client, Hewitt moved to dismiss the charges on the grounds of justifiable homicide and this was done. At this time and place, and under the given circumstances, no other judgment could be expected.

Mrs. Jackson was in the area at the time and heard of the murder. While she and several friends were riding in a buggy in the San Jacinto Mountains, they were discussing the case and commented on the farcical verdict. Will Webster, one of the jury, happened to be their driver and did not hesitate to butt into the conversation.

"Well, I may as well tell you I was on that jury an' I don't blame Sam Temple one mite. What's more, I'd ha' done the same thing myself."

Mrs. Jackson could hardly believe her ears, recalling that the young driver was "a fine, open-hearted, manly young fellow, far superior in intelligence, education and general bearing to the average Southern California ranchman."

"But Mr._____," we exclaimed, "you surely cannot mean what you say. You would not shoot a man down in cold blood for the sake of a horse, would you, even if he had stolen it? And this poor Indian never meant to steal the horse. He left his own horse in the corral in place of it—a horse perfectly well known—and rode the straight trail to his own door, and tied Temple's horse to the post; and there Temple found it. You don't call that

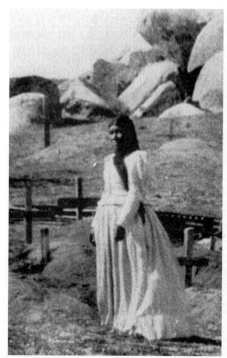

Ramona Lubo poses in the cemetery where her husband is buried, ca. 1895.
Courtesy the Ramona Pageant Association

horse stealing. Do you?" But Mrs. Jackson did not yet know the frontier mind.

"Oh! That's all gammon [nonsense]," Webster replied. "That'll do to tell eastern people. The horse he left in the corral wan't worth twenty dollars. I tell you, if any man had taken a good horse o' mine an' ridden it up that trail, I ha' shot him wherever I'd found him. I tell you, we stockmen in this country have got to protect ourselves. The law don't protect us. There wa'n't a man on that jury that wa'n't on Temple's side."

When the passengers continued insisting that the Indian was unarmed and that his wife said he had no weapon of any kind, Webster shook his head.

"That don't cut any figure at all, the way I look at it. I know Sam said the Indian came at him with a knife. Perhaps he did and then again perhaps he didn't. Sam had got to say so, anyhow. The man had ought to be shot anyhow for taking that horse off up that trail. There was one thing, though, I did blame Sam for; and that was firin' into the Indian after he was dead. There wa'n't any use in that an' it looked bad. Twas real mean, I'll allow. Sam's a rough fellow."

This conversation, recorded in an article written by Mrs. Jackson and published in the New York *Independent* in 1883, says volumes about Indian-white relations even at this late period. Webster and

Temple's opinions were shared by R. P. Stewart, another early settler of the area. His formula for getting along with the Indians, however, was "Don't shoot 'em, feed 'em." Still, so far as the Juan Diego affair was concerned, Stewart was adamant:

"Sam should have had a pension for shooting that ornery Indian, anyhow."

Temple was probably never in doubt as to the outcome of his justice court hearing. He well knew the temper of the times and if he played the game, he was never in danger of anything more than being stuck with the bar bill in Henry Hewitt's saloon after his hearing.

Although a hero in certain circles, Sam

Ramona Lubo, who gained wide recognition because of her husband's death at the hands of Sam Temple.
Author's Collection

went about his business little sus-
pecting the interest that would be
generated by Helen Jackson's book.
The overnight popularity of *Ramona*
was duly noted in the *Los Angeles
Times*, March 14, 1885:

> Mrs. Helen Hunt Jackson's
> "Ramona" is meeting great success,
> having already reached its seventh
> edition. Inasmuch as the scene of the
> story is laid here in Southern Cali-
> fornia, one would think that our
> Public Library ought to have a copy.

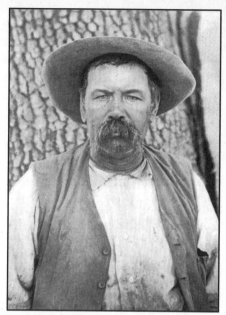

Sam Temple during his later days in a
photograph probably taken by George
Wharton James. *From James'* Through
Ramona's Country

Just when Temple became
aware of the correlation between him-
self and Jim Farrar in the book is not
known. With all the help received
from citizens of the San Jacinto Val-
ley, the book must have made an early appearance locally. Mrs. Jor-
dan had apparently told Mrs. Jackson her version of the Juan Diego
killing. Did she receive an early copy? We don't know.

Being a single man and constantly on the move, Temple can be
tracked by his saloon brawls and pistol problems, although dates
are often lacking. In May 1885, Temple had a disagreement with one
Gus Parti and the two exchanged a few shots from behind trees.
When both men were out of ammunition, Parti began loping to-
wards Sam with upraised pistol, intending to club him. Sam had
other ideas and when a pal offered him a bullet, he quickly reloaded
and stopped Parti with a bullet in the arm.

In December 1887, Sam was convicted of battery against a man
named John Mullin and was fined $25.27.

Although Sam weighed a hefty two hundred pounds, on occa-
sion some of his would-be victims took his measure instead. John
Fenton, who freighted with Temple out of Banning, remarked that
more than once the badman got a set-back from a smaller man:

> In one of his spells of loud talking a little old man asked him

to put on the soft pedal, as there were decent people about. Temple slapped the old man down, to go down himself with a clout to the eye from a bystander. Another time he picked the wrong Texan to force a drink on, and drew another haymaker.

In 1889, Sam was called as a witness in a San Jacinto murder trial that was held in San Diego, then the county seat. One of the maids at the hotel where he stayed caught his eye. The handsome teamster looked pretty good to Elizabeth Winters, also, and they were married soon after, taking up residence in San Jacinto. Reportedly, Temple swore he was going to reform and give up drinking, but that was a promise he could not keep.

Sam was still teaming to the sawmills in the Idyllwild District at this time. Henry Hewitt, a son of the hotelkeeper, claimed Sam was one of his best friends in those days, yet even he got into a squabble with him one day, as he recalled in a 1926 letter:

> I had the nerve to hit him on the jaw. I was about 18 at that time. He just shook hands with me. Some time after that, he shot a man [probably the Parti affair] in a row up near the sawmills. Constable L. Crane arrested him, and that night he deputized me to take care of Sam. I had to sleep with Sam that night, He was in bed next morning when I awoke. Next day Crane took him to San Diego. He was discharged shortly.

Occasionally Sam would tire of his teamster life and take up

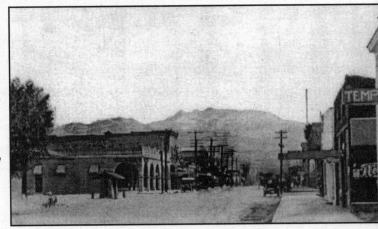

Looking east on San Jacinto's Main Street in the early 1900s. Despite the newfangled automobiles lining the street, the town still had the rustic look of frontier days.
Author's Collection

some new livelihood. The *San Jacinto Register* mentioned that Sam was working as a Diamond Valley ranch foreman in January 1892. The following year he moved north, establishing a home and working for C. O. Barker and Charley Hamilton, out of Banning. In early April 1893, the *Register* reported "Sam Temple was over from Banning last week. Sam with his wife has taken up a piece of government land near Banning and has gone to farming."

Sam was still having his occasional saloon problems, however. After a confrontation with one Joe Waite, Temple accidentally met him in a Banning saloon one day. Waite quickly pulled his pistol and shoved it into the belly of the unarmed Sam. Retreating as diplomatically as he could while talking like a Dutch uncle, Sam calmed Joe down, then slipped out the door. Storming into a livery stable next door, Temple found Charley Hamilton's Winchester rifle and began working the lever. Finding it empty, the frustrated badman decided to leave and perhaps drop by another saloon on the way home to think things over.

By this time Sam had acquired an appreciation of his celebrity as the slayer of Alessandro, or Juan Diego. "Temple," recalled an acquaintance, "delighted in telling the story of how he shot the Indian." In January, 1895, the *San Jacinto Register* noted another visit to town:

> Sam Temple was over from Banning Monday after grain to seed down his fine 80 acre ranch near the city on the hill.

When Mrs. Elisabeth Carl, Sam's step-daughter, came to visit her mother during the summer of 1895, she stayed with them for a year. She heard of Sam's notoriety from neighbors and other local residents and when she asked about it, her mother related the Juan Diego incident to her, giving Sam's version of the killing. At this time, of course, the *Ramona* novel and its origins were famous around the country. Everyone knew that Sam was the original "Jim Farrar" of the book and if they did not, he was glad to tell them. In later years, Mrs. Carl recalled Sam's celebrity was such that the Riverside Chamber of Commerce wrote and asked him if he would ride with Ramona Lubo at the head of their Fourth of July parade. Temple, very much insulted, replied that he "would ride with no damned squaw."

Perhaps Sam changed his mind when he learned a paycheck was involved, as reported in the *Los Angeles Times*, May 22, 1896:

> Riverside, May 21—The Fourth of July celebration will have one novel feature. Among those in the procession will be Ramona, whom Helen Hunt Jackson was supposed to portray in the novel of that name, and Sam Temple, the slayer of Alessandro, another character in the novel. The City Trustees will appropriate $200 for the celebration, and it is expected to raise about $550 more, which will be apportioned to various departments. Never before in the history of the town has such pains been taken to get up a celebration to attract strangers to the city.

Farming, Sam discovered, was not all it was cracked up to be. Other newspaper notices record damage to his crop from excessively dry weather. Either he had given up farming, or he was supplementing his income in September 1897, when he again visited San Jacinto. The *Register* noted he was building an addition to his house and barn at the time, but was also teaming between the Southern Pacific Railroad and the Desert Queen gold mine.

Mrs. Carl, Sam's step-daughter, was living with him during this period and described his farm as being one and a half miles southeast of the town of Cabazon. "There was a pear orchard," she recalled in later years, "a stable for ten horses, a cow shed, chicken pens and a dwelling house of three rooms. There was also a stone house with icy cold water bubbling out of a spring."

It was a teaming incident that once again got Temple into hot water. John Fenton, a Banning acquaintance, was quite probably the author of the following anecdote:

> Dr. King recalls the time C. F. Roth came to him, holding a handkerchief over one of his ears. Sam Temple had cut it half off. The doctor sewed it back, and it healed.
>
> Roth, working for Balfour & Guthrie at Cabazon, had been ordered to close a road through their property which Sam had been using as a short cut to his little place against the hill. Sam started through as usual, and at Roth's explanation that he was merely obeying orders, Sam whipped out his Army .45 from the seat and with a blow against the side of Roth's head, knocked him

reeling. Manager Dave Innes came over to see what the trouble was, to find himself looking down the barrel of Sam's cannon. In no ladylike language Sam advised Innes to get back inside the fence. Some months afterward Dave asked Sam why he hadn't shot that time, and Sam answered that he would never know why he didn't.

In late 1897, Sam received a contract to haul lumber off San Jacinto Mountain for the Native Lumber Company. By May of the following year he and his wife had decided to move back to San Jacinto and they bought the W. J. Hill home on the north edge of town. It was later this same year that Temple had another, more serious shooting scrape. As usual, drinking was the direct cause of the scrimmage, but family problems seem to have contributed to the incident. It was reported in the Riverside *Press & Horticulturist*, August 17, 1898:

> Sam Temple, one of the most notorious characters of this county, and immortalized as a character in Helen Hunt Jackson's Ramona, has at last met his match in gun play—and this in the person of Constable [Robert M.] McKim of San Jacinto.
>
> This is the way it all happened: Saturday morning Sam started in on one of his periodical drunks. By afternoon he was lost to all sense of responsibility, and was in the right condition for a fight. But Sam was at his home in the canyon, and had no one to quarrel with but his wife. Consequently, he started in to abuse the poor woman. She was pretty badly used up, but managed to get to the neighbors and told of her abuse. A warrant was issued for Temple's arrest and Constable McKim set out for the canyon to serve it.
>
> It was dark by the time he arrived there. The belligerent Sam was called out of his house and told to surrender. Instead of doing this, however, he pulled his own ever-ready gun on the constable

ALESSANDRO

10,640 ACRES

Of choice moist and nearly level land, free from rock and stones
NEAR RIVERSIDE,
Subdivided into Five, Ten, Twenty and Forty Acre Tracts now on Sale at Prices ranging from

$25 TO $100 PER ACRE.

No other Tract in Southern California offers such inducements to home-seekers or for investment where quick returns at advanced figures are desired.

Its Superior Location at an Altitude of 1,500 Feet. Its Magnificent Scenery, its freedom from high winds, its equable climate, rich soil, low prices and easy terms cannot be matched.

An early by-product of the Ramona craze that swept the country was land speculation and later the Mission Revival in architecture, which lasted for decades. *Riverside Daily Press, September 19, 1887*

and began to blaze away at him in the dark. McKim returned the fire, his first shot taking effect in Temple's right arm which was so badly shattered that the fight was discontinued. Sam gave up and was taken to the county hospital where it was found necessary to amputate the mutilated arm.

RAMONA!

The Greatest Attraction Yet Offered

IN THE WAY OF A DESIRABLE REAL ESTATE INVESTMENT, AND

FOR BEAUTIFUL VILLA HOMES!

— AS WELL AS FOR BUSINESS.—

Is the New Town of "Ramona."

Three Miles from South Pasadena.

BEING WELL SHELTERED AND FREE FROM FOG AND FROST.

An 1887 *Los Angeles Times* real estate promotion. *Author's Collection*

Luckily, the arm amputation was an exaggeration and Sam was able to retain his mutilated member. The wound was indeed serious, however, and Temple was unable to work for several months. "He says," reported the San Jacinto *Register*, "he hardly expects to ever use the shattered arm to any advantage." The bad-tempered badman spent two weeks in the local *calabozo*, then was released after giving bond that he would behave himself.

George Wharton James, the writer, visited Sam and his wife just after this incident and described Mrs. Temple's face as being "pounded and scratched and looking like raw beefsteak." Since there are no other recorded instances of violence in the family, perhaps the liquor had brought to the surface some grievances Sam had been nurturing. The move back to San Jacinto, for example, may have been the genesis of the problem. It is perhaps significant that in late September Mrs. Temple's property, horses, and wagon were listed as being for sale in the *Register* and at some point during this period she apparently left him.

Sam kept busy. In late 1898, he and two friends made a three-week visit to various points in the desert. Upon his return he made a bet with his friend Jim Thomas on the upcoming governor's election. The loser was to shave off his mustache. "Jim didn't have much to lose by the bet," commented the *Register*, "while Temple has as much hair on his upper lip as Thomas has on his head." When Thomas's candidate, Henry Gage, won the contest, Sam was not eager to ful-

EARLY ROMANCE TO BE REVIVED

Helen Hunt Jackson's Novel Will be Re-enacted

Scenes of Noted Story Laid at Old San Jacinto

Pioneer Gave Writer Her Material for Book

History and romance of early California will be revived next Friday, Saturday and Sunday when the people of Hemet and San Jacinto will present for the second time their spectacular outdoor pageant play, "Ramona," in the colorful Ramona amphitheater, south of Hemet. Five thousand persons attended the production last year. The attendance this year is expected to exceed that number greatly. The pageant will be given Memorial Day, at (p.m.

More than 100 persons will be in the cast in addition to ensembles of Indian dancers from the Soboba and Cahuilla reservations. The production of the annual Ramona pageant by the people of Hemet and San Jacinto has particular significance because of the fact that it was in old San Jacinto, that Helen Hunt Jackson

Notice of the second production of the world-famous Ramona Pageant. *Los Angeles Times, May 25, 1924*

fill the requirements of the wager. He finally persuaded Thomas to take a "small amount" of money in lieu of shaving.

When George Wharton James became acquainted with Temple during this period, he interviewed various early settlers, including Ramona Lubo, concerning Temple's killing of Juan Diego. He even recorded both Ramona and Temple on a

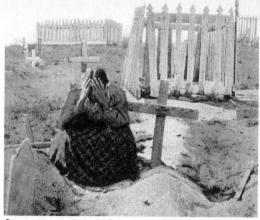

Ramona, weeping at the grave of her husband, ca. 1900. *Courtesy Phil Brigandi*

primitive recording machine. Although the two men got along well enough, James could not understand Sam's total lack of remorse for Juan Diego's death. The badman actually considered himself something of a celebrity for "having rid the country of a dangerous leader of a gang of horse thieves." James would later write:

> Indeed so did he glorify his own action that during the World Fairs, both at Chicago and St. Louis, he thought he saw a great chance to win money and fame by posing there as the man who killed Alessandro. When he approached me in regard to the proposition that I should "finance and manage" this enterprise, receiving a due share of the profits, he seemed somewhat taken aback when I jokingly (but with a great deal more of seriousness and earnestness than appeared in my face and manner) declared that I would far rather raise money to have him tried and hanged for his crime than to send him to the World's Fair to pose as a hero.

Sam was very much aware of his value as an historic personality long before his Riverside Fourth of July venture in 1896. It is difficult to imagine Ramona Lubo, the widow of Temple's victim, appearing with him in any capacity, but apparently neither of them was averse to capitalizing on the tragic incident.

Writing in the style of the times, James gives few dates in his book, *Through Ramona's Country*. It is unlikely James knew Temple as early as the 1893 Chicago World's Fair, however. His claim to have been approached by Temple concerning the 1904 Saint Louis

Fair also seems doubtful, considering Temple's death early that year. What is known is that the *Register* announced that Sam and Ramona Lubo were again going to be on display together during the San Jacinto Fourth of July celebration in 1899. The Indian woman had been utilizing her Ramona celebrity for years. And why not? This was just another aid to surviving in the white man's world.

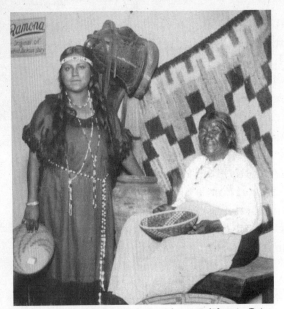

Ramona Lubo at Riverside's Southern California Fair in 1921. Standing is Rose Costo of a prominent Cahuilla family. Two years later the first Ramona Pageant would be produced in the San Jacinto foothills. *Courtesy Phil Brignadi*

Ramona Lubo lived on the Cahuilla reservation for many years, with tourists paying to visit, talk to, and take photographs of the person touted as being the famous "real" Ramona. As early as 1892, the San Jacinto *Register* rudely commented that "she is short and shrewd, knows of her notoriety and makes merchandise of it."

In September 1901, the *Los Angeles Times* reported a rich gold and copper discovery in eastern Riverside County. Sam and four other men, including Jim Carl, Temple's stepdaughter's husband, had made a remarkable find near Yuma. It is not known if the mine was successfully developed, however. Sam may have sold his interest in the project, since Mrs. Temple left in November on an extended visit to Ireland and the Holy Land.

As for Sam, his race was pretty much run. An old rupture reportedly had troubled him for some time and he checked into the San Diego hospital. He died there on May 6, 1904. Few people realized that the grizzled, sun-burnt old-timer was the man who murdered "Ramona's" husband. There was no romance about Sam and he had long ago given up on trying to capitalize on his notoriety.

The popularity of the book had resulted in thousands of tourists flocking to Southern California and a constant stream of magazine and newspaper articles. The locals had been casting about for some way to capitalize on all this. Finally, in 1906 a plan was initiated to produce a play in San Jacinto based on Mrs. Jackson's book, which by this time had gone through a great many editions and printings. An article in the *Los Angeles Times* noted that people who had known Helen Hunt Jackson would have parts in the play along with "hundreds" of local extras. The newspaper stated that "a special invitation will be extended to the real Ramona who still lives in the mountains back of San Jacinto... ."

Perhaps the time was not yet right for such a performance, but a concept was evolving. In October 1921 the *Hemet News* announced that Ramona Lubo would be an "exhibit" at the Southern California Fair to be held in Riverside. A booth, constructed to resemble an Indian shelter, would also feature Miss Rose Costo, who would represent Ramona as she appeared forty years ago. But Ramona's time was running out, also.

According to her only surviving son, Condino, Ramona was on display at the San Bernardino Orange Show, where she contracted influenza and returned home. She recovered but suffered a relapse and died on the afternoon of July 20, 1922. Oddly enough, her obituary in the *Los Angeles Times*, September 17, 1922, states that she had passed away "the other day at the Cahuilla Indian reservation." George Wharton James, who had known her well, wrote in his publication

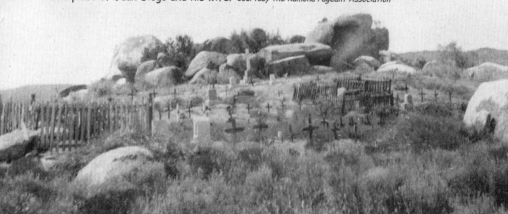

The Cahuilla Cemetery, ca. 1940. No longer open to the public, the cemetery is the burial place of Juan Diego and his wife. *Courtesy the Ramona Pageant Association*

California Indian Herald in January 1924, that she died in the San Bernardino County General Hospital on September 16, 1923. The date is evidently a typo, but since James had died the previous November (1923), the article is puzzling indeed.

The deaths of Temple and Ramona Lubo left questions and lingering doubts about the death of Juan Diego so long ago. The only known witnesses were Ramona, perhaps her niece, and Temple. Few really believed Sam, his character arguing against what he steadily maintained had happened. The truth is few really cared what had happened. While Ramona had insisted her husband had nothing with which to defend himself, Temple never said Juan was armed with anything other than a knife. And any household, then as now, had knives around—skinning knives, cooking knives, and hunting knives.

Aside from this, Ramona related slight variations of her story over the years. Her first story told to the Indians at the Cahuilla village was that Temple had shot Juan when he appeared in the doorway and he fell across the threshold. Rupert Costo, whose parents were in the village when Ramona first told her story, later repeated Ramona's description of the killing. In two published accounts, Costo says Ramona told the story many times to his family. In these later versions, Ramona stated that when Juan was shot in the doorway, he fell forward and began wrestling with his assailant, grabbing Temple by the throat as they tumbled to the ground. Scrambling to his feet, Temple pulled his pistol and shot Juan three or four times as he lay on the ground.

What does all this mean? Perhaps nothing more than Ramona remembering more details when she thought about the incident over the years. That said, it should be remembered that there are no impartial witnesses or hard evidence to refute Temple's story, either. The author's research into such incidents would strongly suggest, however, that Temple was indeed guilty of murder.

But *Ramona*! The book and the name had long ago taken on a life of their own. Stage productions had already dramatized the Jackson book when D. W. Griffith created his 1910 silent film starring Mary Pickford. Two other silent versions made their appearance before the Technicolor sound version was produced in 1936, pairing the unlikely couple of Loretta Young and Don Ameche in the title roles.

The Southern California county fairs and Fourth of July parades evolved into the Ramona Pageant in 1923, all utilizing the state's wonderful weather as an important ingredient of the attraction. The play's initial $2,500 budget and audience of some 3,000 had escalated by 1961 to a $45,000 budget and a crowd of nearly 30,000. Produced by the two cities of San Jacinto and Hemet in a natural amphitheater in the foothills south of Hemet, visitors come from around the country and the world to see this dramatization of a novel based on various bits of early California history. Helen Hunt Jackson's moving and dramatic tale of Indian love, heartbreak, and tragedy magically transformed some unlikely real-life characters into unforgettable figures that will probably live with us forever. To date, the widely heralded novel *Ramona* has gone through more than three hundred printings in many editions.

With all this in mind, is it too much of a stretch to suggest that all of this is at least partially due to the actions of a crude, happy-go-lucky thug, drunk, and murderer? And while towns, buildings, streets and even an architectural style are named after the characters and title of the book *Ramona*, nothing will ever be named after the dastardly, fictional Jim Farrar or the all too-real Sam Temple.

CHAPTER 3 SOURCES

Davis, Carlyle Channing and William A. Alderson. *The True Story of Ramona*. New York: Dodge Publishing Company, 1914.

Holmes, Elmer Wallace. *History of Riverside County, California*. Los Angeles: Historic Record Company, 1912.

Hughes, Tom. *History of Banning & San Gorgonio Pass*. Banning: Banning Record, 1938.

James, George Wharton. *Through Ramona's Country*. Boston: Little, Brown and Company, 1909.

McKanna, Clare V. *Race and Homicide in Nineteenth-Century California*. Reno & Las Vegas: University of Nevada Press, 2002.

Banning Record, April 25, 1946.

Fresno *Morning Republican*, July 4, 1897.

Hemet News, October 7, 1921; August 13, 1926; January 24, 1930; April 20, 1961.

Los Angeles Times, March 14, August 22, 1885; January 4, 1887; May 22, 1896; September 6, 7, 1901; April 1, 1906; November 9, 1916; April 17, October 1, 1922; August 19, 1923; May 25, 1924; April 18, June 27, 1926; April 17, 1927; April 6, 19, 23, 1931.

New York *Independent*, September 27, 1883.

Riverside *Daily Press*, September 19, 1887.

Riverside *Press & Horticulturalist*, January 16, March 18, 1882; August 27, 1898.

Riverside *Enterprise*, June 8, July 9, 1899.

San Jacinto *Register*, January 1, 1892; April 6, 1893; January 10, 1895; September 2, 1897; August 25, September 29, November 17, 1898; April 23, 1931; May 8, 1941.

San Diego *Sun*, April 5, 1883.

San Diego *Union*, July 7, 11, 1878; May 17, 1885.

Arnet, Cory. "Ramona through Indian Eyes," *Indian Historian*: Ramona Pageant Edition, April-May, 1965.

Battle, Don. "The Man who Killed Alessandro," *Westways*, February, 1962.

Brigandi, Phil and John W. Robinson. "The Killing of Juan Diego: From Murder to Mythology," *The Journal of San Diego History*, Winter 1994.

Costo, Rupert. Letter: "Ramona's Own Story," *Desert Magazine*, May 1947.

James, George Wharton. "Ramona is Dead," *California Indian Herald*, January 1924.

Mathes, Valerie Sherer. "Parallel Calls to Concience: Reformers Helen Hunt Jackson and Harriet Beecher Stowe," *The Californians*, July/August 1983.

Maxwell, Ernest. "Justifiable Homicide, California Style," *Desert Magazine*, September 1980.

Powell, Lawrence Clark. "California Classics Reread: Ramona," *Westways*, July 1968.

Ramona Pageant Association. *Ramona Pageant Program*, 1961, Ramona Pageant Association, Inc., H. E. Divine, President.

San Diego Historical Society. *Inquisition by Coroner's Jury in the matter of the Inquisition upon the Body of Refugio Baca.* County of San Diego, July 1878.

San Jacinto Museum, Justice Court Docket. *People of the State of California v. Samuel Temple*, March 24, 1883.

U.S. Federal Census, 1850, McCoy County, Tennessee.

U.S. Federal Census, 1880, San Diego County, California.

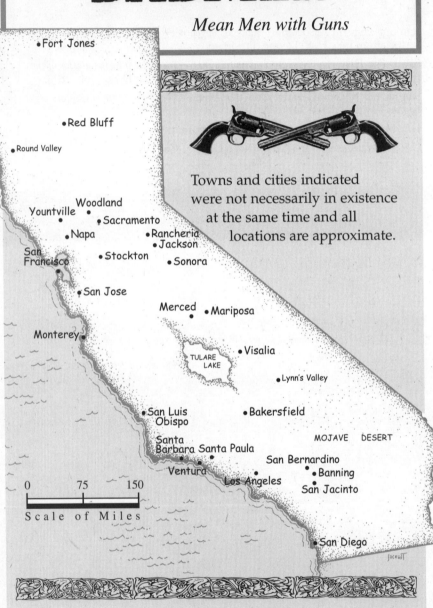

Locales referred to in California

BADMEN

Mean Men with Guns

Towns and cities indicated
were not necessarily in existence
at the same time and all
locations are approximate.

Fort Jones

Red Bluff

Round Valley

Woodland
Yountville
Sacramento
Napa
Rancheria
Jackson
Stockton
Sonora
San Francisco

San Jose

Merced
Mariposa

Monterey

TULARE LAKE

Visalia

Lynn's Valley

San Luis Obispo

Bakersfield

MOJAVE DESERT

Santa Barbara Santa Paula
Ventura
Los Angeles

San Bernardino
Banning
San Jacinto

San Diego

0 75 150

Scale of Miles

Chapter 4

A Brutal Murder Leads to a Mysterious Conclusion!

One of the more remarkable conclusions of a coroner's jury during California's pioneer days was rendered in late February 1887. When a Napa County farmer's wife was murdered in a particularly horrible manner, the lawfully constituted jury responded with a verdict that the murderer be "tried in the court of Judge Lynch!" In calling attention to this highly unusual judgment, the Fresno *Weekly Republican* noted the circumstances prompting such a reaction:

> This is a singular verdict, coming from a lawful jury of lawful citizens. It would seem astonishing that a jury of law-abiding citizens should render such a verdict were the causes which led to it not known. When this jury rendered so remarkable a verdict it had before it a long line of precedents in murder trials which showed them that were this fiend caught and tried according to the law as commonly interpreted by the courts, that in all probability the plea of insanity would be set up and the murderer would escape the penalty for which the blood of his victim cries out and the safety of society demands.

Sound familiar? This is a complaint frequently heard nowdays, but fortunately seldom acted upon. It was not always that way, however.

Situated some fifteen miles above the northern shore of San Francisco Bay, the Napa Valley was a land filled with grizzly bears, deer, elk, and scattered Indian villages. Trapper George Yount was

Above:
A mountain view in northern Napa County.
California State Library

the first American settler, superceded only by General Mariano Vallejo and his sprawling 1836 land grant, Rancho Caymus. Yount established a flouring mill and a sawmill, and by the 1840s American settlers were drifting into the area from Oregon. Other sawmills were established and in 1847 the timbers for six buildings were cut and framed in the Napa Valley and shipped to Benicia and Yerba Buena, later to be called San Francisco. Soon, American and native California farmers were scattered up and down the extended valley.

Established as one of the original California counties in 1850, the sparsely settled area representing Napa County soon began attracting disappointed Gold Rushers as well as Eastern farmers who saw the agricultural potential. The land was rich. Large wheat, stock, and dairy farms began replacing fields of native wild oats. Soon orchards were being planted, while on the sites of old Spanish adobe houses, the towns of Napa City, Yountville, and Calistoga came into existence.

The Napa Valley was the heart of the county. About five miles wide at the southern end, the valley stretched northward some thirty-five miles, surrounded by forested mountains and brush-covered hills. Other, much smaller valleys were scattered throughout the hills and were attracting settlers in the 1860s and '70s.

Wheat was the first big crop in the area. Orchards, vineyards,

The dairy farm and residence of the J. W. Grigsby family, one of the numerous related families in the Napa Valley. From *Smith & Elliott's Illustrations of Napa County*

and other crops followed and in time a wine industry developed. The Napa River bisected the town and steamboats left several times a day for Benicia, Sacramento, and San Francisco.

Rancher Achilles "Kellis" Grigsby took up land in Napa County in the waning years of the great Gold Rush. He originally settled in Yountville, but later acquired property in Wooden Valley, near the city of Napa. His home housed not only his wife, Mary, a daughter, and two sons, but also an adopted son and a niece and nephew. The two latter probably belonged to his brother Melchior, who also lived with him. It was a big crowd to look after and Mary Grigsby had her hands full.

By 1880 two-year-old Everet was the youngest Grigsby and most of the children were in school. Eighteen-year-old Belle helped out at home, while sixteen-year-old Millie was boarding at Yountville while she attended high school.

Just down the road from the Grigsbys, the widow Martha Lyons worked her late husband's farm with the help of her three sons, William, Herman, and Elijah. The family had come west in 1864 and settled in the Napa Valley. When John Lyons died, the boys took care of their mother, buying three hundred acres in Wooden Valley in 1883. The land was mostly devoted to pasture and corn raising, but eventually orchards and vineyards were established, also.

In small Wooden Valley everyone knew everyone else. They helped on each other's farms and attended social events together. Families accompanied each other to town for supplies, attended holiday celebrations together, and helped deliver each other's babies. Probably no one in the valley was surprised when Herman Lyons married Millie Grigsby, Kellis's oldest daughter, on January 7, 1885, in Napa City.

The happy couple settled down on eighty-four acres of the family property next to Kellis's place. Both families probably pitched in to build the couple's modest house. Millie had no illusions about farm life, having grown up on her father's ranch. There was always work to do, but much of it could be done at one's own pace.

Evenings were lovely in the valley. Herman and Millie could go for walks or sit before the fire and talk of the future. On occasion Herman would borrow the elder Grigsby's wagon and escort his wife to a traveling stage show in Napa, located only some eight miles away. When a circus arrived from Sacramento, people flocked to

Napa from all over the valley. Life was simple, but it was a routine to which country women quickly became accustomed.

In the spring of 1886, the Lyons family was blessed with a baby girl and Millie was not able to help her husband as much about the farm. The child was named Lottie.

At times farm work became overwhelming, particularly when crops were coming in. Often itinerant laborers were walking the roads, looking for a specific type of work or for any odd job they could find. When a drifter stopped by the Lyons farm one day in November 1886, Herman said he thought he could keep him busy until planting began in the fall. "Pete" was told he could sleep in the barn and take his meals at the house. There was some fallow land to cultivate and he could haul in a few loads of wood from the hills and start chopping and splitting it for firewood. Although the local press bragged about the warm winters and cool summers in the valley, nighttime in the hills could be very chilly.

Millie Lyons, from a sketch made in 1897. *Author's Collection*

Pete claimed to have been a sailor working on ships plying the coast. Tiring of a nautical life, he had done farm work more recently in Yolo County, but after a big spree in Woodland he found himself broke and started walking west. Pete performed well enough, but Herman was not quite satisfied with what was being accomplished. In mid-January 1887, he hired Frenchman Louis Basar to also start helping to clear the fallow land. The two farm workers kept busy and seemed to enjoy each other's company.

Lyons got along well enough with his two employees. When he and Millie made a trip to Napa in early February, Pete asked Herman if he would purchase a Louisiana lottery ticket for him. The farmer bought two tickets, one for Pete and one for himself. When he returned to the farm, he gave his employee the number of his ticket which Pete wrote down. Lyons later recalled:

Neither ticket drew a prize. Afterward I bought another for

The county seat of Napa City, only eight miles from Wooden Valley, was a convenient supply center for farms and ranches of the area.
Author's Collection

Pete and offered it to him, but he requested that I keep it. I did not get one then for myself. Meanwhile, Pete went to Vallejo on a vacation and on his return asked for the ticket. Upon handing it to him he said it was not the one I bought for him, although I did not give him the number of his coupon. Thereupon hot words passed between us and afterward I was obliged to eject him from my house, tearing his shirt in the scuffle. I allowed him to remain to finish his woodpiling, which he did.

On the morning of February 17, 1887, Lyons took his team of horses over to his father-in-law's place and hitched up his wagon for a trip to town. Returning home, Herman helped his wife and baby into the wagon. When Pete came up and asked for a settlement on his pay, Herman told him they would settle when he returned from town.

"I then left the ranch with my wife and child," recalled Lyons later. "As I went to town I saw Pete and Basar talking together. We remained in town two hours. I borrowed money to pay Pete and when I returned I saw Pete at the corner of my house. He knew I would take the wagon to Achilles Grigsby's. When my wife alighted at the house, Pete went up to where Basar was, about 150 yards from the house. When I left, my wife went immediately into the house."

Lyons drove the quarter of a mile over to the Grigsby place and unhitched his team in the barn. It was about five o'clock in the evening as the farmer drove his two horses back towards his place. About halfway home, Herman noticed Pete standing nearby on a hillside with a rifle in his hands. Suddenly, he swung the weapon to his shoul-

der and fired, just missing his employer. Startled, Lyons jumped behind his horses and Pete fired again. After firing for the third time and again missing, Pete ran past the Lyons home in a northern direction, then turned east and disappeared over a hill and into some brush.

Lyons had noticed his father-in-law with his son Johnston and several nephews building a brush fence nearby. Keeping his horses between him and Pete, Lyons ran toward Kellis Grigsby, yelling for him to get a gun from his house. One of the boys ran over and was soon back with a rifle. Herman had not seen Pete disappear and was terribly worried about his wife. He thought he had seen blood on Pete's hands.

Spreading out, the group now approached the Lyons house and went inside. The men were staggered by the scene before them. It was a slaughterhouse. Millie was sprawled on the floor in a spreading pool of blood that pumped out of gaping wounds in her neck. A broken razor lay nearby, while a knife rested on the body. Her blouse was slashed and ripped, her chin and cheeks deeply slashed as by someone in a frenzy. There were deep wounds made by teeth on her arms, and a fingertip appeared to be bitten off. The *Independent Calistogan* reported the terrible scene on February 23:

> Mrs. Lyons lay upon the floor dead, her face, hands and clothing completely covered with blood, and the floors, doors and sidewalls throughout the dwelling were more or less spattered with blood. There had been a fearful conflict between Mrs. Lyons and her murderer—she to protect herself from his hellish lust, and then to save her life.

Baby Lottie was found in an adjoining room, alternately babbling and crying. She had bloody handprints on her gown, as if the killer had picked her up for some reason. She was taken to the Grigsby home and Johnston Grigsby was sent to Napa for the sheriff and coroner. Clutching his rifle, the horrified Herman ran from

COAST AFFAIRS.

The Dastardly Assassination of Mrs. Millie Lyons.

A Sheriff's Posse and the Neighbors Searching for the Murderer.

The Santa Rosa and Benicia Railroad—Landslide Near Tehachipa—San Diego to Have a Marine Railway.

NAPA, Feb. 18—[Special].—A Sheriff's posse is scouring the mountains for "Pete," who is charged with the dastardly murder of Mrs. Millie Lyons yesterday in Wooden Valley. In fact, the whole neighborhood is hunting him, and if found he will probably not be captured alive, as he took a Henry rifle with him. If captured by anybody but the sheriff's posse, he will surely be lynched, the excitement is so intense. The Sheriff offers $250 reward for "Pete's" capture.

The Napa *Reporter* says of the crime: A most foul and atrocious murder was committed in Wooden Valley on Thursday afternoon, the victim being Mrs. Millie Lyons, wife of Herman Lyons, and a daughter of A. F. Grigsby. The brute who perpetrated the dastardly deed is a Portuguese (Indian by the name of Pete), and was employed on Mr. Lyons' ranch. News of the crime was brought to town about 6 o'clock last evening by Samuel Grigsby, who immediately after the occurrence was dispatched to Napa to notify the officers and Coroner. The young man was found by a representative of this

Millie Lyons's brutal murder made front page news in California. *San Francisco Daily Morning Call,* February 19, 1887

his home to the flats above the road. He looked in every direction, but Pete had vanished. It was getting dark and he went back inside to tend to the body of his dead wife. There was nothing he could do. He ached to rush from the house and track the killer, but he knew the interests of his dead wife and her family must come first. He slumped in a chair with his head in his hands.

As the sky was beginning to darken, Ben Capell, Bush Oliver, and Frank Grigsby were returning from a deer hunt along a road running along the north side of the Lyons barn. Hearing the commotion at the house, the hunters rushed over and were quickly apprised of the terrible crime. When Pete's escape direction was pointed out, the three grim-faced hunters were promptly on the fugitive's trail.

The sheriff and coroner arrived about nine o'clock and preparations were made to transport the body to Yountville, the former Grigsby home, where there were relatives and a family plot in the local cemetery. An account of the funeral was published in the *Yountville Register*:

> The little church was crowded with friends of the stricken family while hundreds remained outside unable to gain admittance.

The Napa City waterfront gave county residents access to Sacramento, Stockton, and San Francisco via the water. From *Smith & Elliott's Illustrations of Napa County*

The Funeral sermon was very affecting, Mr. Wylie himself almost breaking down in its delivery. When the throng pressed forward to view the remains there was hardly a face but paled when the evidences of the brute's attack were seen, and strong men turned away and wept. The face and neck of the body were exposed to view, showing the unsightly cuts on both. Apart from these, the face wore a peaceful expression. The funeral procession was over one mile in length, the remains being deposited in the family lot in Yountville cemetery.

Louis Basar had behaved suspiciously at the time of the murder and because he had worked with Pete on the Lyons farm it was thought he might have been involved in the murder in some way. After the funeral, a gathering of Wooden Valley residents met to decide the merits of lynching the suspected Frenchman. Cooler heads prevailed, however. At his own request, Basar was lodged in the county jail and Herman Lyons charged him with being an accessory to the murder. It was at this time that Pete's last name was discovered to be Olsen and that he was of Swedish nationality.

A good description of Pete was put together by Sheriff H. H. Harris and 2,500 postcards were sent all over the state. A $500 reward was offered by the county supervisors, $250 more by the sheriff, and the governor soon added $300 more. The distraught husband and his father-in-law were said to have added to the official offerings, also. Reports were already being received of suspects being picked up in Suison, Woodland, and Yountville, but all had alibis or did not accurately fit the description. Posses were scouring the area and it did not seem possible the killer could evade capture. The *Napa Reporter* tried to keep up to date in the search for the murderer:

$1050 Reward! Wanted for Murder!

A SWEDE aged about 38 years, 5 ft 10 inches high; rawboned; light complexion; beard of about two weeks growth; bald spot about the size of a half dollar on back of head; hair light, very thin; eyes blue; hard and rough hands stained from cording wood; scar under left eye from burn. Wore blue overalls, blue shirt, pants in boots about No. 9 and very coarse. Black slouch hat. Sways as he walks; takes long steps, talks broken English and drinks when he can. Carried Winchester rifle, 44 calibre, 24 inch barrel, with ivory bead. Killed a woman in Wooden Valley, Napa county, Feb. 17th, 1887, at about 4:30 P. M. The murderer was formerly a sailor and may try to make deep water.
Arrest and telegraph.
H. H. HARRIS,
Sheriff Napa County, Napa City, Cal.

The postcard. *Napa Reporter,*
February 25, 1887

Nearly every hour of the day messages come in announcing

clues to Pete's whereabouts, but in every instance they are proved later on to be without foundation and only tend to mystify the officers more and more. Sheriff Colgan of Sonoma county, with one of his deputies was in town last evening. He reported that news had been received to the effect that the Swede had been seen in Alexander Valley, Sonoma County, during some part of the day Tuesday. However, no great amount of reliance is placed in this report. Undersheriff Kingston received a message yesterday afternoon from police officer James D. Curtis of San Francisco announcing that he had information that led him to believe that Pete was in San Francisco. Herman Lyons is now in Leesville, Colusa County, near the

REWARD!

WHEREAS, on Thursday, the seventeenth day of February, A. D. 1887, in Wooden Valley, Napa County, California, MRS. MILLIE LYONS was murdered by a man known as

PETE OLSEN.

Now, therefore, I, Washington Bartlett, Governor of the State of California, by virtue of the authority in me vested by the Constitution and laws of this State, do hereby offer a reward of

Three Hundred Dollars, $300,

For the arrest and conviction of the said PETE OLSEN. This reward only to be paid upon the presentation of proof of conviction.

In witness whereof, I have set my hand and caused the Great Seal of the State to be hereunto affixed, this twenty-third day of February, A. D. 1887.

[GREAT SEAL.] WASHINGTON BARTLETT,
 Governor of California.
Attest:
W. C. HENDRICKS, Secretary of State.

DESCRIPTION:

OLSEN is a native of Sweden; aged about thirty-eight years; five feet nine or ten inches in height; raw boned and thin; sallow complexion; thin hair, and a bald spot on his head which cannot be seen when his hat is on; has a light mustache, and blue eyes; high cheek bones, with a slight scar on left cheek, apparently from a burn. When last seen, he was dressed in blue shirt and overalls, mixed sack coat, and number nine boots. He carries a 44-calibre Winchester rifle with an ivory sight. The man speaks English quite well. Wachsen a collar

Posted less than a week after the murder, the governor's reward was only good after a conviction. *California State Archives*

boundary line of Lake, and the last dispatch received from him stated that he was still in the dark concerning Pete's whereabouts.

This issue of the *Reporter* also reported over fifty men were out searching in Yolo County during the past few days.

Three days after the murder, Lyons was able to leave on his own pursuit of the killer. He took the direction in which Pete had traveled, following his tracks and hoping to find someone who had seen him. "I followed his tracks and clues through Bear Valley," stated Lyons, "crossed Stoney Creek below Smithville, through Elk Grove, Pascanti and Bailey's sheep ranch in Tehama County where I lost his tracks, thirteen miles west of Red Bluff."

When his horse kicked and injured him, Lyons returned to Wooden Valley after being on the trail for six weeks. On April 15, he again took the trail, heading for Fort Jones in Siskiyou County where a man had been arrested on suspicion of being Pete. This turned out to be yet another wrong identity. Heading north on foot and by train, Lyons began scouring southern Oregon for the fugitive.

Herman Lyons had been in Red Bluff when word was received that Pete Olsen had been caught in Mayfield, just south of San Francisco. Lyons had scoured Tehama County accompanied by Deputy Sheriff Bahney and a large posse, but had seen no sign of the fugi-

tive. Now he awaited news verifying the Mayfield capture but it was yet another disappointment, as reported in the *Napa Reporter* on March 4, 1887:

Undersheriff Kingston left for Mayfield on Wednesday night, and on Thursday afternoon John Lyons was sent to San Francisco on the 4 o'clock train, the undersheriff having previously telephoned that he would bring his man to the metropolis Thursday morning so that some one from this city who knew Pete could go down and identify the man. At about 8 o'clock last night Sheriff Harris received a brief telephonic message from Mr. Kingston saying that Lyons had seen the man arrested at Mayfield and it was not Pete. They will return on this morning's train.

The sheriff received a letter yesterday afternoon from Constable Standiford of Popel Valley, the substance of which was that the so-called clue to Pete's whereabouts at the Aetna Mine had proved, after investigation, to be nothing at all.

The *San Francisco Examiner* published a brief article based on a dispatch from Shasta County in the north. It was filed under the headline "The Napa Murderer:"

French Gulch, March 18.—News was received here today that Pete Olsen, the murderer of Mrs. Lyons at Napa, is in Trinity County above Lewiston, on Trinity River.

Parties in pursuit saw a man last Wednesday on the west side of the river having a rifle. He sat down on a sunny knoll and apparently fell asleep. One of the party approached and when within 100 yards of the sleeper, shouted. This aroused the man who sprang up, snatched the rifle and started to run. He was told to stop, but would not. The pursuer then shot five times at the fugitive, but without effect.

Parties are still in pursuit. Mr. Lyons is in Trinity County exerting all means to secure Pete's arrest.

The furtive sightings were becoming dangerous. It seemed only a matter of time before an innocent person was shot.

Back in Napa, Undersheriff Kingston was discouraged at all the false leads, but still retained hope the fugitive would be found.

"The mere mention of a suspicious character," he noted, will start a hundred men from one township in Napa, Lake or Sonoma County scouring the country. Many think that Olsen was drowned in Putah Creek. Others say that he must have reached the vicinity of Benicia and crossed in a boat."

In Tehama County, Herman Lyons prepared to cross the mountains to Round Valley. There was an unusually heavy snowfall in the mountains. In March, a dispatch from Truckee to a San Francisco newspaper announced that a man answering to the description of Olsen had been arrested and his photograph taken. When the mug shot arrived in Napa, however, it proved to be another wrong man.

Stories came in from all over California. In mid-April, a man with a Swedish accent checked into a hotel called the Lillard House at Davisville, west of Sacramento. When his guest signed the register, Lillard noticed the name was "C. Olsen" and he remembered the Lyons murder and the many newspaper descriptions of the killer. Quickly checking a card with Pete's description on it, the hotel man was sure the fugitive was in one of his rooms and the reward was his. After guarding the suspect's door all night, Lillard kicked open his door at first light with his card in one hand and a pistol in the other. Thinking he was being robbed, Olsen let out a yell, but Lillard told him to shut up or he would blow his head off. Carefully comparing his captured guest to the description, the hotel man realized that he had the wrong man. "Our detective," noted the account in the *Yolo Mail*, "was compelled to give it up. While the name was ominous, Pete's description failed to apply."

The *Ventura Free Press* of April 8 chronicled the arrival of Napa's Sheriff Harris and Tulare County's Sheriff George D. Parker at this coastal community. The two lawmen were following up on a lead that Olsen "is in the coast mountains trying to make his way to the sea-board to leave the country."

About March 12, a lone traveler had been seen near the Tulare County ranch of a man named Merrill. The rancher's wife, like nearly everyone in the state, was aware of Olsen's description and very well aware of the large reward being offered. She wrote Tulare County Sheriff George D. Parker about her suspicions and described the man she had seen. Parker was out of town, but his undersheriff

promptly wrote Napa's sheriff who arrived in Visalia on the next train. Sheriff Harris stated that Mrs. Merrill had described Olsen better than he could have done.

The two lawmen took the train to Lemoore and from there rode out to the Merrill farm where they spent the night. From further descriptions given by Mrs. Merrill, Harris was firmly convinced that he was on the right track at last. The fugitive was some two weeks ahead of them by now, but at last the trail seemed to be warm. Several other ranchers and a French sheep man had all seen the man, who was subsequently tracked through the Cholame Valley on his way to San Luis Obispo. They queried five men with whom the fugitive had talked while they had supper together the day prior to his visiting at the Merrill place. Wherever the man had stopped, he had been looking for work and asking about Bakersfield. He never went to where work was to be had, however, and seemed to be trying to avoid Bakersfield. At another sheep camp occupied by a Chinese and a Mexican, he bought some jerky and bread, then again headed into the mountains where his trail was lost.

At Bakersfield, the two officers talked to the sheriff and described their journey after Olsen. He had not been seen locally, but there were reports to the northeast, and also at Tehachapi, of wan-

Roundup scene on the Carver Ranch, date unknown. *Jeff Edwards Collection*

Located in the southern San Joaquin Valley, Bakersfield was no longer a frontier town, but its Wild West past still lay just beneath the surface. *Author's Collection*

dering strangers. The two officers split up, and Sheriff Harris sought out the cattle ranch of the Carver brothers in the White River area.

Alexander and Jefferson Carver lived with their mother and several younger siblings and ran cattle in the foothills south of Visalia and Porterville. Harris asked about any strangers in the hills and here the story gets rather murky. The likely scenario was that the Carver brothers told the sheriff that a stranger had wandered through the area and talked to them briefly, but then disappeared, perhaps going to Bakersfield. Harris met Parker at Visalia, where he learned the Tulare sheriff had also been disappointed at Tehachapi.

The next day the two lawmen took the train south to Newhall, south of old Fort Tejon. From there they caught the stage to Santa Paula and Ventura where they hoped to obtain word of a sighting on the coast. After a talk with the local sheriff, they moved on to Santa Barbara, only to meet with more disappointment. Crossing the mountains in a heavy rain, Harris and Parker caught the train at San Luis Obispo, then separated at San Francisco. The officers, noted the *Visalia Weekly Delta*, "having put in almost two weeks in a fruitless chase, none the less are to be commended for the effort made to capture the murderer."

With all the false reports coming from around the state it would

seem that a verifiable sighting was inevitable. Finally, a dispatch from the south was published in the *San Francisco Chronicle* on May 1, 1887. The headline blared "Peter Olsen Said to have been Killed. Shot Down while Resisting Arrest."

Bakersfield, April 30.—The dead body of Peter Olsen was brought into town at a late hour last night. He was killed resisting arrest. The fact was immediately telegraphed to Sheriff Harris of Napa, who replies that he will be here tomorrow. The body has been viewed by hundreds today and all agree that it corresponds with the published description of Peter Olsen.

Thought to be a photo of Jeff Carver and his family in the 1890s. *Jeff Edwards Collection*

It seemed that the nightmare was at last over. Piecing together the story, it seemed that during the final week of April a stranger had appeared in the southern San Joaquin Valley town of Bakersfield.

No longer a ragged, false-fronted frontier town, Bakersfield was the county seat of Kern County. A growing mercantile and farming economy was reflected by the beautiful new stone and brick buildings springing up on the main streets of the town. Still, a stranger was noticed by many people who were conscious of the constant sightings of the Napa murderer. The man's name was given as R. M. Siebert and he was looking for land. Traveling northeast from town, the man stopped briefly at the Carver ranch and spoke to the owners before moving on. Locating an abandoned cabin above Lynn's Valley, Siebert prepared to settle down.

Later, as the two Carver brothers were out working cattle,

Siebert returned to the Carver ranch and told the mother and sisters that he was living at the abandoned cabin he had found and was putting in a small crop of potatoes. He told them where his cabin was located and that the snow was just beginning to melt. By the time Aleck and Jeff Carver returned home that evening, Siebert had left. Louisa, their mother, however, had the unsettling news that the stranger closely matched descriptions she had read of Pete Olsen, the Napa murderer. This was obviously after Sheriff Harris had interviewed the family.

Discussing the matter with their family, the brothers decided that one of them would ride up to the cabin and interview Siebert, keeping in mind that he was now suspected of being Olsen, the murderer. Under the guise of hunting cattle, Aleck rode up to the cabin and met with the suspicious stranger. Reportedly, a long conversation was had in which Siebert admitted to have previously lived and worked in Napa County. Carver also now noted the man's similarity to the Olsen description. When he left to ride back down the mountain, he was convinced the Napa killer had been found.

The two Carver brothers and a friend named Bowen armed themselves with a pistol and two shotguns and set out to arrest Siebert at his cabin. It was around eleven o'clock the next morning when the posse found the suspect out chopping wood. After getting in position, the men called out to Siebert that he was under arrest. The startled man stopped and looked up.

"I've done nothing to be arrested for!" he answered as he reportedly raised his ax. The move was taken as being hostile and the Carver brothers both fired their shotguns at the same time. Aleck ran over and looked down on the torn and bleeding body.

"You are Peter Olsen!"

Looking up with glazing eyes, the suspect could only mutter, "I am dying." A few minutes more and he was dead.

The body was loaded on a horse and taken to a lumbering road three miles away. A wagon was obtained and Siebert taken to Bakersfield, the procession arriving late on the night of April 30. Those who examined the body agreed that it seemed to fit the description of Pete Olsen and a telegram was sent to the Napa sheriff asking that he bring someone to positively identify the body.

Sheriff Harris and a brother of the murdered woman caught the first train south and arrived the following day. A Bakersfield dispatch was published in the *San Francisco Chronicle* on May 2, 1887:

> The inquest on the remains of the supposed Olsen was commenced soon after. The local testimony as to the tragedy was the same as telegraphed, but Grigsby and Harris stated that the remains were not those of Olsen.

The inquest was held over until some of the dead man's personal effects could be summoned. While all agreed that Siebert's appearance was very close to that of Olsen, it seemed certain that the wrong man had been killed. Long letters in the Visalia *Weekly Delta* and the Bakersfield *Californian* deplored the accidental death of an innocent man, but noted the good reputation of the Carver family in the area. A letter from Siebert to a friend named Cecil told of his occupying the cabin and the planting of a potato patch. He also mentioned looking for work at Delano so as to be able to sustain himself the following year. The word had gone out all over California that Pete Olsen had been killed while resisting arrest, but now there was no doubt but that the wrong man had been shot down.

The Carver family were prominent and well known in Kern County. When the coroner's jury delivered its verdict on May 4, it closed by stating:

> ...R. M. Siebert...came to his death on the 29 day of April, 1887, in Tulare County, by gun shot wounds inflicted by the hands of Jefferson and Alexander Carver, officers of the law, while resisting arrest, all of which we duly certify...

The *Kern County Californian*, in its story of these events, mentions that the Carver boys

THE PACIFIC SLOPE.

It Was Not Pete Olsen After All.

The Wrong Man Killed Near Bakersfield.

Special Dispatches to the CHRONICLE.

BAKERSFIELD, May 1.—Sheriff Harris and A. J. Grigsby, a brother of Mrs. Lyons, arrived here this morning. The inquest on the remains of the supposed Olsen was commenced soon after. The local testimony as to the tragedy was the same as telegraphed, but Grigsby and Harris stated that the remains were not those of Olsen. The scar on the face of Olsen is not so clearly defined. His hair is thinner, his forehead lower and the bare spot on the back of the head of deceased is an indentation and the result of a wound, while in the case of Olsen it is baldness. In all other particulars the resemblance is very close.

The inquest has been adjourned until to-morrow in order to obtain a letter in the Linn's Valley postoffice addressed to M. H. Siebert, the name cut on the door of the cabin of deceased and also on a tree

Notice of the tragic shooting of Siebert in Kern County. *San Francisco Chronicle*, May 2, 1887

had been given a warrant to arrest Siebert. The question is, were they given the warrant before or after Siebert's killing?

On May 27, 1887, the *Napa Reporter* called attention to the winding down of the great manhunt throughout the state:

> Herman Lyons has returned from his long hunt after Pete Olsen, the murderer of his wife, and was in town Wednesday. Mr. Lyons still believes that Pete is in Washington Territory, or the country thereabouts, but says that the hunt for him has been very discouraging.

Herman's frustration quickly took a different turn, however. Louis Basar was still in the Napa jail as a material witness. A *San Francisco Examiner* reporter, nosing around town looking for a new angle on the Lyons murder, stopped at the jail and asked to see the prisoner. He had heard rumors that Basar had suggested he could tell more of the murder were he so disposed, and the reporter thought he would check it out. The two sat down in the cell, and the reporter learned much more than he had expected.

There had been more to the lottery story than had come out. Pete was certain he had somehow been cheated out of a winning lottery ticket and the thought festered in his mind up to the day of the murder. On that day, after Herman and Millie had left for town, Pete made several visits to a small store and saloon on the flat above the Lyons home. Pete was pretty drunk when he had returned and confided to Basar that he had been intimate with Mrs. Lyons for some time. Warming to his subject, Pete said that she had often called him into the house when her husband went to town. He was cursing the couple throughout his nasty dissertation, insisting they had stolen his lottery money.

"I told Olsen then," insisted Basar, "that I didn't believe what he was saying; that Mrs. Lyons appeared to me to be a good young woman and that I had never seen any strange men about the place as would probably be the case if she was not virtuous."

Basar had been present when Olsen had been thrown out of the house by Lyons after a bitter exchange over the lottery money. There would be a reckoning, however.

The *Examiner* doted on this type of sensational story and it was

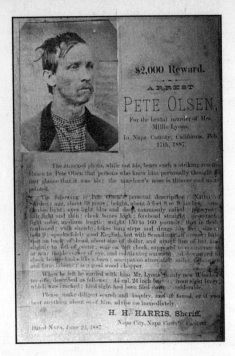

written up and published on June 1 and 2, 1887. The Grigsby and Lyons families were obviously unhappy about Basar's so-called revelations, and the local *Napa Reporter* was just as outraged. "The *San Francisco Examiner* may be enterprising," it discoursed on June 3, "—it can be of course, as it is owned by a young man whose father stands behind him with millions of money but it is lost to all sense of decency, and has sunk to the lowest depths of journalism." This was only the beginning of a long editorial against publishing such a defamatory article against a dead woman who could not defend herself. Exposing such subjects in the public prints was the real objection, however.

"One of Napa's leading physicians," noted the *Reporter*, "is of the opinion that if the *Examiner* were only printed on pink paper its apeing of the *Police Gazette* would be complete."

Few believed Olsen's drunken ramblings, but it particularly hurt Herman Lyons." Mr. Lyons felt quite indignant that Basar would relate such a story," noted the *Examiner*, "and further said that if the Savior himself vouched for the truth of the yarn he (Lyons) would not believe it. The story was mere braggadocio and contains not an atom of truth."

Sheriff Harris sent out what was probably the final reward notice on Pete Olsen in early June 1887. This gave the description and a tintype portrait which was described as that of a man who looked so much like Olsen that "persons who knew him personally thought at first glance that it was his."

Basar's revelations added yet another facet to the terrible aura that seemed to hover about the murder case. The escape of the

killer, the long, expensive, and fruitless statewide pursuit, the needless shooting and death of Siebert, and now the cruel accusations against the dead woman all combined to make the public weary of a tale that seemed to have no end. As the years passed by, no one claimed the reward for Pete Olsen. And, as memories faded, in time it was forgotten.

It was a few years later that rancher W. H. Samuels was deer hunting along the ridge of Rag Canyon, near Wooden Valley. His dog had plunged ahead of him into the canyon, hoping to surprise a buck for his master. As Samuels was picking his way through the brush and trees, the hound began baying in the distance. Soon the dog came running toward him with some object in his teeth. As Samuels swung down off his horse, he quickly saw the dog was holding a human skull. Thinking the skull might be meaningful to the sheriff, Samuels sent it to Napa, then forgot about it.

Frank Grigsby, the man who killed Pete Olsen? *San Francisco Examiner,* February 14, 1897

On a visit to see Sheriff Harris, Kellis Grigsby happened to see the skull in his office and asked about it. When Harris told him where it was found, Grigsby blurted out, "That's Pete Olsen's skull! I know it by that ugly tooth." An upper eye tooth was the only tooth left and the lower jaw was missing. A young girl with Grigsby also recognized the skull.

"Why, that's Pete. That's his big tooth."

The sheriff and other locals agreed that the skull was probably Pete's, but there was no definite proof. Then some years later, in February 1897, Bush Oliver broke the long silence and told his story. It was Bush, Ben Capell, and Frank Grigsby who were returning from a deer hunt at the time of Millie Lyons's murder.

The trio had immediately joined the manhunt for

The skull identified by many as that of Pete Olsen. It was given to the San Francisco *Examiner* by the Napa County sheriff in 1897. San Francisco *Examiner,* February 14, 1897

Olsen. All were familiar with the country and were expert trackers. They speculated that Olsen would have to pass through Cherry Valley and the head of Rag Canyon on his route out of the area. Positioning themselves some distance apart, the three men were confident that if Olsen passed that way, they would see him.

It was just becoming light when Oliver and Capell heard sixteen shots in the area where Frank Grigsby had been stationed. Oliver was closest and he rushed down to see what the shooting was about. Grigsby was just coming down the side of a canyon and commented that "they might as well go home." Nothing was said of the shooting.

Bush Oliver later told an *Examiner* reporter that he had ridden back to the spot a few days later and saw buzzards circling. He did not look too closely, however. He did not want to know at what Frank Grigsby had been shooting that early morning.

So far as is known, none of the three hunters ever elaborated on those shots that were fired some sixteen hours after Millie Lyons's murder. With $2,000 in rewards being offered, the question is—why? Could it be that the many false leads, close calls and the memory of the Siebert death still haunted their dreams? Odds are that we will never know.

CHAPTER 4 SOURCES

Gregory, Tom. *History of Solano and Napa Counties*. Los Angeles: Historic Record Company, 1912.

Hunt, Marguerite, and Harry L. Gunn. *History of Solano County and Napa County*, Vol. I. Chicago: The S. J. Clarke Publishing Co., 1926.

Smith, Clarence, and Wallace W. Elliott. *Illustrations of Napa County, California*. Oakland: Smith & Elliott, 1878.

Bakersfield *Weekly Californian*, May 7, 1887.

Fresno *Weekly Republican*, February 25, 1887.

Independant Calistogan, February 23, 1887.

Merced *San Joaquin Valley Argus*, April 9, 1887.

Napa *Daily Journal*, February 16, 1887.

Napa *County Reporter*, February 25, March 4, 11, April 8, May 27, June 3, 1887.

San Francisco *Daily Morning Call*, February 18, 19, 20, 22, 24, 1887.

San Francisco *Chronicle*, May 1, 2, 1887.

San Francisco *Examiner*, April 8, 18, May 10, June 1, 2, 3, 1887; February 14, 1897.

Ventura Free Press, April 18, May 6, 1887.

Visalia *Weekly Delta*, April 21, May 5, 12, 1887.

Carver Family Genealogy. Courtesy Jeff Edwards, Porterville.

George Yount Cemetery Inscription Book. Napa County Genealogical Society.

Marriage Certificate of Herman Lyons and Millie Grigsby, Napa County, California, January 7, 1885. Napa County Recorders Office.

Reward Notice, "Pete Olsen," February 17, 1887. John Boessenecker Collection.

1880 and 1910 United States Federal Census, Napa County, California.

1880 United States Federal Census, Tulare County, California.

Chapter 5

In Some Circumstances, Fast Draws Just Don't Matter!

As the long line of people shuffled past the casket, several of the mourners glanced around uneasily as if searching for something. There were all types of people there, from all walks of life: bankers, farmers, clerks, teamsters, and housewives. Lawyer Henry T. Gage, later governor of California, was there, as well as many other prominent citizens of Los Angeles.

Gradually, it became obvious what was wrong; there were few tears. While a scattering of old-timers were seen to have glistening eyes, no one was dabbing at their eyes or sobbing. Some of the mourners even seemed to be trying to disguise a faint smile.

Although many of the people in line had never known Joe Dye, everyone knew *of* him. He was a legendary figure in Los Angeles and Ventura counties and he had attracted attention and prompted questions everywhere he went. Some would ask, "Wasn't Dye a killer?" "He killed some," would be the reply, "but mostly when he was a lawman." "I thought he was in the oil business." "He was, but he was also a miner." "Some said he was a rich farmer and also ran cattle on the Sespe ranch that he owned." Many recalled that he was just a bully who pushed, punched, and plugged anyone who denied him his own way in all matters.

To those curious enough to ask, "Why did Joe Dye die?"—that was quite a story.

Joe Dye provided little information on his past to friends, but his humble frontier beginnings were typical of the time. His father,

Above:
An 1880s Ventura County farm in Joe
Dye's time. *California State Library*

Benjamin Dye, was born in either 1792 or '93. He married Sarah "Sally" Cazier (sometimes Cozear) on May 15, 1815 in Wood County, Virginia, when Sally was about seventeen. The following year their first child, Jane, was born. At the time of the 1820 census, there were several more children, including a young boy named William Dye who was thirteen at this time. It is not known if he was illegitimate, or an adopted orphan of a relative.

Benjamin was a farmer and his household continued to grow. Big families were the rule in those days, not only because infant mortality was so high, but because offspring meant more workers to help on the farm. There was a good deal of immigration at this time, mostly because of cheap land. Taxes were high on the East Coast and property sold in Virginia could buy much more land in the new territories. A daughter had died by the time Benjamin decided to move west with his family. Whether their route was by the Ohio River or through the Cumberland Gap is not known. By 1831, the family included five boys and three girls. They were living in Union County in western Kentucky on the Ohio River. Here, Benjamin farmed seventy-five acres on two land grants he had acquired.

An early Kentucky cabin of the period when the Dye family sojourned there.
Author's Collection

It was this same year that Joseph Franklin was born to what eventually became a brood of sixteen. There were nine girls and seven boys, but four of the siblings died in Kentucky.

Sometime during this period the family moved again, this time to Oldham County, Kentucky, some miles to the east, but still on the Ohio River. Daughter Adelaide was born in 1839, joining sisters Miranda, Ennis, and Sarah and brothers Joe, Enoch, Ben, William, and twelve year-old George.

The elder Dye was still not satisfied with his location. Things had not worked out in Kentucky, but he could not make up his mind just where to go next. Finally, he decided to return to Virginia, but was surprised when his boys objected to moving again and refused to go. This was the state of affairs in the autumn of 1847 when the family had a surprise visitor. In her later years young Adelaide— "Addie" as she was called—had a vivid memory of those frontier days:

Adelaide Dye McDermett, one of Joe Dye's sisters.
Author's Collection

> My father, Benjamin Dye was on the eve of going back to Virginia, when his brother Amos Dye, returned from the Mexican War, having served in General Taylor's command. On his way home Uncle Amos had traversed Texas, which he told father was a paradise, where the settler at the head of a family received a grant of 640 acres, and a single man a grant of 320 acres. But this liberal offer held good, he added, only until January 1, 1848. Father at once assembled my brothers, who had already refused to go back to Virginia with him, and asked if they were willing to accompany him to Texas, laying before them the inducements. They accepted the proposition with enthusiasm, and as there was no time to be lost they at once set about preparations for the journey. Father sold at auction everything he could not bring with him. I remember the auction took place in the midst of a blinding snowstorm, the like of which I have never seen since.

Taking what property they could with them, the family made their way to Louisville, where they boarded a steamboat on November 28, 1847. The long trip downriver must have been boring, with little to pass the time but watch the waterfront scenery. From New Orleans, the family proceeded to Shreveport, a small but lively supply village. A single man named Daniel Sage is known to have accompanied the Dye family to Texas and he perhaps influenced their acquisition of 640 acres in the area where a settlement had been made on the Trinity River.

The elder Dye purchased a wagon and horses in Shreveport, then stocked it with "sugar, coffee, cheese, bacon and flour." The

family was some two weeks on the trail, reaching the small settlement in Dallas County on December 28, 1847. The Dye boys who were twenty-one or older each filed on and received 320 acres in and around the scraggly village on the Trinity. Addie Dye recalled:

> Texas was a beautiful country in early days. It must have rained more then than it ever has since. The trees were greener and more vigorous, and the prairies were covered with a great variety of the most brilliant flowers from which the wild bees made barrels of honey, which was to be found in every tree and rock that had a hole in it. The very finest dewberries and grapes grew wild.

Martha Dye Beeman and her husband. *Author's Collection*

There was a collection of cabins at the Trinity River settlement, now being called Dallas. The Dye property was a few miles away and they soon had built a cabin for the winter. "We didn't dress as fine back in the forties as the present inhabitants of Dallas do," recalled William Beeman, one of the early settlers. "Deer skins were plentiful and I've dressed many. We made nearly all men's and boys' clothing out of buckskin, sewed with deer sinews. We wore coats, pants and leggings of buckskin. Also made moccasins of it for footwear."

Sixteen year-old Joe and his brothers all aided in the work while their sisters helped out around the house. When the great California Gold Rush thrilled the country in early 1849, the Dye family was affected also, as Addie recalled:

> A number of Dallas men joined the rush to the gold fields, among them three of my brothers, Joe, Benjamin and Enoch. The southern route to the coast lay through the Arizona deserts, and the Argonauts going that way underwent incredible hardships. I remember my brothers reported that they almost perished for water, and that the trail was blazed with the bones of horses, mules and oxen.

The California mines were apparently disappointing for the Dye brothers; the 1850 Dallas County census showed five boys and four girls still at home, with Joe, Ben, and Enoch back among them.

There was a small settlement of cabins at nearby Long Creek. The Bethany Missionary Baptist Church, one of the first in the county, listed several of the Dye family as members. The growing village of Dallas was host to the marriage of Martha Eunice Dye to William Beeman on September 15, 1851. Beeman was a brother-in-law to John Neely Bryan, who had founded the town. The couple were to have twelve children.

When the elder Dye passed away in July 1852, the boys were all old enough to keep up the farm. Two of them, William and Benjamin Jr., never married and may have still been at the old farm when their mother died in 1879.

Perhaps the father had been his anchor, but in 1853 the twenty-two-year-old Joe left the family farm and headed west. He probably didn't know where he was going or what he was going to do, but he had farmed, worked stock, and driven teams. There would be plenty of work in the new country he wanted to see.

"Yes," recalled an old-timer at Dye's funeral, "I knew Joe before he struck California. We were in Santa Fe in 1852 [53]. Joe was teaming and I was a laborer doing work for a mining concern. In those days Dye was full of fun; fond of a practical joke and a good shot." The speaker, a tall, raw-boned man, continued:

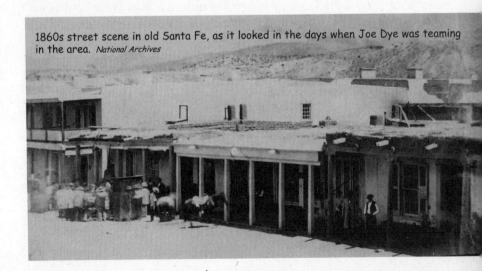

1860s street scene in old Santa Fe, as it looked in the days when Joe Dye was teaming in the area. *National Archives*

Well, as I said, Joe liked to joke. In our camp was a hard character that we called on the quiet "Hand Saw Pete." His name was Peter Fantig, and he came from a Georgia family of bad repute. We called him "Hand Saw" because he killed a man by cutting him to pieces with a saw. This fellow and Dye got into a dispute over a game of Old Sledge and came to blows. Both were unarmed at the time. Pete told Dye that if he did not take back what he had said about cheating at cards he would plant him on the hillside. Dye left the room and did not see Pete till next day. "How are you fixed?" said Dye. Pete said he had no gun with him, but would get one. "You have threatened to kill me, Pete, and we might as well have it out one time as another. Here are two guns, take your choice," at the same time offering him two navy sixshooters. Pete was a coward at heart, but he saw he had to fight or be branded as a cur dog. He took his pick, and the two men agreed to walk around the adobe hotel in opposite directions and fire when they got in sight of each other. This they did do. Pete was hit in the neck. His ball went through Dye's hat. Pete fell and it was thought he would die, but he was too mean for that. He recovered and went to Salt Lake, and was killed by a Montana gambler. That's why I say Dye was no coward and liked to see fair play, even in a fight.

We can assume Dye teamed throughout the Southwest for the next few years, making his way to California sometime in the 1860s. Joe considered himself a Southerner and in the 1870 Los Angeles census listed his birthplace as Missouri, even though he had been born in Kentucky, a border state. His temperament and Confederate sympathies would have made him a prime candidate for the Mason Henry gang that ravaged the San Joaquin Valley in the mid 1860s.

Despite the election of Republican Leland Stanford as governor in 1861, California was a hotbed of Southern sympathizers during the Civil War. Some newspapers were outspoken in their loyalty to the South and rebel victories were noisily celebrated in Los Angeles, Visalia, Santa Clara, and San Francisco saloons. Radical Southern editors were threatened with either taking a loyalty oath or going to the federal prison on Alcatraz Island.

The serious concerns of the state and federal authorities were

given validity by an 1863 attempt to arm and equip a rebel ship at a San Francisco wharf. The plan was to raid the coastal shipping that was carrying California gold to the East. It was nipped in the bud, however, by alert federal officials and local police. The following year a bullion-carrying stagecoach was robbed by bandits calling themselves Confederate cavalry.

On top of all this, in early 1864, a rebel sympathizer named George G. Belt organized a group of Confederate guerrillas at his ranch on the Merced River. A former alcalde at Stockton, Belt equipped a half dozen men and sent them out to recruit more members and pillage the countryside. The nucleus of the group were two men named John Mason and Jim Henry. Whether Judge Belt knew, or cared, that both men were dangerous criminals is not known. All were rabid secessionists and that was all that mattered.

John Mason was a former stage hostler who had reportedly killed several men in altercations. Jim Henry's real name was Tom McCauley. In 1857, he and his brother Ed were thugs living in Tuolumne County where they murdered a young Shaw's Flat miner. Ed was hanged and although Tom was sent to state prison, he was pardoned in 1861. Using the name Jackson, Tom joined a gang of robbers operating along the Fresno River. When Al Dixon and several others were captured and lynched by vigilantes, the gang was effectively broken up. Tom McCauley now reappeared as Jim Henry.

> MORE DEPREDATIONS BY DESPERADOES
> A private letter from Millerton, of Nov. 16th states that news had just come to that place by a Chinaman, that Jackson, one of the villains who murdered Anderson, Heathorn and Robinson, had with three others robbed every Chinaman on the Chowchilla two nights previous to that date. Sheriff Ashman, with two men, was out in pursuit of the party

The "Jackson" referred to here is also the "Henry" of infamous record.
Mariposa Free Press, November 26, 1864

In the spring of 1864, Mason and Henry's gang rode over to Santa Clara County to recruit more members, but were unsuccessful. A drought year and increasingly bad war news lost them most of their men and they returned to the San Joaquin Valley. After a series of vicious murders and robberies, and many narrow escapes from posses and detachments of soldiers, the gang sought refuge in the mountains and deserts of Southern California.

Telegram urging a reward be offered for three murders committed by Mason and Henry.
California State Archives

Although estimates of the number of gang members ranged from sixteen to as few as four or five, the truth is that members would come and go. Some quietly disappeared with the advent of continual bad news on the war. Others probably left when it became obvious that the war had nothing to do with the brutal crimes of Mason and Henry. The *Visalia Delta* voiced editorially what was obvious now even to Southern sympathizers:

> The suggestion that the assassins were governed by any political motives or objects is totally without foundation. Whatever other motives the assassins may have ostentatiously and industriously assigned, there can be no doubt that their prime object was plunder.

Most membership in the gang was so fleeting that positively identified gang members are only two: Tom Hawkins and one John Rogers. Various newspaper dispatches, however, mention two Mexican gang members, as well as a man named Pierce, alias Hall. "Old man Kelsey and several of his sons" were also identified in the *Visalia Delta*, April 17, 1865, as being members. This apparently refers to Missourians Ben and Nancy Kelsey's large family. A man named "Overton" is mentioned as being a late member of the group.

Robert Glenn, a pioneer of Tehachapi, was living with his father on Lytle Creek in the 1860s. Glenn told historian Frank Latta that his father was acquainted with Mason and Henry and the elder Glenn had little choice but to give them shelter when they stopped at his ranch. Years later Robert Glenn told Latta that he had known two of the gang. "One of these was a little fellow by the name of Rogers," stated Glenn, "and the other was Joe Dye, who was later killed in Los Angeles. Mason told me that he was going to kill both of these men, but he was never able to do so." According to Glenn, Dye and Rogers were pals.

There is no reason to doubt Glenn's story. Dye had probably joined the gang during one of their Southern California sojourns and perhaps quickly figured out that their days were numbered. When he left, he earned the hatred of Mason. It all makes sense.

There had been numerous murders and robberies attributed to Mason and Henry by now and a reward of $2,500 was on their heads. In late summer 1865, the two gang leaders split up. For a time Henry and several followers roamed the San Bernardino Mountains looking for opportunities for plunder. Setting up a camp one day in mid-September, Henry sent John Rogers to town for ammunition and supplies. Unable to pass up the first saloon he encountered, Rogers began slaking his thirst and soon was blabbering drunk. When he announced his association with the famous Mason and Henry gang, Sheriff Benjamin F. Mathews was quickly informed and a posse was assembled. The Los Angeles *Tri-Weekly News* reported what happened next:

> San Bernardino, September 16th, 1865. Day before yesterday morning, about daylight, our sheriff, with a posse of three soldiers and two or three citizens, ran across the notorious Henry, of Mason and Henry notoriety, and after making some resistance he was killed by them. They found him about twenty-five miles from this place, near Santa Jacinto Canyon, and when discovered he was sound asleep.
>
> The posse kept as still as possible, but their noise awoke him, when he jumped up, drew a revolver, and resisted to the last, firing three times and wounding one man in the foot. But the shot

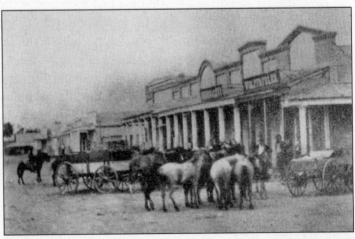

San Bernardino in the days of Mason and Henry when the latter's bullet-riddled body was displayed and photographed in the town.
Author's Collection

and balls soon brought him down, covered with wounds, and he died immediately without saying a word.

Henry's body, now somewhat heavier with the addition of some fifty-seven bullets, was brought to town and photographed for identification purposes. When he heard the news, Mason is said to have ridden furiously to San Bernardino where he reportedly dressed as a woman prior to viewing the body. But his race was run, also. In April 1866, John Mason was killed by Ben Mayfield in a personal gunfight in Tejon Canyon. John Rogers was sent to San Quentin for

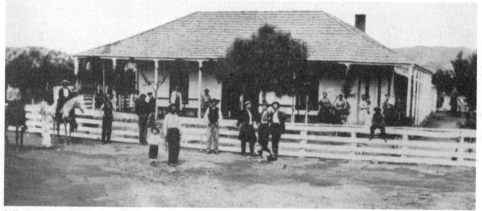

Billy Rubottom's home and hotel on the San Bernardino road to Los Angeles. Rubottom and his son stand in the foreground. Joe Dye stands with two others next to the fence, although it is not clear which figure is Joe. *Pomona Valley Historical Society*

five years on a grand larceny charge and Joe Dye could now rest easy.

There were many secessionists in the area, but probably no one knew of Dye's connection to the Mason-Henry gang, although his Southern sympathies were known. But if his life had made a wrong turn, Joe had a penchant for making friends that was to stand him in good stead throughout his life.

Indications are that Joe was appointed a temporary lawman, as he was a friend of Billy Rubottom, a deputy sheriff stationed in El Monte. In February 1866, two brothers stole a wagon and some horses from a local ranch. Rubottom, a rancher, hotel, and stage-stop owner, may have been too busy (and old) to want to chase a couple of thieves across the bleak Mojave Desert. Instead, he deputized Dye to do the

This is the territory west of Camp Cady where Dye pursued the two horse thieves. It was hot, miserable country, even in winter time. *Courtesy Dennis G. Casebier*

job. Joe's title of "special" deputy, as mentioned in a newspaper account, would seem to indicate this was the case.

Two brothers, John and James Kincaid, stole a wagon and six horses from the Santa Gertrudes ranch of former Governor John G. Downey. The theft had occurred while Downey and his family were on a visit to Los Angeles. It was eight days after the theft before Joe was able to take the trail, following the tracks across the desert toward Salt Lake City. At Camp Cady, an isolated army post, Joe was able to get fresh horses, provisions, a soldier escort, and a guide. He caught up with the thieves at the border and easily captured the brothers and Downey's worn-out animals. The *Los Angeles News* reported:

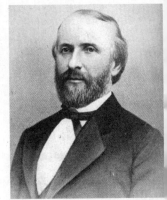

> Mr. Dye returns thanks to the military for their prompt and effectual assistance in the matter. Too much cannot be said of the energy displayed in bringing these offenders to justice; they are now securely lodged in jail, where they remain to await the action of the Grand Jury.

Governor, rancher, businessman, John G. Downey. *Author's Collection*

Joe was making a reputation for himself. He was obviously a man who accomplished what he set out to do. Although no record appeared in the press, Governor Downey, also a Southerner, probably gave Joe a reward for the return of his property, as was the custom of the time. Joe had also impressed various civic authorities. In November, the Los Angeles Common Council passed a resolution "signed by the mayor appointing J. F. Dye a special police (officer) to be paid by the citizens of certain localities."

Dye's boss was one William C. Warren, who had been elected

city marshal in 1865. A good-looking, bearded man, Warren was a thirty-four-year-old Michigan native who had arrived on the West Coast in 1858. He was a deputy city marshal in 1860 when he married Juana Lopez. By 1870 the couple had three young daughters, the youngest being six months old. Warren was tough as nails and proved it time and again in personal encounters with hardcases.

The marshal instructed the new officer as to his duties, explaining that property owners in Chinatown would be paying his salary, but in all other respects he was a regular city police officer. Enforcing the law in town was a primary consideration, but making sure fire-fighting materials were always available, serving writs and warrants, collecting city taxes and license fees, and locating trial witnesses were also important.

Joe's duty locale, the Los Angeles Chinatown, was a cluster of adobes and frame shacks lining each side of a street known as Calle de los Negros. Called "Nigger Alley" at the time, this was not an intolerant reference to black people, but was a name dating to the early days when dark-skinned local Indians frequented the area. The *Los Angeles Daily News* had a particularly dim view of Joe Dye's district:

> Located almost in the heart of the business portion of the city, leading from Los Angeles street to the corner of the Plaza, this street has become to Los Angeles what the Five Points was to New York. It is the chosen abode of the pariahs of society. The low adobe buildings are simply hives to hold swarms of social outcasts. Here the copper colored Indian, the ebony African, yellow Mongol and degraded Caucasian, herd together within the buildings, herded like beasts, men, women and children, male and female, dwell to-

The notorious Calle de los Negros in old Los Angeles.
Sven Crongeyer

gether ignoring all distinction of sex, and filthy to a degree absolutely appalling. Here crimes too horrible to name are undoubtedly matters of ordinary and perhaps daily or nightly occurrence. After nightfall the day sleepers rouse themselves; the hum of voices is heard, glasses clink, and the sounds of rude revelry break forth to vex the air, and disturb all adjacent dwellers. One by one the "night birds" slink forth upon their missions of crime.

Although the account seems somewhat overwrought, a reading of news items in the local press verifies the description. At this time it was a wide-open part of town where gambling halls, saloons, and bordellos flourished. Apparently a policeman was just what Chinatown needed, since Joe's tenure was as peaceful as could be expected.

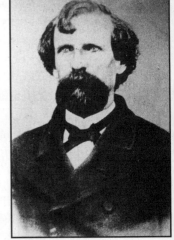

In mid-April 1867, Dye arrested a Chinese merchant accused of manufacturing cigars without a federal license. His shop was in a cellar with a "cunningly devised trap door that the highest order of detective talent was necessary in order to discover the whereabouts of his *sub rosa* factory," noted the local press.

Dye arrested another Chinese man for passing counterfeit money in January 1869. When the suspect was brought before a local justice court, however, he admitted to passing the money, but argued that he did not know it

Joe Dye as he appeared about the time of the Warren shooting. *Los Angeles County Museum*

was counterfeit. Upon making restitution to the victim, the Chinese man was discharged, with Justice Gray stating that there was now no evidence on which to convict him.

If anyone doubted that Joe knew his business, an article in the *Daily News* the following month dispelled all such notions:

> Arrested—Marshal Warren having been informed of the attempt which was made to rob the room of Mr. O. M. Potter, of which we made mention yesterday, detailed Joe Dye to hunt up and arrest the thief if he was in the city. Half an hour afterwards he was safely lodged in jail, Mr. Dye having had no difficulty in finding him.

This same month Marshal Warren had a dangerous encounter with one Miguel Soto, who was threatening to shoot Oliver Stearns for having property claimed by Soto. Drawing his own revolver, Warren identified himself to Soto and ordered him to drop his weapon. When Soto turned toward the marshal, Warren was too quick for him and he forced the badman to drop his pistol. "Soto is a well known desperate character," reported the *Los Angeles Star*, "and his arrest was made only at the risk of the life of the marshal."

In late July, Dye investigated a burglary of the Rinaldi & Company shop on Commercial Street. The *Daily News* reported:

> All of the stolen property was recovered by Mr. Dye, and we need not be surprised if, during the next few days, he succeeds in capturing the remaining two persons who were engaged in that little speculation. Evil doers are not known to flourish much in Mr. Dye's vicinity.

Late one night in early February 1870, Joe was called to Billy Rapp's saloon on Commercial Street. The owner, after seizing a burglar in his place about midnight, blew his whistle for an officer. Officer Dye lived just a few doors down the street and was promptly on the scene. Louis Meyer, the burglar, was hauled before Justice Gray the next morning.

Joe was married at this time, or living with, a twenty-one-year-old Mexican girl named Francisca. She was a native Californian, but details of the union are unknown.

Sometime during the early spring of 1870, Marshal Warren and Dye had a disagreement. Tradition, and the memory of Warren's grandson, has it that Warren was considering adding a new deputy to his staff and wanted to hire one Jack Rhodes, a former Union soldier. Dye knew that Warren was also a strong Union man during the war. When Joe disagreed with the appointment, Warren walked away. He was the boss and that's the way it was. Later, Warren's grandson, a long-term Los Angeles County sheriff named Eugene Biscailuz, remarked, "It's unfortunate that people here couldn't have settled their Civil War animosities a lot earlier." But that was not Dye's style. He just glowered and never forgot.

In late summer, a Chinese woman named Sing Yu was kid-

napped from her master in Negro Alley, along with an assortment of "coin, greenbacks and jewelry to the value of seven or eight hundred dollars." Whether the woman had been sold to the man from whom she was abducted or it was some other arrangement, a $100 reward was offered for the return of the woman and the stolen property. Joe and fellow officers Hamilton and Dobson, suspected who the kidnapper was and were hot on his trail when Marshal Warren and Constable Sam Bryant were tipped off to where the woman was being hidden and picked her up. The *Daily News* suggested the tip had come from the abductor himself. "If it did, the public would like to know how much of the reward he got for informing on himself." Joe Dye fumed that his boss had spit in his eye once again.

Earlier that same morning, Constable Bryant caught some local thugs throwing rocks into a Chinese house in Negro Alley. The officer chased the men, while blowing his whistle for assistance. He chased his quarry down several streets off the Plaza and when Joe

A beautiful Chinese girl of early Los Angeles. *Los Angeles County Library*

ran to his aid they were able to arrest at least one of the culprits and deposit him in the city jail. Several weeks later, Dye and Officer Hamilton came to the aid of policemen Jesus Bilderain and Sanchez. The two officers had arrested six troublesome drunks and were herding them to jail when the rioters turned on them. With the reinforcement of Dye and Hamilton, the officers were able to subdue their captives and throw them into jail to await the justice court in the morning.

In October, there was another Chinatown kidnapping. On November 1, 1870, the *Los Angeles Star* reported "Sing Lo, the China woman about three weeks ago almost broke the heart and pocket of her owner, Ah Jo, by absconding from the classic precincts of Negro Alley with another Chinaman and a lot of valuable jewelry." Acting on a tip, Marshal Warren and Constable Jose Redona caught the first stage for San Buenaventura (now Ventura), just south of Santa Barbara. Apparently Sing Lo had relatives on the coast. Joe Dye had been tipped off, also, and he had

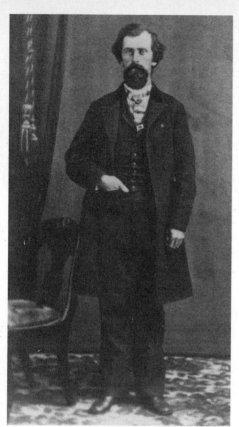

Marshal William Warren as he appeared about the time of his shootout with Joe Dye.
John Boessenecker Collection

telegraphed ahead with a bench warrant. When Warren and Redona got off the stage in Buenaventura, Sing Lo had already been detained by the town marshal. The two officers and their prisoner caught the next stage for Los Angeles.

On October 31, 1870, Sing Lo was escorted into Judge Thomas Trafford's court by Warren and Redona. The presence of the two men was necessary since two rival Chinese Tongs were involved in a squabble over the woman and a war might break out at any moment. Joe Dye was in court at the time and he stared hard at his superior when Warren applied for the $100 reward for the return of the fugitive. His boss had beaten him out of the previous reward and he would not stand for it again. As Warren turned around, he caught the eye of Joe Dye, but the marshal kept moving. He had seen death in those cold, grey eyes.

Walking across Temple Street, Warren heard Dye call his name several times. He was in the middle of the street when he stopped and turned to face his deputy. Warren had already palmed his derringer and held it behind his back.

"How do you intend to get the money?" asked an infuriated Dye.

"I don't want anything to do with you, Joe. Get away from me."

"Do you suppose I am going to be swindled out of my money that way?" shot back Dye. His face was contorted and he had obviously worked himself into a frenzy, worrying about not getting a share of the reward. "Sir, you have robbed me of that money!"

"You're a liar, " Warren yelled, "I've never robbed anybody out of money!" At the same instant the marshal swiftly brought his derringer in view and fired at Dye's head. Joe was able to dodge just enough so that the shot barely grazed his face. The two men were about five feet apart.

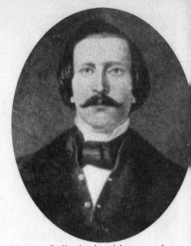

Dye was holding a walking stick at the time, but dropped it and went for the pistol holstered at his hip. Both men drew their six-shooters now and the firing became general. Constable Redona tried to interfere and was shot in the arm. Another constable was

Horace Bell, the local lawyer who helped stop the Warren-Dye shootout. *Author's Collection*

shot in the hand during the powder-shrouded melee. Groups of Chinese had been outside the courtroom and one of them now dropped with a bullet in the jaw.

Horace Bell, a local lawyer, was talking to Judge Trafford in his office when the shooting started. He rushed out the door, and later he recalled what happened next:

> I saw Warren and the man I supposed to be Dye, rapidly firing at each other—the two were facing each other about the middle of the street. The two shots that were fired when the parties were in this position, seemed to be almost simultaneous. At the same instant the man I took to be Mr. Dye, made a quick movement to the left, and at the same time that he made this movement, Warren fell, with the exclamation, "I am killed!" Warren was facing me and seemed to be endeavoring to raise his pistol towards me; and Dye fired another shot in that position, and then moved to the right, some fifteen feet in which he delivered the last shot. Dye then raised his pistol, and I made a dash at him and caught him by the hair with my left hand, and tried to seize his pistol with my right. —he broke loose from me and rushed at Warren with his pistol raised up, and struck at Warren, and struck him on the head. At this time other parties interposed. Dye seemed to loose the grip of his pistol, and seized Warren with both hands, drew him up to him, and took hold of him with his teeth. I then seized Dye by the throat—others came to my assistance.

If anyone had ever doubted the courage and ferocity of Joe Dye, they were true believers now. When his pistol was empty, Dye had rushed at Warren and, lifting him by his coat, bitten a chunk out of his ear! All the stories, the tall tales, the fear and legends of Joe Dye began this day in the middle of Temple Street in old Los Angeles.

Dye was now led away limping with the blood streaming from his grazed forehead and another wound in his thigh. Physicians John S. Griffin and Joseph P. Widney attended him in his rooms, aided by Mrs. Dye. The mortally wounded marshal was taken to a nearby paint shop where he was attended by the same two physicians and later taken home. Both newspapers gave long accounts of the incident. "The affair has created no little excitement," commented the *News*. "Both parties have large numbers of warm friends, and much feeling is naturally exhibited.

Marshal Warren's home where the physicians tried to save his life. *From an old newspaper print in Author's Collection*

The examination today will develop all the facts in the case, when all will be able to judge its merits."

Actually, the *News* had pretty much made up its mind. Highly critical of Marshal Warren for political reasons, the *News* printed a long column of prosecution testimony, all of which identified Warren as firing the first shot. "A clearer case of self-defense is rarely presented," reported the newspaper. Joe was released on $2,000 bail to await the hearing before the next grand jury early the following year.

Meanwhile, William Warren died and was buried on the afternoon of November 2, 1870. Services were

Shooting Affray Between City Marshal Warren and Policeman Dye---Both Parties Wounded---One, Probably Fatally---Three Others Wounded.

Yesterday afternoon our citizens were startled at the sound of rapid shooting on Temple street, and soon it passed from mouth to mouth that Marshal Warren and Policeman Dye had been engaged in an affray. Dame Rumor circulated the wildest tales, and much excitement prevailed. An eye witness furnished the NEWS reporter with the following

ACCOUNT OF THE COMBAT!

Both parties had been in Justice Trafford's Court, in connection with a grand larceny case elsewhere reported, in which a Chinawoman was involved. Passing outside the Court room there arose a dispute concerning the credit due for the capture of the alleged thief, it seeming that Police-

Portion of a newspaper account of the Warren-Dye shootout. *Los Angeles Express,* November 1, 1870

held at the Catholic church and the procession was one of the longest ever witnessed in the city.

Joe Dye was out on bail and back on duty, at least until the election on December 5. Sent to San Bernardino in search of a Chinese horse thief by acting marshal Frank Baker, Joe found the thief with little trouble. A local Tong had tried to get the prisoner released on a habeus corpus writ, but a judge ordered the thief returned to Joe. A brief item in the *News* chronicled Joe's return home:

Dr. Joseph P. Widney, one of the physicians who tended Dye and Warren after the shootout. *Author's Collection*

Antelope Killed—Yesterday, the San Bernardino stage was traversing the distance between San Bernardino and the Cucamonga Rancho, a herd of antelope numbering twenty or more came within 150 yards of the stage. Officer Dye, of this city, who was riding outside could not resist the temptation, and blazed away with one barrel of his shotgun. The dead antelope, a splendid animal, may be seen at a local market.

A farmer named Michel Lachenais had murdered a neighbor in a water dispute and escaped detection. When the killer's drunken comments led to suspicions that he was the killer, Lachenais was seized and thrown into jail. For a long time the *Los Angeles News* had complained about the crime rate and the fact that killers were almost always allowed to escape punishment. "No man can be con-

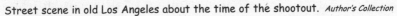

Street scene in old Los Angeles about the time of the shootout. *Author's Collection*

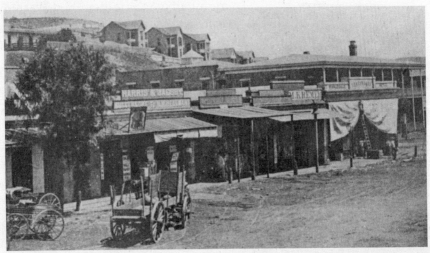

victed of murder in Los Angeles," wailed the *News*. "The result of some fifteen indictments during the past year, go far to justify the popular idea in that regard."

A typical case had gone to trial in the district court on November 18, 1870. Cyrus Sanford was accused of killing Enoch L. Barnes, but it was announced that the prosecution needed a ten-day continuance since the principal witness had disappeared. The defendant's counsel announced that the witness had been offered money some time ago to absent herself from the trial. Other witnesses had vanished, also.

The *Los Angeles Star* announced during this same period that a vigilance committee had been formed. There was in the *Star*, suggested the *News*, "a faint intimation that such action on the part of the people would become necessary." With fifteen killers turned loose in the past year, it certainly appeared that the local legal system needed repair of some kind.

Joe had become a poster boy for the local law and order tug-of-war. While the *Los Angeles Daily News* was very much in his corner because of its Southern leanings, the vigilantes were threatening to hang him as an example of one of the badmen and gunmen who had given the town such a tough name. That he was now considered something of a bad apple is reflected in the card from city marshal candidate H. M. Johnston published in the *News* of December 4, 1870:

Ed. News:—Sir, the report that if elected City Marshal, I would appoint Mr. J. F. Dye to the position of Deputy Marshal, having been circulated and having made no compromises or promises on that subject, I desire to say to the public through your columns, that there is not one word of truth in the report, and that its author is a willful falsifier, and has placed a falsehood in circulation from dishonest political motives. Mr. Frank Baker, who is a candidate for City Marshal, knows the report to be false, and in justice to me will deny the same wherever he hears it.

H. M. Johnston

Joe knew he was out of a job now. Johnston was not going to keep him on; he had killed the former marshal! Frank Baker was

keeping quiet, but he was running for full-time marshal, also, and Dye was too much of a hot potato to have around.

The Dye trial had been postponed on February 18, 1871, when the jurors failed to show up. When summoned again on February 20, the jurors finally made an appearance. Dye's two legal representatives were an attorney named Frank Ganahl and E. J.C. Kewen, a fire-eating Southerner and a noted orator. Questioning by the Dye attorneys brought out that one of the jurors had expressed himself as being in sympathy with the local vigilance committee. Such a man

Edward J. C. Kewen, a fiery Southerner, was Joe's lawyer. *Author's Collection*

could not serve on a jury, argued Ganahl, since he was clearly in sympathy with murder. The district attorney did not agree, but the court, after castigating the vigilantes, decided that the juror could not be excluded.

Kewen now challenged the juror, a man named Kuchland, for bias, stating the vigilance committee had threatened the life of the defendant and this was the same as the juror threatening his life. Three men appointed to decide if the man was biased or not concluded that he was, and Kuchland was dismissed from the jury. The case was scheduled for the following morning.

The trial commenced at 10:30 and followed the same procedures as the preliminary hearing. A series of the same witnesses repeated the same testimony and little in the way of new information was offered. After printing a long column of testimony, the *Daily News* gave a brief summary of the results:

> District Court—A jury was completed early in the forenoon, and, after hearing the evidence for the prosecution, none having been introduced for the defense, the jury acquitted from the box, and the defendant was discharged.

So that was it! Dye was acquitted without even putting up a defense. Moreover, he was cleared solely on the prosecution's case. And why not? All the eye-witnesses had testified that Warren had

fired first. Joe was happy. Others were not. In a letter to the *Los Angeles Star*, the widow Warren reflected the disappointment of many in the community:

> If the only object of a legal investigation is to seek for all the facts in the case, so as to meet the ends of justice, I should like to know why it was that all the evidence for the prosecution was not brought forward and examined, as is generally the case in such prosecutions.
>
> Several individuals, who were possessed of important facts, were ready to testify, but it appears by the prosecution that the ends of justice did not require this testimony. Only such testimony was admitted as would clear the murderer.
>
> My husband had been warned that very morning by several responsible persons, that Dye had said he would kill him, that he would never live to see the election. That fact being impressed on his mind, and knowing that Dye intended to kill him, should, and would have been testified to, had all the witnesses been summoned.
>
> Base, ungrateful wretch, who so often has received the gratuitous help and kind assistance of the very man whom he wan-

The lynching of Michel Lachenais by Los Angeles vigilantes. *Author's Collection*

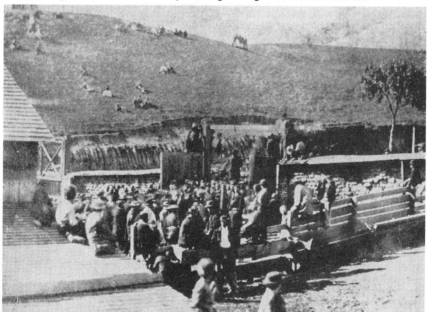

tonly followed up, and forced into a difficulty which deprived him of life.

<div align="center">Juana Lopez Warren</div>

Joe considered his options. He had not been selected for the new police force under the recently elected marshal, Frank Baker. The murderer Michel Lachenais had been taken from jail in broad daylight on December 17, 1870, and lynched by a mob of some three hundred armed vigilantes. When the grand jury was directed to ferret out the leaders of the mob, it refused, stating that if the law had been faithfully executed in Los Angeles, such events would not be necessary. Dye did not need a revelation from above to know what to do next. He got the hell out of town!

Leonard J. Rose, prominent stockman, Southern California farmer and Joe Dye's partner. *California State Library*

Indications are that Dye moved to eastern Santa Barbara County at this time. In 1872, the area would be split off and the county of Ventura formed. They could say what they liked about Joe, but he always associated with prominent people. He took up a government claim in Sespe Canyon, north of the Santa Clara River, in partnership with Stephen Mott, Captain Wesley Roberts, Hancock Johnston, and L. J. Rose to prospect for oil in the area. All these men were wealthy Los Angeles businessmen and property owners. It is probable that Dye was let into the deal to protect their interests. It was not likely any claim jumping would be a threat with Joe Dye as a partner. L. J. Rose, Jr., who had known Joe in Los Angeles, later characterized him as having "a friendly disposition," but "a violent temper."

On August 8, 1874, the Ventura *Signal* reported that a series of oil springs had been discovered on a branch of Sespe Creek. No names were mentioned, but the article was probably a reference to the Dye party. The following year the *Signal* reported specifically about the group:

> Somewhere in the Alamo Mountains Mr. Joe Dye has discovered a flow of fine petroleum, almost pure; so pure that it can

be put into a lamp and burned without refining. It is said to be one of the best ever found in this state.

Oil drilling and production was still in its infancy in the area. The Sespe Rancho, a large Mexican land grant straddling the Santa Clara River, originally was for six leagues (26,400 acres) but a second document listed the grant area as being only *two* leagues. Squatters had taken up some of the disputed land and the owner of the grant, T. W. More, had been murdered while quarreling with these squatters. The disputed lands were likely another reason Joe had been taken into the partnership. If his claim was indeed on "government land" as reported, he was on the disputed Sespe grant land.

After hearing that the vigilantes were no longer active, Joe soon drifted back into Los Angeles. He had business to conduct and supplies to purchase, and his wife was still living in town. Visiting with friends in the local saloons was a bonus. On the evening of July 29, 1873, Dye was talking to Charles E. Beane, editor of the now defunct *Daily News*, in front of the Orient Saloon.

Los Angeles Sheriff William R. Rowland.
California State Library

William R. Rowland had defeated James Burns for sheriff at the last election. Rowland came from a wealthy background, his father being one of the original owners of the forty-nine thousand acre La Puente Rancho. On this day the sheriff had been talking to a man named Cecil concerning a local political convention. Cecil, quoting a man named "Higbie" (probably George H. Higbee), commented that Joe Dye had made statements that Rowland had pledged himself to the entire People Party's ticket. Rowland denied this and said he was going to look up Joe Dye and obtain the source of his information. He knew Dye and his reputation and the sheriff did not intend to let matters go any further with a man of Joe's pistol proclivities.

Several friends counseled the young sheriff to avoid a confrontation. James B. Winston urged Rowland not to say anything. Another man suggested he just put a card in the newspaper and explain matters. Rowland would have none of it and walked off, looking for Dye.

Dye was still talking to Beane when Rowland sauntered up. Later, the sheriff recalled what happened:

> I was coming up the street when I saw Mr. Dye and Captain Beane talking in front of the Orient saloon. I came up to them and said "Good morning gentlemen;" I think I called them by name and spoke to the Captain first; I told Mr. Dye that I had heard that he had made some remarks in reference to myself and thought it was nothing more than my duty to ask him what his authority was for saying so; he said "Higbie;" I said come let's go and see Higbie and if that was the condition of things it was his quarrel and mine; he refused to go with me and when he did that I gave him the lie—I can't state the exact language I used. Captain Beane said it was better for us to go into a private room and talk it over, but when I gave him the lie, I struck at him. He caught me by the beard and then we clinched; he asked me to take it back, but of course I would not.

Dye went for his pistol and in his haste ripped a piece of fabric from his trousers. The torn material caught on the hammer of his weapon and Dye tried to rip it

Los Angeles Weekly Star.

SATURDAY............AUGUST 9, 1873

THE DYE-ROWLAND DIFFICULTY.

Before Justice Trafford.

Aug. 2, 1873—9 A. M.

The People vs. J. F. Dye.

W. H. Workman sworn—I was in my place of business on Main street; I have forgotten the date, some three or four days ago; I happened to look out of the door; I saw Dye and Rowland clinched together, that is Dye had hold of Rowland's beard with his left hand—in his right hand he had his pistol hanging down by his side; I could hear the words "take it back;" I heard those words several times—I did not hear any response; I watched them I suppose five minutes and saw them in that position; they both appeared to be talking but I did not hear only those words. At the time I saw Dye with his pistol he was not making any demonstration; I saw officer Harris rush up there from towards the Bella Union hotel; he got hold of Dye

Newspaper account of the Rowland-Dye confrontation hearing.

off with his teeth. Rowland had one hand on Dye and the other in his pocket where he clutched his own pistol. "I did not cock my pistol while talking to Dye," the sheriff later said, "but I had it cocked in my pocket, because Gates told me some three or four months ago that Dye had made some tough remarks about me."

A crowd quickly gathered. William Workman rushed from his saddle shop across the street and stood watching the argument. Pedro Carrillo was talking to policeman J. R. McMurray on the sidewalk and they turned to see what was happening. Constable M. D. Hare rushed out of the Orient Saloon and quickly took in the situation.

Policeman Emil Harris rushed up and immediately got between the combatants and separated them. Hare stepped up now and thrust his thumb under the hammer of Dye's pistol so it could not fire. Harris led Dye away and told him he had to give up his pistol, which he did. When Joe asked to go to his room to change from his torn trousers, Harris accompanied him and the crisis seemed to be over.

On August 2, there was a hearing in Justice Thomas Trafford's court. A number of bystanders and participants were assembled and since it was an unusual case where no one had been injured, Joe was allowed to question the witnesses in his own defense. Sixteen witnesses were examined, questioned by Dye and the district attorney. All told much the same story, differing only in minor details. Sheriff Rowland's account was basically the same as others and he had clearly shown much nerve in standing up to the desperado. But he wanted to get the disturbing incident out of the way.

"I never asked to have Mr. Dye arrested," he stated, "and as far as I am concerned I want this prosecution to stop."

In the end it was ruled that there was enough evidence to prosecute the defendant and a date was set for the trial. Since there was no more mention of the case in the press, it is possible that Rowland had a serious talk with the district attorney, insisting that the matter be dropped.

The following year the Piru Mining Company was filed on and certified to be a partnership between Joe Dye, S. Levy, and Charles A. Holmes. Their claim was within the Alamo Mountains. After two dry winters, however, the claim was sold and Joe went back to oil prospecting.

Thomas Bard, a very prominent ramcher and civic leader of Ventura County, was another target of Joe Dye's hatred.
Author's Collection

Thomas Bard had drilled the first well in the area in 1865, and Dye, Wes Roberts, and his other partners were not far behind when they made their oil discoveries in the early 1870s. Joe and Roberts had separate claims now, with Joe leasing the property on which his claim was located. He was particularly testy when it came to this

Sespe property which was located between the coast and the Camulos Rancho. The Sespe's brownish oil was much lighter than the heavy black liquid being pumped in other areas. Tom Bard and other big developers made Joe nervous, and he never missed an opportunity to scare off prospectors. "Tenderfeet," he called them, and he always wore his pistol when around them so they knew he meant business.

Joe continued to reside in Los Angeles, but he was gone for long stretches of time now. He prowled the hills and canyons of the Ventura mountains or kept things moving at his various claims. The 1880 census shows him still living in Los Angeles with Francisca, but with no children. Remarkably, the twenty-one-year-old wife in 1870 had aged only four years at the time of the 1880 census. Living with someone like Joe Dye, it should have been just the opposite.

Dye was back in Los Angeles in late December 1880, perhaps home for the holidays. On a Wednesday evening, he stepped into a local restaurant for a bite to eat. The *Los Angeles Evening Express*, December 23, 1880, chronicled an unscheduled floor show:

> A Bottle and a Knife—A disturbance occurred in the Commercal Restaurant at an early hour last evening. Three young bloods who had been imbibing pretty freely of the rosy were in one of the compartments dining when Mr. Joe Dye entered and

Los Angeles was spreading out. It was no longer a frontier town, and frame and brick structures were becoming more common. *Author's Collection*

took a seat at a table. One of the party accosted him, wanting to know what he was doing there, intimating that they had chartered the place. Dye responded that he had come for his dinner, and proposed to get it, regardless of their charters. The spokesman called him a cowboy, applying a vigorous epithet or two and followed his speech with a bottle which struck Dye on the head. Dye drew a dirk and started for the party, when a general melee ensued, the aggressor receiving a scalp wound from the dirk and a broken knuckle as a result of one of his own blows. Dye had his right eye bruised somewhat, either by the bottle or by a fist blow. The combatants were quickly separated.

The three party boys promptly fled the place as Joe assayed his damages. "It is stated," reported the *Express*, "that after the fracas was over, Dye searched the town over for his assailants and had he found them, serious trouble might have resulted." Joe, no doubt, had gone home for his six-shooter.

Sometime during the 1870s Francisca had left him. Perhaps she was tired of living alone. Or maybe he was as violent with her as he was with others. She disappeared from his life and Joe moved on as though she had never existed.

In the early and mid-1880s, the oil lands of Ventura County were rapidly being developed. Oil prospectors were prowling over the area while concerns like the Pacific Coast Oil Company and pioneers like Wallace Hardison and Lyman Stewart, who later would evolve into the Union Oil Company, would be producing 2,800 barrels a month by 1886. It was infuriating to Dye. Tom Bard was another one of the Hardison crowd. Bard had laid out the port town of Hueneme and was involved in Ventura County government and various oil and agricultural projects. J. C. Udall was another of the group that had bought up a lot of the lapsed claims in the Sespe area. Joe considered himself one of the real pioneers in this country. He would tell people he had drilled his first well here in 1856, which was not true, but he had been here in the early 1870s. He saw what was happening. He would be crowded out by these big-spending tenderfeet, but they would find that Joe Dye would not go quietly.

It was probably on a business trip to San Francisco that Dye met a young woman named Grace. Joe was dressed up, and he was

Oil derricks in the hills of old Ventura County where Joe Dye caused
so much trouble. *Author's Collection*

on his best behavior and for a time he forgot his oil troubles, no
doubt impressing Grace with the potential of his Ventura proper-
ties. She was recalled as being a good-looking woman, but her strata
of society is not known. In lieu of her later actions, it is not difficult
to guess the woman's origins, however. It was a whirlwind court-
ship and when he returned to the Sespe and the shack he called
home, he was a married man, or so he claimed. But few dared ques-
tion Joe Dye about anything.

"Dye," commented the *Los Angeles Times* in 1891, "had for so
long ruled affairs in the Sespe region that he regarded anyone else
coming in as an infringement on his personal rights, and unless they
came in on his terms , he looked on them as personal ememies." A
prominent Los Angeles attorney told a tale that was typical of Dye's
bullying:

> Several years ago an old man came to my office and told me
> that he was in great trouble. He said he had located a piece of land
> near Dye's claims; as soon as he put up a few improvements, Dye
> came along and wanted to know what he was doing there. Dye
> claimed the land and a quarrel followed. Before they parted Dye
> threatened to kill him, and intimated that he would shoot him on
> sight if he did not leave the land at once. This threat frightened the
> old man so that he came to me for advice. I told him that if he had
> plenty of money he might go to law and settle it that way, or if he

was a dead shot and mighty quick on the trigger he might remain on the land and have it out in that way, but if he had no money and did not consider himself an expert with the pistol, he had better get out of that country or he would be killed.

Joe was bluffing much of the time, but who knew just *when* he was bluffing? Everyone knew of the Billy Warren killing and there were the rumors of others. Few were willing to call Joe's bluff, including a man called "Coal Oil" Scott. Dye and Scott had a claim dispute that wound up in court. When the two men met in a Santa Paula saloon one day, they had a drink together and engaged in conversation. "Coal Oil" carefully avoided mention of their conflicting claims in the course of their talk, but Dye slyly brought up the subject in terms of his own particular point of view.

"Joe, you're a damn liar," blurted out "Coal Oil," as Joe's hand flashed to his hip pocket.

"As soon as the words were out of my mouth," recalled Scott later, "he yanked his revolver and stuck it under my nose. But I was too quick for him. I took it back before he could shoot."

But for all his fits of temper and feuds with the oil claimants surrounding his Sespe holdings, Joe was genuinely moved and delighted when his wife became pregnant. Little Gracie was born in 1882 and we can assume Joe fixed up his cabin and made it as comfortable as he could for his new family. He was doing some farming now, and he began carving out an irrigation ditch off Sespe Creek.

Joe had taken in a partner on his operations, a man named H. J. Crow who lived in Los Angeles. "[Joe] farmed the ranch," noted an article in the *Los Angeles Times*, "and led the happy existence of a rich ranchero, alternating in place of residence between his domain and the cities to the west and south of it, always accompanied by his pretty wife, and seemingly the happiest of men." Perhaps there was a pot of gold at the end of Joe's rainbow after all.

It is not clear just how much oil Dye actually pumped from his claims. The Sespe Petroleum Mining District was organized in July 1876 and the area was more orderly now. Any individual could claim 160 acres, but he must spend at least $200 improving the property and it must have clearly established boundaries. Dye apparently held many claims of his own, or with partners, and he scared off many

other claimants. However, he probably expected to make his money leasing or selling his claims, rather than pumping oil himself.

In April 1886, Joe was repairing a wagon near his barn when he noticed the young son of Herman Haines ride up on a pony and drop something on the Dye porch. He was well acquainted with

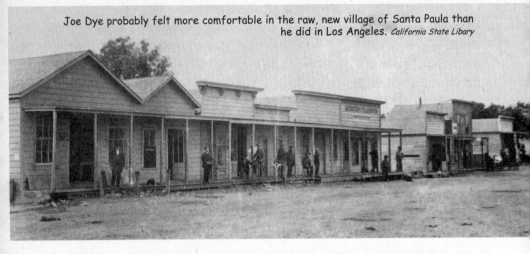

Joe Dye probably felt more comfortable in the raw, new village of Santa Paula than he did in Los Angeles. *California State Libary*

Haines, a former postmaster at Cienega and now a merchant in the nearby town of Santa Paula. Joe paid little attention to the scene, but when he looked up again the boy was still by the porch on his pony. Mrs. Dye then came out, picked up the note and read it. She hastily scribbled a response and gave it to the boy, who then rode off toward town.

Joe had stood up by now. What the hell was going on? He could not be seen from the house and he quickly bridled his horse and galloped after the Haines boy. He caught up with him in a nearby canyon, jerked him off his pony and demanded the two notes. When the boy refused, Dye slapped him to the ground, then stuck his pistol in his ear. "Give me those notes or I will kill you, your father and Mrs. Dye!"

Terrified, the boy fished them out of his pocket and handed them to the infuriated rancher. One after the other, Dye unfolded the two notes and read them. It was as if he had been hit in the head with a hammer. The first note read:

Mrs. Dye: If you don't meet me in the barn tonight at 9 o'clock,

as I want you to, I will see Dye and tell him all about that medicine. Herman Haines

The second note was the response:

Herman Haines: You dirty dog! You can do what you please, you coward! I will not meet you tonight or at any other time.
Gracie L. Dye

It was a stunned Dye who rode back to his place, put his horse away, and walked slowly up to the house. He found his wife sewing and held the two notes before her face.

"What does this mean, Grace?"

The woman turned white and after a few threats from Joe, soon gushed out the whole sordid story. Joe Dye, the most feared man of the Sespe, had been betrayed by his wife and his ranch partner, H. J. Crow. Dye walked out to the barn, mounted his horse, and disappeared for two days. At least that is the story and it makes sense.

Dye needed to think. As crude as he was, he was known to be close to his wife and his marriage was one of the few virtues that confounded his enemies. And, it was no secret how much he loved his five-year-old daughter, Gracie. Now his whole life was changed. His wife had told him how she had been exchanging letters with Crow for some time. Crow, in an effort to cover his tracks, had dictated the letters to a second party, then sent them to Herman Haines at Santa Paula. Haines used his son as a courier to deliver the letters to Mrs. Dye. Responses would be dealt with in the same way.

The Catholic school where Joe placed his daughter. *1872 Los Angeles City Directory*

When Dye returned home, he was thinking clearly. His wife took the stage the next day and disappeared from his life. His daughter stayed with Joe. He planned to put her in a Los Angeles Catholic boarding school where he would be able to visit her at every opportunity.

As for Crow, Dye reportedly bided

his time. He was still a partner and when he next showed up at the ranch, he was a dead man and no jury would ever convict him.

Herman Haines must be dealt with now. Reportedly, Joe sent him word never to come to the ranch. A debt he owed Haines would be taken care of without their having any contact with each other. Haines, too, deserved to die for that note he sent Dye's wife, but no court would consider that a killing offense. Instead, Joe offered a young friend of his a horse if he would "ruin" Haines' daughter. Fortunately, the young man refused. Joe bided

Henry T. Gage, prominent attorney and later governor of California. *Author's Collection*

his time. He decided to keep away from Haines, but apparently he had not considered that Haines knew the game was up and would now warn Crow. Or perhaps he did.

Dye found it necessary to ride into Santa Paula on August 27, 1886. What occasioned this visit is not known, but its result was chronicled in the Ventura *Free Press* on September 3:

Witnesses of the tragedy at Santa Paula yesterday say that the shooting of Haines was entirely unprovoked. Dye was standing in Cohn's store when Haines came in carrying a Winchester rifle. He set his gun down by the door and going on in, passed the time of day with Dye. "Don't speak to me," Dye said—and at the same time

Haines in the face. Mr. Cohn caught hold of it was thrown to one side, and Haines started is gun—Dye following. Mr. Haines secured ifle and ran behind the counter. His assailant as close upon him, however, and knocking up the muzzle of the gun, shot the man twice with his revolver. Haines then dropped the rifle and started for the door. Dye followed him out upon the porch and shot him again as he was making his way up the street. Haines ran around the corner to escape his assailant and Dye gave himself up to Constable Sutton.

Stephen M. White was a noted lawye, orator, and state legislator. *Author's Collection*

Whether this was an accidental meeting, or whether Joe could no longer stand the thought of the note to his wife, will probably never be known. It would make more sense if he had gone to Los Angeles and sought out his partner Crow. Cohn's store, like many places of business in those days, had a bar at which Joe was probably having a drink or two. When Haines spoke to him, he might as well have said, "Shoot me, Joe!" In any case, at a hearing Joe was released on $5,000 bail, provided by "some prominent Los Angeles capitalists." Haines had been badly wounded, but was reported to be slowly improving. Then on September 11, the ominous news was announced in Santa Paula. The *Los Angeles Times* reported:

The Ventura County Courthouse, where Dye's trial took place. *From* History of Santa Barbara and Ventura Counties, 1883

HAINES DEAD

And Joe Dye, His Slayer, Held for Murder.— Herman Haines, the man shot by Joe Dye at Santa Paula last Friday, died at the hospital at one o'clock this morning. Mrs. Kate Haines, the wife of the dead man, at once swore out a warrant for Dye's arrest on a murder charge and Sheriff Snodgrass went out to Santa Paula this morning to execute it.

Joe was picked up by the sheriff and returned to Ventura. He appeared before Justice Bledsoe and was committed to the county jail to await his preliminary hearing at ten o'clock the following morning. Dye immediately telegraphed attorney Henry T. Gage in Los Angeles who caught the next stage for Newhall.

Gage was a heavy-hitter in legal circles. A practicing lawyer in Los Angeles since 1877, Gage was active in Republican politics, and he had known Dye for some time. Another prominent attorney from the angelic city was also engaged; he was a noted speaker and member of the state senate named Stephen M. White. Both men were

heavily involved in the Sespe oil fields. Dye was very well represented, indeed.

The trial took place in late November, the case hinging on the letters exchanged between Crow and Mrs. Dye. Gage and White knew this evidence was not enough, and Gage had opened the defense with a statement lasting over three hours. Much evidence had not been published, the editor of the *Free Press* deeming it not proper to do so. Still, the courtroom had been jammed by women who stayed until the "last dog was hung."

Grace Dye was subpoenaed, but Joe must have cringed at what was going to happen to his persona as a deadly gunman and badman. Indications are he insisted that her testimony be as limited as possible. The content of the letters must be minimized also. One can almost hear Joe's defense team trying to tell Dye he was risking going to prison by this course of action. In the end, Gage and White bowed to Joe's wishes.

White's closing argument was some three hours long and, according to the *Free Press*, "brought tears to the eyes of both the jury and audience." But, after deliberating for two and a half hours, the jury brought in a verdict of "Guilty of Murder" in the second degree.

Gage and White immediately appealed the verdict and requested bail. Joe stayed in the Ventura jail while matters dragged on

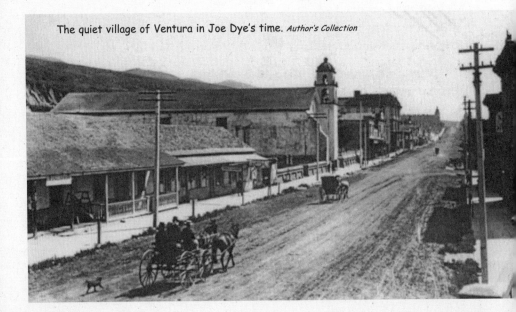

The quiet village of Ventura in Joe Dye's time. *Author's Collection*

for many months. In the first week of March 1887, Dye was sentenced to sixteen years in prison and the following week was on his way to San Quentin in custody of Sheriff Snodgrass. The sheriff and his prisoner were back in town two days later as reported in the Ventura *Daily Free Press*:

> Sheriff Snodgrass returned with J. F. Dye, the Supreme Court having granted a stay of proceedings pending a motion to admit defendant to bail. This will probably be decided by the Supreme Court in a few days, after which it will consider the motion for a new trial.

Joe had spent some seven months in jail and was grateful to be able finally to resume his life. He must have been perplexed by the

actions of his erstwhile partner, the redoubtable Crow. Crow had filed a $50,000 libel suit against the Los Angeles *Evening Express* for publishing in December 1886 a long and lurid article detailing the transgressions of Crow against the Dye family. Keeping the matter in the public eye, the *Los Angeles Times*, on January 6, published an article on the lawsuit, reiterating much of the offensive tale. The *Times* credited a "red-headed reporter" named Carlton Kemp as author of the objectional article, stating that he had "gained unenviable notoriety here by·many crooked acts, and has imposed upon his employers who are right-meaning gentlemen and cannot be presumed to have any malice against Mr. Crow."

Wallace Hardison, one of the most prominent oil men on the Coast.
California State Library

Of course, the *Times* proprietors knew perfectly well the *Express* owners were responsible for anything that appeared in their paper. By suing, Crow perhaps hoped that the public, and especially Dye, would think there was not as much to the trial evidence as the newspaper articles suggested.

There were apparently flaws in the *Express* article, since on January 27, the *Express* editor ate "crow" in a retraction under the heading, "An Explanation":

> The Express, as stated in these columns the day after the suit was commenced, published the article as a matter of news, and

under the belief that it was giving merely a synopsis of the evidence adduced at the trial, and without any intention to injure Mr. Crow or to treat him unfairly. But we find that the article, after admitting that all the most sensational circumstances were, for some reason, not brought out at the trial, proceeds to give what has been construed by Mr. Crow's friends to purport to be the facts, and not the evidence in the case, and we are free to say that the language is capable of being so construed.

The article was quite long and apparently assuaged Mr. Crow to the extent that he dropped the suit. It would be some years, however, before he could stop looking over his shoulder for the sinister form of Joe Dye stalking him. That Joe's difficult reputation was still intact, however, was verified by a letter from oil man Wallace Hardison to Thomas Bard:

> He is out on bail and is a bad man. Everybody on the Sespe that has business with Dye is afraid of him. Within six months he has threatened to shoot three different men. One (Haines) he did shoot. Owing to my connection with the oil business at the Sespe I do not want my name mentioned just now as a party uging vigorous prosecution but I am in favor of putting such fellows where they can't shoot any other person. Dye passed through here [Santa Paula] tonight full of whiskey.

In April 1888, Joe took his dog along on a visit to a neighbor, J. C. Udall, who had bought up several of Joe's claims when they had expired. Whether Joe was merely on a friendly visit, or something more sinister was afoot, is not known. As the two men conversed, their dogs suddenly lunged at each other and engaged in a vicious fight. Udall moved to break them up, but Dye pulled him back.

"Let them fight it out," he said, "otherwise they'll fight every time they see each other."

The two men watched the bloody scrap for a few minutes, then a disappointed Dye pulled his badly mauled dog away and rode for home. He was back a short time later and found Udall and his dog sitting on the porch. Raising his rifle, Joe shot and killed the dog, then turned to his master.

"I'll settle with you the same way when it is convenient," com-

mented Dye, who then returned home. The incident resulted in another letter from oil man Wallace Hardison to his friend Bard:

> I regard Mr. Dye as a very dangerous man and there certainly ought to be something done to take care of him, for none of our lives will be safe with him running at large. I have not the least doubt in the world but that he fully intends to kill Mr. Udall. I have no plans to suggest, but would like the privilege of assisting in taking care of the desperado.

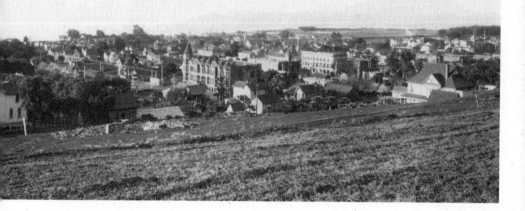

The Pacific Ocean is just beyond the buildings in this view of Ventura in the 1890s.
California State Library

Hardison's plea has a desperate tone to it and he was perhaps hoping someone would suggest Dye be done away with some dark night as was More, the first owner of the Sespe rancho.

Joe's second trial was called to order in November 1888. Gage and White covered much of the material utilized in the previous trial, working their way towards the introduction of some new evidence that would insure an acquittal. A big surprise was the introduction of Edward L. Baker, of Los Angeles, as a defense witness. In Dye's previous trial, Baker had been a prosecution witness. Baker, Crow's secretary, explained that it was he who had penned the notes between Crow and Mrs. Dye, and he now provided a long letter

Haines had written to him. The letter, meant to warn Crow that Dye was onto him, told of Joe's catching the Haines boy and the intercepting of the incriminating notes. Haines wrote that he had never known what was in the letters he had delivered to Mrs. Dye, but he wished he did know what notes Dye had gotten from the boy. He was referring, of course, to the note where he, Haines, had demanded Mrs. Dye meet him in the barn.

The Anacapa Hotel, where Dye's friends hung out and celebrated his legal victory. *California State Library*

Baker produced another letter that changed the whole tone of the trial, as reported in the *Los Angeles Times*, November 2, 1888:

> The most startling letter in evidence was one from Haines to Crow's secretary, which letter stated an intention to put Dye out of the way, and acknowledged malice toward him and an intention to try to obtain favors of Dye's wife.

The letter startled the crowd in the courtroom and the jury. Haines had threatened Dye as well as made illicit advances to his wife. In the frontier West, a man was expected to protect his family, to shoot those who trespassed over the bounds of decency. There were certain natural laws that superceded legalities. That was the way things were.

It was evening when the jury went into seclusion. Joe had given up a lot, and he hoped it would pay off. Gage and White were con-

fident. The *Times* heralded the resulting news:

> The old town of Ventura is filled with people, witnesses and spectators, crowding the hotels. The Anacapa, the headquarters of the defense's friends, much resembles the headquarters of a political convention. Dye is well known in Los Angeles.
>
> LATER—At 8 o'clock this evening the jury announced a verdict of not guilty. It was the signal for much applause. Judge Williams ordered Dye's discharge from custody. Dye was the recipient of hearty congratulations from hundreds of friends. He held a levee at the Hotel Anacapa throughout the evening. Messrs. White, Gage and Dye depart for Los Angeles tomorrow.

The hordes of Dye's friends and associates noted in the press is hard to understand, given his reputation as a dangerous man and gunman. But such was the case. Many probably just wanted to stay on his good side, while there is no doubt that he could be a good friend so long as you avoided crossing him in any way. The terror expressed in the letters of some of the Sespe oil men and others, however, was very real.

Joe Dye was understandably eager to get back to work. His farm had suffered since he had dissolved his partnership with Crow. He was building a road from the village of Fillmore up the Sespe River and was also talking of an oil pipeline to Los Angeles. Although he seemed to be trying to make up for lost time, he always managed to visit his daughter as often as possible.

It was during this period that Joe reportedly came up with other means of getting even with his enemies. He tried to get an employee to blow up an oil field enemy with dynamite and when this failed, Dye reportedly introduced scale bugs into the orchards of enemies such as Thomas Bard, the prominent oil man and farmer. True or not, there were insect infestations in the Santa Clara Valley in the late 1880s.

Mason Bradfield's prison mugshot taken at the time of a later shooting in which he was involved. *California State Archives*

Sometime during the middle 1880s, Dye met a young man named Mason Bradfield who was scouting out oil properties in Ventura County. In his mid-twenties at the time, young Bradfield readily accepted a partnership with Dye when it was offered. This seemed to be a pattern with the badman. He would take in a partner who would share work and expenses, then if a claim proved profitable he would scare his partner off by making unreasonable demands. Dye could also use his partner as a reputable witness in any shady deals he might concoct.

A typical example was an ad Dye ran in the local press. He announced to his partner that he had expended $100 on Star Oil No. 2 Mining claim and if Minor B. Smoot, the partner, did not come up with his share, he forfeited all rights in the claims.

Mason Bradfield was too young and naive to be aware of Dye's perfidious character. Or, perhaps, he liked the idea of being a friend and partner of the notorious badman. In any case, the boy introduced Dye to his parents in Los Angeles and the two worked together for several years without incident.

One day, Joe came up with a scheme in which he really outdid himself. Dye had a claim he had named "The Oil Spouter," situated next to some unsurveyed government land. When a new Los Angeles company called the California Oil Company wanted to lease the Oil Spouter claim, Joe was only too happy to oblige. When these

California was growing out of its adobe frontier days, as can be seen in this view of Spring Street in Los Angeles in the late 1880s. *Author's Collection*

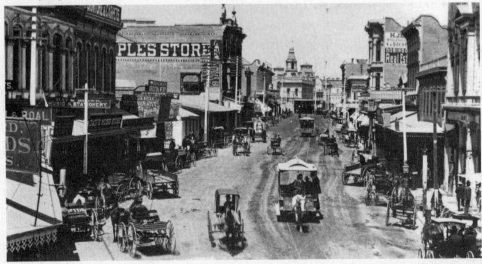

"greenhorns" asked Dye's advice about where to drill, he was delighted to show them the exact spot. Unbeknown to the lessees, Joe's spot was located on the unsurveyed government land *next* to the Oil Spouter. When their claim began producing some time later, Joe met Mason Bradfield in Los Angeles and told him to file on the land and they could both make $100,000 on the deal.

"I'm tired of leasing," coaxed Dye. "I'm an old man and I want that well and I'll turn those tenderfeet sons of bitches over for it."

Bradfield refused to do as he was told, saying he could not stand by and see those men cheated like that.

"It's not on their claim," smiled Dye.

Bradfield told him he knew it was not on their claim, but he could not do what Dye asked. "Never mind what you know," shouted Dye, "just do as I tell you. You dance to my music, or I will make it so hot for you that you can't stay in the country. You know Haines; you know Billy Warren; you remember the son-of-a-bitch in the vineyard. You do as I tell you or I will give you some of the same medicine."

When Joe continued to rage over his refusal, threatening to "let daylight" through his protoge, Bradfield walked out and the badman assumed his threats had worked. The man "in the vineyard" is apparently an unknown Dye victim.

Bradfield returned to the Sespe and did register the claim on December 8, 1890, but in the names of himself, George Henley, and one John Thompson. The three claims were then transferred to the California Oil Company, Mason Bradfield being made superintendent of the company. Dye's scheme had blown up in his face.

Dye had been in Los Angeles while most of this was going on, but in March 1891, he had occasion to visit his properties in the Sespe. When he discovered Bradfield's treachery, his fury was monumental. To make matters worse, the California Oil Company gave Bradfield a deed to a ledge of brownstone on the claim. This was leased to the Mentone Stone Company, and Joe watched helplessly as the stone was being quarried by workers on property that he had considered to be his.

Boarding the train for Los Angeles, Joe hit the streets of the angelic city at a trot and began searching for Mason Bradfield. He

was walking past Fred Linde's jewelry store on Spring Street when he stopped and looked in the window and saw Bradfield talking to Linde. Rushing through the front door and up to Bradfield, Joe began shaking his fist in the young man's face.

Newspaper sketch of Mason Bradfield at the time of the Dye murder. *Los Angeles Times,* May 15, 1891

"You son-of-a-bitch," shouted Dye, "you have thrown me down. I gave you a chance to make a stake; to make $10,000, and you have thrown me down for a lot of tenderfeet sons of bitches. This will cost you your life. I have a mind to kill you right now. If you take an inch of rock off that claim, I'll kill you!"

Linde quickly handed a watch he had been looking at back to Bradfield, then backed away. Mason slipped the watch into his pocket, while Dye continued to shout and threaten him.

"Mr. Dye, I'm not afraid of you, but I don't care to have any words with you."

At this, Dye shouted, "Don't you draw on me," then slapped Bradfield across the face with his gloved left hand, while his right hand went to his hip pocket. Dye had a piece of iron in his glove which left a mark on the younger man's face. Joe was still berating him when Bradfield turned to leave the store and was shoved against a showcase.

"If you dare to leave here before I'm through with you," raged Dye, "I'll fill your back with lead."

At this point, Linde and an employee eased behind a large safe, while Sam Davis, another clerk, was observing the altercation from behind a partition.

"Dye appeared to be very much worked up," Davis would later recall, "and spoke loudly, but Bradfield's replies were in such a low tone as to be inaudible."

Finally, Bradfield was able to walk out of the shop.

"If it was not for your folks," shouted the badman after him, "I'd kill you, but I don't want to hurt you on account of your mother."

When Joe left Linde's shop he was as furious as ever. For the following month he told various acquaintances of the incident in

the jewelry store, while reiterating his threats to kill Bradfield. He told P. H. Irland in a Temple Street saloon that "if the little son-of-a-bitch had moved a step I'd have killed him. You tell the president of the California Oil Company," Joe continued, "that if he don't discharge Mason Bradfield, I will, and I will put a hole through the white livered son-of-a-bitch big enough for him to stick a two-inch pipe through him if he ever comes on the Kentuck claim."

When Irland returned from a trip to New York on April 23, he again ran into Dye, who was still fuming in the same saloon: "If he crosses my track I will dig another grave in my graveyard. I've got them planted from Texas to the Pacific Ocean. You tell him that I say he's the next."

One evening near the first of May, Joe walked into the office of the California Oil Company, where he confronted manager O. F. Brandt, as reported in the *Los Angeles Times:*

> Dye called at his office one night between 9:30 and 10 o'clock, and demanded that the witness discharge Bradfield from the company's employ. The witness told him that he did not feel disposed to do so, whereupon Dye replied, "If you don't I'll kill him, and I am willing to go before a jury and be tried for it."

Not getting any satisfaction, Joe now began stalking Bradfield and harassing his business associates. When most of his associates

Looking east down Commercial Street from Main Street. The two-story white building to the right is the old White Hotel, later refurbished into the Arlington Hotel, from where Dye was shot. *Author's Collection*

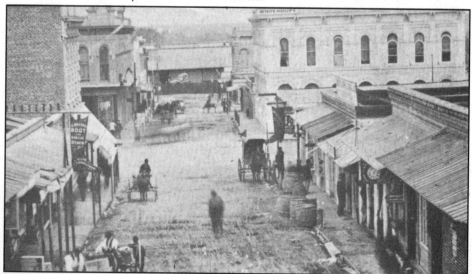

simply confronted Dye, or ignored him, he concentrated on Bradfield who was easily intimidated. Just how much Joe followed him around is not known, but it was enough to scare Bradfield silly. His friends were constantly reporting Joe's threats and he was soon seeing Dye everywhere. Bradfield blocked his bedroom window so he could not be shot as he slept. Actually, he slept very little and became increasingly nervous, reaching a point where he was so overwrought that his friends were concerned that he was insane.

On May 13, 1891, Bradfield decided he had only one course of action. He rented room number 29 on the second story of the Arlington Hotel, which fronted Commercial Street in Los Angeles. The young man was reported as being in a good humor at this time and he spent the night in the room with a friend named Smith.

Joe Dye roomed in a building on the corner of Commercial and Alameda streets. Aware of Joe's habit of walking up and down Commercial Street, the day after he had rented the room, Bradfield watched the street most of the day. Just after three o'clock, he saw Dye across the street, walking toward the Arlington. Bradfield checked the loads of his double-barrelled shotgun and waited.

Witnesses said later that Dye had been walking along the sidewalk looking down, as if meditating. Suddenly the boom of the shotgun was heard and a moment later, a second boom. Dye had just looked up and he threw up his arms and cried out, "My God!" He sprawled crossways on the sidewalk. Two men in a buggy had been passing by; the shotgun slugs and a cloud of powdersmoke crashed through the air over their head. Startled, they jumped from their vehicle, not knowing if they were being shot at or just what was happening. Seeing Dye on the walk, they rushed over, but a passing physician named Percival was already there. Opening Dye's shirt, Percival saw at a glance the ten buckshot wounds that indicated life was extinct.

Bradfield had rushed out through a side door, but was stopped by a policeman who had seen him

running from the hotel. He readily admitted the shooting and was taken into custody. The *Los Angeles Times* reported:

It was estimated at Orr & Sutch's undertaking rooms yesterday afternoon that fully 7,000 people, of all stations and conditions, visited the dead-room to get a peep at the dead body of Joe Dye. Old women and young women, old men and small boys shoved and jostled each other in their efforts to get a view of the murdered man. Some tears were shed, but a cold stare, mingled with curiosity and hatred, rested on the faces as a rule.

The funeral, held on May 16, began in the undertaking rooms with another huge crowd walking past the casket. "The most pathetic scene," noted the *Times*, "occurred when his only child, a little 10-year-old girl entered the room in charge of two sisters from the convent where she has been for some time. The little girl wept as though her heart would break and had to be removed by main force. Whatever Dye's faults may have been, he was a devoted father."

Eight or nine carriages followed the remains to Evergreen Cemetery where the Reverend Knighten conducted the services. The pall bearers were Stephen White, Henry Gage, General Rollins, Dr. Crawford, Solomon Lazzard, and William Cartwell, all prominent residents of the city. The grave was literally filled with flowers and some genuine expressions of sorrow were heard.

Mason Bradfield's deliberate murder of Joe Dye was excused during his trial by the many witnesses who testified to the badman's vicious behavior and long reputation for violence. The jury's initial verdict was that Bradfield "might have been insane, and therefore not guilty." The judge ordered the jury to retire again and come up

with a more suitable verdict. When they returned again a few minutes later it was with a plain verdict of "not guilty."

An editorial in the *Santa Paula Chronicle*, May 27, 1891, brought the late enigmatic badman's career into a more distinct focus:

> It often happens that men die unregretted and unmissed, but it rarely happens that a man's death, either naturally or violently, is a cause of rejoicing. And yet such is the fact in the case of the death of Joe Dye. Not only did he die unmourned and unregretted, but the people of this community were glad of it, and were not slow to express their opinions.
>
> He has stood in the way of the progress and development of this county as all other obstacles put together could not do. He terrorized everybody with whom he came in contact who did not agree with him. The life of J. C. Udall was made a burden to him and there is little doubt but what Dye would have killed him on the slightest provocation. Mr. Udall has not lived here for a year past, although having valuable interests which need his attention. Many other interests will be looked after now, which would have lain dormant as long as Dye was alive. He stood in the way of progress, and his death in any manner is beneficial.

And that is why Joe Dye died. No man could behave as did Joe Dye without eventually antagonizing someone who would not put up with it. For Mason Bradfield, it was a simple matter of waiting for Dye to kill him, or kill Dye first. The method of killing was never an option. Bradfield recognized he stood no chance in a fair fight and a deadly ambush was planned and carried out. In the Sespe, the road to progress lay in the barrel of Mason Bradfield's shotgun.

The real question, however, was never the *reason* for his demise, but rather, how on earth had that evil man lived as long as he had? Certainly, more than one person at his funeral suggested that the huge crowd was simply a manifestation of just how many people wanted to make sure that a very bad man was really dead.

CHAPTER 5 SOURCES

No author given. *Memorial and Biographical History of Dallas County, Texas.* Chicago: The Lewis Publishing Company, 1892.

Franks, Kenny A. and Lambert, Paul F. *Early California Oil; A Photographic History, 1865–1940.* College Station, Texas: Texas A&M University Press, 1985.

Gidney, C. M., Benjamin Brooks, and Edwin M. Sheridan. *History of Santa Barbara, San Luis Obispo and Ventura Counties, California.* Chicago: The Lewis Publishing Company, 1917.

Hutchinson, W. H. *Oil Land and Politics; The California Career of Thomas Robert Bard*, Vol. 1. Norman: University of Oklahoma Press, 1965.

Latta, Frank F. *Tailholt Tales.* Santa Cruz: Bear State Books, 1976.

Outland, Charles F. *Mines, Murders & Grizzlies.* Ventura: Ventura Historical Society and the Arthur H. Clark Company, 1986.

Rose, Leonard J., Jr. *L. J. Rose of Sunny Slope, 1827–1899.* San Marino: the Huntington Library, 1983.

Dallas Morning News, January 26, 1901; January 16, 1905; June 21, 1925.

Fresno Morning Expositor, July 24, 1891.

Los Angeles Daily News, January 16, February 13, August 1, 1869; August 7, 10, 4, 26, September 9, 13, November 1, 2, 3, 13, 19, 22, December 4, 6, 24, 1870; January 1, February 18, 21, 22, 23, 1871.

Los Angeles Evening Express, December 23, 1880; May 14, 15, 16, 23, 28, 1891.

Los Angeles Star, February 5, August 27, November 1, 2, 1870; March 4, 1871; August 2, 9, 1873; January 16, 1875.

Los Angeles Times, March 26, 1882; August 29, September 4, 1886; November 22, 1888; May 15, 21, 24, 27, 31, July 12, 14, 15, 16, 17, 18, 21, 22, 23, 24, 26, 1891; May 17, 1900; May 29, 1901; July 5, 1957.

San Francisco *Daily Morning Call*, May 16, 1891.

Stockton *Daily Evening Herald*, March 20, 1866.

Ventura *Weekly Free Press*, September 1, 3, 4, November 19, 26, 1886; January 6, 28, March 18, 1887; November 22, 1888; May 8, 15, 16, 17, 18, 20, 22, 31, June 5, July 12, 31, 1891.

Outland, Charles F. "The Life and Times of Joe Dye, Southern California Gunfighter," *Ventura County Historical Society Quarterly*, Fall 1984.

U.S. Federal Census, 1820, Virginia.

U.S. Federal Census, 1840, Kentucky.

U.S. Federal Census, 1850, Dallas County, Texas.

U.S. Federal Census, 1860, Los Angeles County, California.

U.S. Federal Census, 1870, Los Angeles County, California.

U.S. Federal Census, 1880, Los Angeles County, California.

California 1890 Great Register of Voters.

Ancestry.com: Records of Kentucky Land Office from 1782 to 1924, Kentucky Land Grants. Benjamin Dye in United States from 1825–1835.

Rootsweb.com: Ferris Cemetery, Dallas County, Texas. Dye Family graves.

Ancestrylibrary.com: World Tree Project: Bennett and Related Families of Texas. Benjamin Dye and Family / Cazier & Related Families.

Ancestry.com: Virginia Marriages, 1740–1850.

Ancestry.com: Family Data Collection – Individual records. Benjamin Dye in Virginia from 1820–1840.

Chapter 6

There Is Little Hope for Someone Born to Be Bad!

The group of men rode slowly and defiantly down the main street of town. The streets of Merced, California, a typical railroad village of the period, were lined with false-fronted wooden buildings, slowly being replaced by stone and brick structures. Established in early 1872, when a station was designated to be built there by the Southern Pacific Railroad, the rowdy railroad town had given way to a farm and stock-raising community by the 1880s. The heavily-armed, grim-faced riders plodding down the street suggested that frontier days still lingered just beneath the town's surface.

The leader of the riders was a slim young man in his twenties, carrying a pistol at his side and a Winchester in his lap ready for instant use. His companions in the buggy and alongside included a young sheepman named Bob Prouty, and all were heavily armed.

Born in California in 1857, Robert L. McFarlane came from solid '49er stock. His was an honored pioneer family and he should have been riding a trail to a respectable life as a farmer and stockman like his father. But that was not his destiny. Despite the opportunities offered by his family, Bob McFarlane was following a dark star, and there seemed to be every indication that he was born for trouble.

His father, John L. McFarlane, came to California during the Gold Rush of 1849, taking up land in Mariposa County in 1854. The new county of Merced was formed the following year, just at the time McFarlane courted and married Hannah Peeler, the daughter of a neighboring farmer. In time the couple had five children: John,

Above:
A shepherd and his flock in 1890s
California. *Fresno County Public Library*

Nathan, Robert L., George L., and Laura. As the farm grew, the elder McFarlane acquired more property and in time was raising crops and running cattle over twelve hundred acres located a few miles northeast of the small village of Snelling. He hoped that someday his boys would continue to work the property.

The four boys all worked the farm and herded stock as they were growing up. Bob had different ideas concerning his future, however. When he was eighteen years old, about 1875, he left home to work out his own destiny. We can imagine that perhaps he had been slacking off in his work, or his father had caught him once too

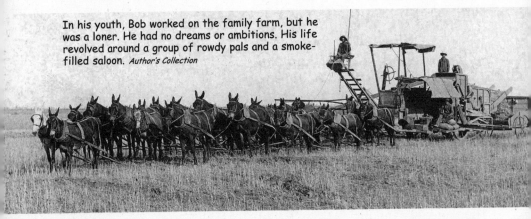

In his youth, Bob worked on the family farm, but he was a loner. He had no dreams or ambitions. His life revolved around a group of rowdy pals and a smoke-filled saloon. *Author's Collection*

often in a local saloon. His parents were good, hard working people. They no doubt hoped he would see the opportunity he was missing after he had lived on his own for a while. This never happened, however. Bob shunned responsibility. Being free to do as he pleased and be accountable to no one was what he sought.

For the next few years, Bob worked only as often as he felt necessary and quickly fell into the dissolute habits of his pals in the saloons of Snelling, Mariposa, and Merced. He worked for a man named Shaw for a time, but when Shaw died suddenly, Bob was forced to wait for his money until the estate was settled. Work was hard to find that fall of 1883, and Bob became increasingly impatient.

John Ivett was a large rancher who owned nearly seven thousand acres on the Merced River. When Ivett was made administrator of the Shaw estate, Bob called on him and reiterated his demand to collect the money owed him. The meeting was chronicled in the

Merced *San Joaquin Valley Argus*, October 13, 1883:

> Assault to Murder—On Thursday last, Robert McFarlane was examined at Snelling, before Justice Harrelson, and held for trial in the sum of $1,000, on a charge of assault to murder John Ivett, Esq. The trouble, we are informed, was about the payment of an account which McFarlane presented against the estate of Shaw, of which Ivett is the Administrator, and took place at the house of the latter. Mr. Ivett is said to have been knocked down and badly bruised by his assailant.

The elder McFarlane and his wife must have been mortified at the situation. Ivett was a friend of the family and a very prominent member of the county. The McFarlane's had little choice but to pay the thousand dollars and may have been present at his arraignment on November 5. Bob entered a plea of "not guilty" to the charge of "assault with a deadly weapon to commit murder" and his trial was set for December 12.

At his trial, Bob and his attorney must have been able to communicate his frustration to the jury as he was only convicted of the assault charge and fined twenty-five dollars. When the Shaw estate finally settled with him, Bob no doubt celebrated in his usual saloon style.

An 1880s farm scene in the San Joaquin Valley.
Elliott's History of Merced County

In the spring of 1884, Bob was reportedly living in the small village of Hopeton while working as a sheepherder in the hills east of Snelling. It was an easy job, but lonely. There were many sheep herds in the hills, some competing for the same range, and conflicts were frequent. In 1879, a Chinese sheepherder was murdered south of town, probably by a rival sheep outfit. Often, men like McFarlane were hired to keep others off their range, and this was undoubtedly the case with Bob. He already had a reputation as

a barroom brawler who would stand up to anyone who crossed him.

Another aspect of the territorial sheep grazing problems was that many of the herders were Portuguese who spoke little or no English. Given McFarlane's combative nature, it was perhaps inevitable that he should collide with another shepherd perceived to be encroaching on his grazing area. And, it was indeed a Portuguese with whom Bob engaged in several brawls on the range, as recounted in a contemporary newspaper account:

> McFarlane was set upon by a number of Portuguese in a sheep camp in the mountains northeast of this place [Merced], and in the encounter which followed, aided by a friend, "got away" with them to the extent of "putting a head on" several, but no one was seriously hurt. Subsequently a number of the Portuguese attacked McFarlane in one of the Mexican dance houses in this place and used him up pretty badly. About three weeks ago the parties met again on the occasion of the Democratic primaries, and the old quarrel was renewed, and in this encounter McFarlane is reported to have come out best.

Bob's "friend" who aided him in the encounter was named Jim Bradley. Another account reports McFarlane was packing supplies to a sheep camp in Mariposa County when the conflict took place. Arriving at the camp, Bob discovered the Portuguese sheepmen had run off his Chinese herder and this was the cause of the feud that erupted.

A McFarlane pal in Merced was "Allie" Hulse, who also came from a prominent pioneer family. Alfred W. Hulse, Sr. was a '49er who spent most of his life mining. He was a justice of the peace for a time and when the railroad came through the San Joaquin Valley, he moved with his family to the new town of Merced, where he worked as a carpenter. Ann, his wife, was a lovely person, described by Rowena Steele, a local newspaper publisher, as "modest and unassuming, commanding and dignified as a queen." Mrs. Steele, a popular actress and novelist, was so impressed with Mrs. Hulse she devoted the whole front page of the *San Joaquin Valley Argus*, her Merced newspaper, to her obituary. There were two daughters in addition to Alfred in the family when Ann Hulse died at age fifty-two in 1879. It was a terrible shock to her family, with the father

described as being "inconsolable in his grief." It was possibly his mother's death that changed fourteen year-old Allie Hulse. He left school and began drifting aimlessly and by 1883 he was associating with the likes of Bob McFarlane.

Bob could not let go of his sheepherders' quarrel, no matter what the results were at the election skirmish. He was well aware that the Portuguese herders frequented Jose Arros's Spanish dance house in the town's tenderloin area. The place had a large dance floor, with a saloon and bar off to the side and the women's cribs in the back. On the night of June 19, 1884, Bob received word that the men he was looking for were at the Arros dance hall. It was about 11:30 at night when McFarlane and Hulse entered the place and drew their pistols. An eyewitness recounted what followed in the *San Joaquin Valley Argus*:

> McFarlane and Hulse came in at the front door, and when they reached the arch between the bar-room and dance-hall, Hulse stopped, while McFarlane walked along to the center of the hall, wheeled around, and approaching a bench where a number of Portuguese sat—the three victims among the number—suddenly drew his pistol, and with the remark, "You sons of bitches!" opened fire right among them. Immediately the shooting commenced, the unarmed objects of McFarlane's wrath started to effect their escape through the front door, leaving one of their number behind struggling in the throes of death. Here they were met by Hulse, who, in his turn, commenced to shoot at the terror-stricken Portuguese, firing four shots. While this was going on there was a general stampede among the inmates to get out of danger, and the house was soon deserted, save by one or two. When the firing was over McFarlane passed out the front door and effected his escape. Hulse took to the rear door, made his way to the back yard, scaled the fence and disappeared.

An account in the *Merced Express* reported that Bob "deliberately drew his pistol, and placing it against Enos' breast, fired, the ball taking effect in the chest near the clavicle bone and ranging downwards, causing death instantly." Whatever the details, Antone Enos was just as

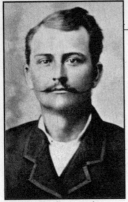

Bob McFarlane as he appeared at the time of the Enos shooting.
Author's Collection

dead. Bob fled out the front door, mounted his horse and rode off into the night. Hulse had left by the back door in the confusion and run into the arms of an officer hurrying toward the sound of the gunshots. Inside the hall, twenty-five year-old Antone Enos lay sprawled on the floor in a spreading pool of blood. He had been shot in the heart and was dead. Antone S. Brazil was shot in the right leg and the right lung and was not expected to live. Hulse's victim, Joao Mundonca, was shot in the right side and it was thought he would survive. The victims were all young men and cousins. A coroner's jury, convened on June 28, concluded that McFarlane and Hulse were jointly responsible for the death of twenty-four-year-old Antone Enos.

"It is to be much regretted," noted the *Merced Express*, "that these young men have brought this trouble upon themselves and their parents."

Bob, meanwhile, had disappeared that night and had not been seen after leaving the dance hall. On the same day the coroner's jury had convened, a rumor was circulated in town that the fugitive had been captured. A daughter of attorney Russ Ward had visited at rancher John Ruddle's home in Merced. When the little girl returned home, she told her father she had seen Bob McFarlane eating supper at the Ruddle home just before she left. Sending his son after Sheriff Anthony J. Meany, Ward made arrangements for someone to watch the Ruddle home while he

$300 REWARD!

STATE OF CALIFORNIA,
EXECUTIVE DEPARTMENT.
SACRAMENTO, Cal, July 21st, 1884.

Three hundred dollars reward will be paid by the State of California for the

ARREST AND CONVICTION

Of ROBERT McFARLANE, who murdered ANTONE ENOS, in the County of Merced, State of California, on the night of June 19th, A. D. 1884.

The said Robert McFarlane is about twenty-six years of age; five feet and nine or ten inches high; weighs one hundred and ninety pounds; has a smooth, dark skin and a black moustache.

(GREAT SEAL.) GEORGE STONEMAN,
 Governor of California.

Attest:
 THOS. L. THOMPSON, Secretary of State.

The state reward notice probably played a part in Bob's decision to surrender.
California State Archives

hitched up his buggy and met the sheriff on the way to the rancher's residence. It turned out to be a total fiasco. Interviewing Ruddle, the

sheriff and Ward were told the man eating supper was merely an employee who had come into town from the Ruddle ranch on the Merced River.

McFarlane had been a fugitive for just over a month when he became convinced he had better surrender and take his chances in court. His situation really hit home in late July when Governor George Stoneman offered a three hundred dollar reward for his arrest and conviction. He had probably been lying low in hillside sheep camps, obtaining food from friends like Bob Prouty with whom he discussed his situation. Later he would say that he had also visited various towns in the area during this period. If he turned himself in, however, there was considerable animosity against him in Merced, especially in the Portuguese community. A lynch mob was a very real concern. Rather than summoning the sheriff to come out and take him into town like a common criminal, Bob had a different plan, as described in the columns of the *Argus*, August 9, 1884:

SURRENDERED TO JUSTICE—Robert McFarlane, who killed Antone Enos, in Jesus Arros' dance house in this town some six weeks ago, and who has since eluded the glance of the officers of the county, came into town on Tuesday last, accompanied by some eight or ten friends, all well armed with shotguns, pistols and repeating rifles,

The Cosmopolitan Saloon was one of the city's favorite watering holes. *Elliott's History of Merced County*

and surrendered himself to the sheriff and was locked up in the county jail, to await trial for the high crime for which he stands accused. R. H. Ward, his attorney, was one of the party of friends who came in with him, and the object of arming so carefully and completely was to be able to baffle any attempt that might be made by Enos' friends or others to lynch the accused. Entering town, the party rode up to Booth's Cosmopolitan, which place they entered

and refreshed themselves with Danny's most inviting drinks, after their long and rapid ride from the Merced River over to the county seat. We are informed by Mr. Ward that McFarlane says that he has never been out of Merced County but once since the shooting and that when he visited Coulterville, Mariposa County, where he had some business to transact. Hulse, who is jointly accused with McFarlane of the crime of murder, has been in jail since his arrest on the night of the shooting.

On September 6, both McFarlane and Hulse were arraigned in justice court and trial dates set. During his October trial, Bob was able to establish self defense in the Enos killing to the extent that the jury was out for three days and could not agree on a verdict. Finally, the case was dismissed and he was tried on the charge of assault with intent to kill Brazil and Mundonca. When the charge was reduced to a misdemeanor assault, Bob pled guilty and was fined twenty-five dollars. For some reason McFarlane was still held in the city jail for a time, perhaps as a witness. Hulse's trial date had not yet been set and both men were still in residence on the night of November 8 when they watched three other prisoners climb to the top of their barred cells and begin chipping away at the plastered ceiling with makeshift tools. They perhaps smiled at the efforts until the second story flooring began to appear. The three jailbirds were soon prying up the floorboards and disappeared through the gap.

Bob was not going to escape with the others; he had too much to lose. Hulse may have considered escaping, but changed his mind, as noted in the *Argus* of November 15:

> McFarlane and Hulse also came out after the escape of the other three. Hulse stood guard at the courthouse, while McFarlane went into town and notified Sheriff Meany of what had taken place, when he and Hulse were again placed in their cells.

If Al Hulse thought he was going to garner any sympathy in his pending case, he was sadly mistaken. It was April 15, 1885, before his trial was set for the following May. He was convicted and sentenced on June 22 to five years in Folsom state prison on the one assault charge, and two years on the other, making a seven-year term.

Once released from jail, McFarlane thought a change of scene might be in order. In January 1885, Bob drifted south to Tulare County, where he apparently made a serious effort at diminishing the county's liquor supply. It is not clear just where and when he first met a man named Jim McKinney, but the two were kindred spirits and spent their time gambling and drinking in the Visalia saloons.

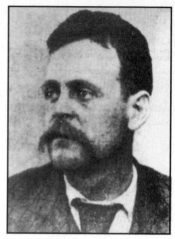

Tulare County's worst badman, Jim McKinney. *Lee Edwards' Collection*

Like McFarlane, McKinney came from a highly respected family. Born in Illinois in early 1860, young Jim traveled a good deal with his family before they settled in Tulare County in 1880 or 1881. He grew up doing farm work and working as a teamster, but he early discovered an affinity for liquor—and trouble. He liked life on the wild side and was soon spending much too much time in Spanish Town, Visalia's tenderloin.

In a short time McFarlane and McKinney decided they could do better in another environment and they took the train north to Modesto, some thirty-five miles above Merced. They hung out in Barney Garner's saloon for a time, but when Garner had a disagreement with Bob, the two gamblers rented a horse and buggy and headed for the hills east of Merced. They had a bottle for company during the drive and by the time they arrived at Merced Falls, both were feeling no pain.

Merced Falls was a small, foothill community, with many of the residents being employed at the local wool and flouring mills. Besides Rapelje's hotel and Pat Farrell's general store, both of

The village of Merced Falls as it appeared at the time of the rowdy McFarlane-McKinney spree. *California State Library*

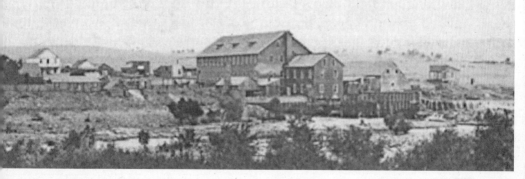

which served liquor, Billy Webb's was the only saloon in town. The Ollrich brothers operated a blacksmith and wagon shop. Simon and Jacobs operated another general merchandise store and there were barely forty residents in town, counting a few local farmers. A wide range of stockmen and farmers obtained their supplies from the small village.

McFarlane and McKinney staggered out of their buggy and looked around. Both pulled their pistols and began shooting at the chickens that were scratching about in the street. This served to announce their arrival and after chasing the squawking chickens off down the road, they retired to Billy Webb's saloon.

Staggering over to a table, the two called for a bottle and were served by Webb, the bartender-owner. When another saloon patron came over and wanted to sell them a watch, Webb and the two roisterers bought it, then began to play cards to see who would win the timepiece. McFarlane became upset when Webb won the game and tried to take the watch away from the saloon owner. During the

San Quentin state prison showing the three rows of cellblocks just beyond the wall, a factory at left, and several guard towers in the distance. *California State Library*

resulting fist fight, Bob's pistol fell to the floor. When McKinney picked up the weapon, it discharged, startling them all. Webb and several friends, upset with the brawling and shooting, filed charges against the two men, and McKinney and Bob were arrested by a Snelling constable.

On February 9, 1885, in the justice court at Snelling, both men

plead "not guilty" to charges of assault with a deadly weapon and intent to commit murder. Trials were set for March 16. Bob's trial was moved up to March 12, and the jury disagreed on the charge of attempted murder and it was dismissed. On March 18, he was tried on the charge of assault with a deadly weapon and was convicted and sentenced to two years at San Quentin. McKinney was convicted also and sentenced to pay a five hundred dollar fine or spend 250 days in the city jail. His empty wallet dictated he choose the jail term.

Bob was duly delivered to the state prison on March 31, 1885. With liquor taken out of his diet, he was a pleasant enough fellow and he got along well with both the inmates and prison staff. In other words, he followed the rules and avoided trouble. There had been many changes from the early days, as Bob learned from some of the older inmates. Various industries within the walls had been operated by private contractors over the years, but now all such work projects were owned by the state, and the profits were used to support the prison. A large jute mill was in operation and had shown a profit of $31,504 in the year previous. Harness and belting were being manufactured, as well as doors, furniture, and foundry products. Convicts were now being paid ten cents a day for their labors.

Bob was probably put to work in the stable which was located outside the walls. Having been raised on a farm, he knew something of blacksmithing and he began seriously learning his new trade.

Some of the noted criminals in the prison were pointed out to Bob as he went about his daily duties and activities. The famous burglar Jimmy Hope was working in the laundry. Caught as he attempted the burglary of a San Francisco bank, Hope was the reason time locks had been invented for safes. Old Jim Ivey was "behind the walls" at this time, also. He too was a notorious burglar, but was known for his sense of honor. At one time the fugitive Ivey presented himself in a courtroom where a man was being tried for one of Jim's crimes. When Ivey confessed to the crime, the other man was released and Old Jim went back to prison again. The cream of the stage-robbing fraternity were in San Quentin during this period; Black Bart, Bill Miner and "Shorty" Hays, all with desperate careers behind them.

Although Bob probably envied the notoriety of these colorful characters, he did not envy their long prison terms. He kept busy, learned his trade, and looked forward to an early release on good behavior. When he walked through the gate on November 30, 1886, he was grateful to be free again. The *Argus* chronicled the badman's return on December 4, 1886:

> Robert McFarlane came up last night on the Overland train, having served out his term of sentence. He eschews alcohol which has been the bane of his young days, expresses a determination to lead a peaceable, quiet, industrious life, and prove himself worthy of the confidence and respect of the public; and we believe he means it.

Bob moved to Visalia, where he found work as a blacksmith. He seems to have made an effort to lead an "industrious" life, at least for a time. He registered to vote in 1888 like any good citizen, but on May 6 of that year he engaged in some rowdyism that was roundly condemned by the editor of the Visalia *Weekly Delta*:

> On Sunday evening last an affair occurred in the saloon on the corner of Main and Church streets. The persons concerned were Bob McFarland [sic] and Frank Hill, both of whom were drunk. McFarland was flourishing a loaded revolver and aching all over for an opportunity to distinguish himself in some manner. He announced his intention of shooting a hole through Frank Hill's hat, and the latter told him to "blaze away," and he blazed, the ball passing through the hair over Frank's ear. His face was burned with the powder quite badly. Hill got what he

The Tulare County Courthouse. The jail was in the basement as indicated by the lower window to the right of the front stairs. *California State Archives*

deserved; and if the pistol had kicked McFarland into the middle of next week he would have received only a part of his just deserts. When the officers arrived on the scene they encountered the usual difficulty experienced in such cases. The bystanders pretend to know nothing of the affair and without any definite information it is difficult to make an arrest.

Late the following year he was in yet another saloon brawl. On October 8, 1889, McFarlane was arrested after a saloon tussel in which he struck one Lee Wheeler on the head with his pistol. The pistol had discharged at the time and Wheeler had filed a felony charge. Bail was set at $800, and Bob remained in the Tulare County jail pending his arraignment and trial.

The Tulare County Courthouse was a beautiful edifice, designed and built in the style of the time. It has long since been razed and replaced, but many similar courthouses can still be seen throughout California. The county jail was on the ground floor in the rear of the courthouse and was made up of granite block walls with a series of iron barred cells and a barred corridor that served as a drunk tank. When he sobered up, Bob must have thought, "Here we go again."

One end of the corridor had a window and he was perhaps talking to a friend through the bars when another prisoner joined him in the "tank." Jim McKinney had been involved in a similar saloon incident and the two pals must have been pleased at the prospect of each other's company. McKinney spent much time in Porterville, where his parents and siblings lived, but he made periodic visits to Visalia. Neither incident was considered serious and friends assured them the charges would be dismissed.

The two jailbirds were frequently seen at the tank window talking to friends and it soon enough became clear that more than "talking" had been going on. Despite the assurances of their friends, the two prisoners decided they wanted out. They had seen enough of the inside of jails and prisons in the past and determined to escape and leave the area.

Perhaps inspired by witnessing the Merced jail break, McFarlane began looking up at the ceiling. While the regular cells were composed of iron bars and a sheet iron ceiling, the tank had a plaster

ceiling. Climbing to the top of the bars at night, one of them probed a corner of the ceiling and discovered the plaster covered the wooden flooring of the county assessor's office above. All they had to do was cut a hole through the wooden ceiling during the night and they could easily escape from the building. Friends, recruited to aid them, slipped a brace and bit through the window. That night, holes were drilled very close together in a circle through the floor above. A little prying and the circle would be pushed out and the rest was easy. The *Tulare County Times*, November 28, 1889, reported:

> James McKinney and Robert McFarland [sic], each confined in the county jail awaiting examination before the Superior Court on charges of assault to murder, made a successful jail break on Tuesday night. A confederate on the outside of the jail had supplied them with a rachet brace and bit, and with these utensils they bored a hole in the floor of the Assessor's office, by getting on top of one of the iron cells in the jail. After getting in to the Assessor's office, escape was easy, as all they had to do was to spring a common lock and walk out into the hall and liberty. Notwithstanding the fact that notices are posted on the outside walls of the jail forbidding outsiders to converse with the prisoners, the rule is violated every day, and on Tuesday, it is stated, there was a woman standing at one of the windows conversing with the prisoners, and later in the day a man dressed in a brown suit of clothes is said to have been seen passing something through the window to a prisoner.

Sheriff Dan Overall grabbe a bear by the tail when he p McFarlane and McKinney together in the same cell. *Courtesy Monna Olsen*

Tulare County Sheriff Dan G. Overall was reportedly furious when the break was discovered the next morning. He sent telegrams to the various sheriffs' offices around the valley as well as to all points in Tulare County. "Jim McKinney and Bob McFarland [sic] broke jail last night," telegraphed Overall to his deputy in Porterville. "Send word everywhere—one hundred dollars reward for each. Keep sharp lookout. D. G. Overall, Sheriff."

Horses, weapons, and provisions had been waiting for the two fugitives and they headed north into the dark and bitter cold night. Riding hard and keeping under cover during the day, the fugitives were soon in sight of the Merced River, as reported in the Visalia *Weekly Delta*:

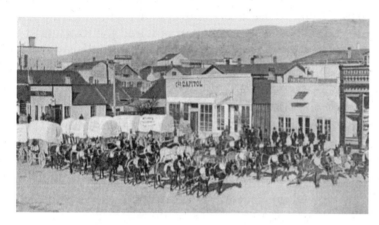

Located on the Union Pacific Railroad, Rawlins was booming in 1890, as indicated by these supply wagons in the streets. *American Heritage Center, University of Wyoming*

McFarlane fell in with a sheep herder he knew and the boys were glad to remain with him and rest. Officers were then in that part of the country looking for them, and they kept shady most of the time. On Tuesday morning a stage was robbed a few miles from where they were and it was thought that they were the guilty parties. The officers guarding the bridge joined in the pursuit of the stage robbers and McKinney and McFarlane crossed the river and went to the Tuolumne. Striking into the mountains they remained two weeks with a friend until things got more quiet. During this period they spent a good portion of the time hunting. After a good rest they started on fresh horses, that had been provided them in Merced County, for the railroad, and arriving at Rocklin took the train for the east.

Sheriff Overall tracked them to Merced, then to Snelling, but McFarlane was among friends now and the trail quickly became cold. Selling their horses and gear, the two fugitives caught a train at Rocklin and by Christmas day were in Ogden, Utah. After a few days' rest, the fugitives hopped the train to Rawlins, Wyoming, where McKinney won $250 in a faro game.

All puffed up over the success of the escape, McKinney could not resist gloating to his pals back home. Writing to Tom McIntyre, a Porterville friend, on January 2, 1890, he noted, "I am going to start to Canada tomorrow. If they catch me I will keep them guessing. The snow is two feet deep here and still snowing. Give my friends my regards and tell my enemies to ____ ____ ____. Give this to the *Porterville Enterprise*. Yours Respectfully, James McKinney."

It was a bad mistake. When Sheriff Overall wired the Rawlins chief of police, A. M. R. Schnitzer, to hold McKinney until he could get there, Jim's days of freedom were limited. He was arrested while bartending in a Rawlins saloon, but managed to alert McFarlane, who promptly disappeared. Back in Visalia, McKinney was convicted on multiple charges and sentenced to ninety days in the local jail and eight years in San Quentin.

Bob McFarlane had headed south, eventually vanishing into the Southwest. He may have stopped along the way and worked for a time, perhaps somewhere near Salt Lake City, where there was easy access to the railroad and a fast escape. Wherever it was, he worked for close to a year before succumbing to a feeling of nostalgia for his old friends and those rolling foothills of the Sierra. In late February 1891, Bob decided to make a quick trip home. Catching a train, he soon passed over the snow-covered mountains at Donner Pass, then down into Sacramento. Heading south down the San Joaquin Valley, he stopped at Turlock, some twenty-five miles north of Merced.

There is no indication of just how long McFarlane was in the area, but he knew he could not stay too long. He was apparently wearing a beard at this time, no doubt as a disguise. Walking down the tracks, he stopped at a roadside saloon from where he sent word to some friends to come join him in a celebration. When his pals arrived, Bob had a great time regaling them with his adventures, but the party got out of hand in the usual way, as reported in the Modesto *Daily Evening News*, March 4, 1891:

> The trial of Bob McFarlane charged with battering Theodore Geist took place in Justice Robert's court at Turlock before a jury yesterday. The battery took place at the half-way saloon three miles from Turlock a couple of days ago and grew out of a dispute about

paying for some drinks. Geist's face was badly battered up. The jury disagreed.

Bob had apparently not been found out during his Turlock sabbatical, but he was now quite eager to leave. When he again headed east, he probably thought a change

San Marcial was a rough little cowtown and supply center south of Socorro. It was a place in which a fugitive could easily disappear. *Author's Collection*

in residence was in order and he got off the train at San Marcial, a small village some two and one-half miles south of Socorro, New Mexico. A typical false-fronted town in the middle of the scrubby desert, San Marcial was located on the Rio Grande River and had been destroyed several times by fire and flood. Located on the Santa Fe Railroad, the village was a supply town for the many mines, stock farms, and ranches of the area. By hanging out in the saloons, Bob soon found work, through word of mouth, as a cowboy or sheepherder. He was calling himself "Jim Wilson" and soon convinced himself he was safe from the California authorities. But he was never safe from himself.

On the Fourth of July 1892, he was celebrating the holiday along with the rest of the crowd in a noisy San Marcial saloon. A rodeo featuring a rope-throwing contest and other celebrations had brought in settlers and cowboys from around the countryside. Bob filled up on high-octane tanglefoot and soon began looking for trouble. That he easily found it was verified by an article in the *Socorro Chieftain* of July 15, 1892:

> On July Fourth at San Marcial one James McFarland [sic], alias Jim Wilson, murdered Tomas Vesques in cold blood. The defendant was at once arrested. In the afternoon the outraged people assembled and would have hanged the murderer had it not been for the determined stand taken by F. J. Blunt, deputy sheriff who took him to Socorro for safe keeping.

The *Chieftain* got few things right in its article, barely hinting at the drama that actually transpired. Along with Bob and the hordes of other visitors that day, a Mexican vaquero named Atanacio Bargas

(perhaps Vargas) had ridden in that morning to participate in the rope throwing. Described in the press as "very homely and black," Bargas was drinking in a saloon when he became aware that a drunken McFarlane was following him around. The Californian was taunting him in some way when Bargas suddenly turned and de-

manded he stop following him, referring to Bob's antecedents in an unflattering manner. Bob pulled his pistol and fired four quick shots into Bargas's chest and stomach. He was dead in a few minutes. There were a great many Mexicans in town and word of the shooting quickly spread around town.

A special dispatch to the *Albuquerque Democrat* was published on July 7, 1892:

Document from Bob's New Mexico trial. *New Mexico State Archives*

McFarland [sic] was arrested, and the Mexican element immediately assembled and organized to lynch McFarland, but the officers kept their prisoner hid until the north-bound train in the afternoon arrived, when they quietly slipped him to the train, none too soon, for the now infuriated Mexicans, joined by some Americans, quickly followed toward the depot, and one Mexican, mounted, rode into the immense throng with lasso ready and tried to swing the noose over McFarland's head, but the prisoner

was too quick. The lassoist then handed the noose to a Mexican, retaining one end of the lariat fastened to the pommel of his saddle. Pushing his way through the now excited crowd the ally of the rodero was in the act of dropping the noose over the prisoner's head when a pistol placed at his head caused him to drop the rope. Dr.

The grim walls of the New Mexico state prison when Bob McFarlane was there. *New Mexico State Records Center and Archives*

Cruikshak, the Santa Fe company's physician, who is influential among the Mexican element, made an address in the Spanish lan-

The main cell block at Santa Fe's New Mexico penitentiary.
Museum of New Mexico

guage and while they were listening the train pulled out as fast as steam could carry it.

That the crime was a cold-blooded murder all claim, and that McFarland will hang is as sure as he is brought to trial.

It was a narrow escape for Bob. He must have recalled those dangerous days after the Enos shooting in Merced when he was also in danger of being lynched.

In May 1893, McFarlane was indicted for murder but his attorney was able to obtain a change of venue to Lincoln County. Convicted of second degree murder, he was sentenced to twenty-one years in the state penitentiary at Santa Fe, where he was logged in on September 16, 1894. Bob lied several times on his prison record sheet. He claimed to be married with a child, probably to aid him in securing a pardon at the right time. He also claimed to be temperate and denied he had any previous prison records. Most of the convicts lied about these things. After all, what did they have to lose?

Established in 1884, the New Mexico penitentiary was originally a collection of wooden structures and a stockade. When Bob arrived, a substantial brick cellblock had been constructed, with the convicts making the bricks and doing most of the work. There had been substantial other improvements, including a brick powerhouse for electric lights, several other brick structures for storage, stables, and work sheds. A surrounding brick wall was still under construction. About one hundred and forty convicts were kept busy landscaping, harness making, raising vegetable crops, making bricks, and laying brick walks in the prison yard.

Like so many of the early prisons, the New Mexico penitentiary was a political football, the legislative penitentiary committee chairman referring to it as "that celebrated school for scandal, sometimes called a prison" on the outskirts of Santa Fe. Always short of funding, constantly attempting to collect debts, and with kickbacks involved in most dealings, the prison nevertheless was kept on an even keel by those in charge. Besides Superintendent (warden) Edward H. Bergmann and his assistant, the staff consisted of a physician, a chaplain, a matron, two guard captains, two cell-block keepers, and ten guards.

Bob had listed his occupation as "farmer" on the prison register, which pretty much qualified him to work in the gardens and tend the hogs that were being raised. When he tired of farming, he probably acknowledged his blacksmith experience. In time he was working at the stables and was kept busy shoeing horses and doing various iron work. Those who obeyed the rules and kept their noses clean were given perks as well, such as private work and other jobs for extra money. The time passed quickly when you kept busy, but in late 1896 an accident totally altered Bob's situation.

He was shoeing a horse in August when the animal fell on him, driving a nail deeply into his leg. Dr. J. H. Sloan, the prison physician, did what he could but the wound did not respond to treatment. The physician tried different remedies, but ulcers developed to the point where Dr. Sloan felt his facilities were inadequate. On September 12, he wrote to Governor William Thornton suggesting a special dispensation in the case:

> I wish to call your attention to the condition of R. L. McFarlane, prisoner Number 753, in the New Mexico Penitentiary. While shoeing a horse—he being at that time the blacksmith—the animal fell upon him and ran a nail into his leg, cutting one of the large blood vessels—the internal saphenous. Since that time he has been a cripple, confined to his bed. His leg at present is in a very bad condition, being covered from the knee to the ankle with large corroding ulcers. He has every possible care, but continues to grow steadily worse in spite of all treatment, at the rate that the ulcers are growing it will be necessary soon to amputate the leg to

Rancher Robert Prouty was always there for his pal Bob, who disappointed him every time. *Mariposa County Sheriff's Office*

save his life. I believe that if he were in a position to visit some of our well known springs, there would be a chance of eradicating the disease, but being a prisoner serving out a long sentence, he can not have this chance unless you see fit to use the authority invested in you and set him at liberty. He is, and will be for the rest of his life a cripple, unless some clemency be shown him, and he is given a chance to try outside—what we are unable to do for him while under confinement, to take a course of baths at the Springs—Hoping your excellency will see fit to investigate this matter, I am very truly,

J. H. Sloan, Physician in charge,
New Mexico State Prison

We do not think of these old-time penal institutions as humane institutions, but in this case humane people were involved. On October 2, 1896, the governor responded with an executive order granting the prisoner a period of nine months to enable him to "visit the Sulphur Springs for treatment of his disease; the said McFarlane to be released upon his own personal obligation in the sum of one thousand dollars, to return to prison at the end of the said nine (9) months, or as soon thereafter as he may have been thoroughly cured of his present infirmities."

Details of what transpired next are not known. All convicts in those days knew the importance of maintaining contacts on the outside and to always have someone working on your case. Family, friends, and lawyers were expected to write letters on your behalf, pleading the circumstances of your situation, seeking appeals, etc. Many convicts had disposed of their self-respect early on. They still expected their relatives to go to bat for them over and over again, if for no other reason than to remove an embarrassment to the family. Bob's parents were both still alive at this time, but their involvement in his prison release is not known. His parents were good people and apparently felt obligated in providing his $1,000 bond and a chance for him to regain his health.

What is known is that Bob was released from the New Mexico state prison on October 6, 1896. Reportedly, it was Mariposa County rancher Robert Prouty, Bob's long-time friend, who was active in obtaining Bob's release. Besides being a prominent rancher, Prouty was also a former tax collector who had been elected sheriff in 1893. He was everything Bob McFarlane was not, but he was a true friend to the badman. The sheriff probably sent a representative to Santa Fe who took the convict to a mountain hot springs resort near Santa Fe. When Prouty joined them there in November, Bob's leg had healed sufficiently for him to be able to move about.

The sheriff next did what he had done in the past. He talked Bob into giving himself up. Prouty telegraphed Tulare County Sheriff Dan Overall, who was probably still chafing from the convict's escape from his jail. Catching the first train east, Overall was in Santa Fe in a few days. The Tulare sheriff's determination paid off handsomely, as reported in the *Mariposa Gazette*, December 20, 1896:

> Arrest of Bob McFarlane—the Tulare "Register" of December 16th gives the following particulars of the arrest of Bob McFarlane: Sheriff Overall returned on Sunday from New Mexico where he had been since Thanksgiving Day. He brought with him Bob McFarlane, the jail breaker who escaped at the same time with James McKinney, who was caught in Wyoming. McFarlane was working on the railroad down there, and getting wind of Overall's

Merced was no longer a raw frontier town, but when Bob McFarlane was around, anything could happen. *Author's Collection*

coming had fled to the mountains. The Sheriff remained here two weeks quietly waiting, and finally through the assistance of a confederate arranged a plan by which McFarlane was lured into town and gobbled before he had been there an hour. The capture was a clever one.

Details are lacking in all this, but one thing is certain; Bob was back in the Tulare County jail. In preparing to prosecute McFarlane for the jailbreak, however, it was discovered that the 1889 arrest documents for the saloon shooting were missing. Apparently, not wanting to pursue the jailbreak case since there were no papers showing why he had been jailed in the first place, the district attorney decided not to prosecute. McFarlane was free once again. Just how he avoided returning to the Santa Fe penitentiary is yet another mystery, but apparently the prison officials were satisfied with keeping the thousand dollars and being rid of a problem.

By January 1897, McFarlane had returned to Merced and was among his old pals and saloon companions. He worked at blacksmithing and still did farm work and sheepherding. He had learned little from his various stints in jails and prisons, however. Everyone knew—or knew of—the notorious Bob McFarlane and shied away from any trouble with him. Bob had put on some weight as he aged and the scars on his face bore silent witness to his many years of a rough-and-tumble lifestyle in the saloons and bordellos of frontier California. He looked and talked like someone to avoid if at all possible.

By the end of the century, he was up to speed again, however. A favorite hangout was Ida and Jim Tucker's Blue Wing Saloon. It was one of the Merced tenderloin joints that was open all night and rowdy enough to have an officer on duty to control the crowd.

Al Hulse was a gambler and genuine badman. *Lee Edwards Collection*

"My orders were to maintain order and when they made too much noise, to close them down," recalled John R. Graham some years later. "Tucker had sense enough to cooperate. I would sit on top of the piano (Truie Potter, the old time fiddler, and Jesus Sasuse, piano). It was waltz around for a

few whirls then up to the bar for drinks, twenty-five cents per couple. China Ida served enchiladas—good ones—in the corner at 12."

"At times the electric lights went out," continued Graham, "and Tucker would light up the Rochester oil lamps with large globes. Once in a while Bob McFarlane or 'Too Fun' Allie Hulse would shoot the globes off. It was then time to quit.

"I was pretty roughly handled at times. Dick Meekan, city police officer, and I would tell McFarlane and Hulse they had fun enough for the night and they would deliver up their artillery and knives. We would leave them at Johnnie Smith's [Cosmopolitan] Saloon for them to get the next day. McFarlane was sweet on China Ida and Tucker caught him sneaking from her room at daylight one morning."

Graham is very vague about the timing of all this, but since both Hulse and McFarlane were intermittently in prison, they can be tracked during the latter 1890s. McFarlane was in jail or prison between 1892 and October 1896. Since Graham turned twenty in 1889, this would make his age about right for his saloon job during 1897–1900.

Al Hulse would fit into this time period, also. After serving three years for the Portuguese shooting incident, Hulse was released in June 1888. In 1890, he was gambling, and probably pimping, in Fresno. When his landlady, Nettie Lewis, objected to his smoking opium in his room and refusing to pay his rent, Hulse struck her several times knocking her to the floor. He then grabbed a hammer and dealt her a "stunning blow on the head with it," according to an account in the *Daily Morning Republican*. "He knocked her down again, and while she was lying prostrate he kicked her in the stomach, inflicting serious injuries. When leaving the house he threatened to kill her if she procured his arrest."

Skipping town, Hulse apparently avoided arrest by fleeing to Los Angeles. He was back in Merced in October 1892, when he shot and wounded a man named Enrique. In December he drew two years in Folsom for the shooting, then another year for throwing an inkstand at the judge. He was released in April 1895. After apparently spending some time in Merced during the 1895–1900 period, Hulse again headed south to Los Angeles and Bakersfield.

Graham's statement that McFarlane had been caught sneaking from China Ida's room might very well have been the start of trouble in this particular triangle. Jim and Ida Tucker reportedly had been married, but were divorced by early 1901. Graham's referring to their saloon and bordello as the "Blue Wing" is probably a memory lapse. The place was located west of the railroad tracks at Fifteenth and Alameda streets, and was referred to as the Alameda House in contemporary reports.

Although James H. and Ida Tucker had come to a parting of the ways, ownership of the Alameda House was in dispute and Ida continued to live there. Born in Arkansas in 1860, Jim Tucker came from a good family, but enjoyed the sleazier side of life in saloons and bordellos. Ida, listed as his wife in the 1900 census, was some three years older. Apparently the two had a partnership understanding in their bordello-saloon, but after the divorce Ida did not want to go away. Neither did Jim. And, when Ida began showing an interest in Bob McFarlane, there was bound to be trouble.

The Merced County Courthouse, where Bob had several unpleasant trial experiences. *Author's Collection*

It was a Thursday evening, February 21, 1901, when Jim Tucker discovered Ida in her regular crib in the Alameda House. He was exasperated and at the end of his rope. He had told her several times she had to leave. Now, after the usual shouting match, he hustled her outside and onto the porch where he shoved her off into the mud.

Screaming as she staggered to her feet, she began shouting pleasantries at Tucker who was responding in kind. The *Merced Express* picked up the sordid incident at this point:

> Her yelling brought to her aid McFarlane, who, it is claimed by the "boys," was Ida's "friend."

George Goucher, one of McFarlane's lawyers. *Author's Collection*

McFarlane, who was in Mrs. Tucker's residence, came running down the long porch of the Alameda House *en deshabille*. Some words passed between McFarlane and Tucker, and both commenced shooting. McFarlane says that he fired five shots, two of which took effect in Tucker's body, one in the arm and the other in the head. The one in the head killed him, and he fell over in the mud.

After the shooting McFarlane gave himself up to Constable Smith and was lodged in the county jail.

At his preliminary hearing in justice court, McFarlane was held without bond for trial in the superior court. The trial took place during the week of March 29, with Mariposa Judge John M. Corcoran presiding. District Attorney John F. McSwain, with two assistant counsels, prosecuted, while McFarlane was defended by F. H. Farrar and ex-Senator George G. Goucher. The jury came in with a verdict of manslaughter, six for acquittal, five for second degree murder, and one not voting.

On April 6, a motion for a new trial was heard by Judge Corcoran. After listening to testimony for three days, the judge rendered a verdict for a new trial based on the following: 1. misconduct on the part of the jury who had imbibed in liquor during the trial and in the jury room. 2. Misconduct on the part of the district attorney in having asked various improper questions of a witness. 3. Error on the part of the court in sustaining the prosecution's objections to certain questions asked witnesses by defendant's attorneys, and 4. Newly discovered evidence.

Judge Corcoran threw out all the motions but the last, which was accepted as grounds for a new trial. District Attorney McSwain announced he was ready to retry the case as soon as a new

The grim, stone walls and buildings of the entrance to San Quentin once again loomed up before Bob McFarlane.
California State Library

jury could be summoned. When Judge Corcoran announced he would be unavailable for the new trial, the local judge was disqualified and Judge M. T. Dooley of San Benito County was appointed to take his place. The jury was selected in one day and the trial began on April 29 with the same legal teams involved.

The new evidence turned out to be recently discovered witnesses who had heard Tucker making threats against McFarlane, or had seen him brandishing a pistol on the night of the killing. It was of little account, however. Bob was again convicted of manslaughter and May 18, 1901, was set as the day for passing sentence. The *Merced Express* commented on May 24:

Bob's brawling and boozing had changed him greatly over the years, as his 1903 mugshot shows. *California State Archives*

> In the Superior Court last Saturday Robert McFarlane, convicted of manslaughter, was sentenced by Judge Dooling of San Benito County to eight years in San Quentin. F. H. Farrar, defendant's attorney, moved for a new trial that was denied, and notice of appeal to the Supreme Court. McFarlane will remain in the county jail pending the decision of the higher court.

The trial was overturned by the higher court and when a third trial resulted in a hung jury, a fourth attempt was scheduled. All these trials were expensive and hard fought by skilled attorneys. Ex-State Senator George Goucher, however, was a weak link in McFarlane's defense team. Although popular, Goucher was known to let his drinking habits interfere with his legal obligations and at least once was removed from a case for continually showing up in court while intoxicated. Whether Goucher compromised his client, or not, McFarlane was again convicted of manslaughter and sentenced to San Quentin for a term of eight years, and he took up residence once again on March 2, 1903.

There had been many changes since Bob's first term, the most important of which was the parole law of 1893. Now it was possible to be released early for good behavior. Another convict of the time

described what entering the prison was like in the first years of the twentieth century:

> My first impression on entering the yard was that of surprise. I had expected to see massive bars and rigid discipline. Instead I saw a beautiful flower garden, a fountain surmounted by a figure of a white swan, in the center.
>
> We were received by the Captain of the Yard —at that time an old man who had been engaged in prison work all his life. After a thorough "frisk" I was escorted to the photograph gallery and "mugged," with my prison number attached to my breast. The operation over, I was bustled to the bathroom and ordered to strip.
>
> My body was carefully inspected by the Chinaman in charge—a highbinder serving life—to see that I had nothing concealed between my toes or any other possible place. Subsequently I learned that it had to be done to prevent the smuggling of "dope" into the prison.

After a hot bath, another convict entered the bathroom with new clothes. The garments were laid on a chair with a pair of shoes.

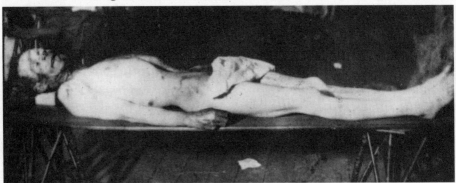

The shotgun-blasted body of Jim McKinney as it lay on the Kern County mortician's slab. *Jeff Edwards Collection*

The narrative continues:

> Ten minutes later I was dressed, and felt very uncomfortable. The underclothing was coarse and heavy, as were the outer garments. The "top shirt" was of stripes, black and white, each about an inch and a quarter in width and running horizontally.

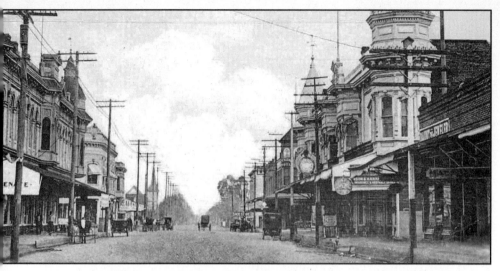
Merced had evolved into a modern city with street lights and automobiles, although horses were still much in evidence towing buggies and wagons. *Author's Collection*

The stripes of the outer garments were perpendicuclar. Most prisoners get used to the stripes and forget them. I never did. I found it difficult to walk in the brogans. They had no shape and the soles were slippery.

After having his head shaved, the convict was returned to have another mug shot taken. Next he was seated on a bench while the Lieutenant of the Yard recited all the rules of the prison. Only one letter a month was allowed to be written. Next the prisoner was taken to the Bertillon room where measurements and fingerprints were recorded. He was then given two blankets and a change of underwear, all of which were labeled with his prison number—in Bob's case, number 20028. He was then given a mattress and taken to his cell.

One way or another, Bob surely heard of Jim McKinney's death in April 1903. Jim had continued his reckless life after he and McFarlane had split up in Wyoming. After several killings and murders resulting in a long manhunt, McKinney holed up in a Bakersfield Chinese joss house. When his hideout was discovered, there was a confrontation with local officers and McKinney shot it out with City Marshal Jeff Packard and Deputy Sheriff William Tibbet, who were both mortally wounded. McKinney was in turn shot-

gunned and killed by Deputy Sheriff Bert Tibbet, brother of one of the slain officers.

Al Hulse had been with McKinney, also, and both the dying lawmen had accused Hulse of shooting them. After several trials, Hulse was convicted and sentenced to life in Folsom state prison. He had other ideas, however, and on October 14, 1906, Hulse slit his throat and bled to death in the Bakersfield jail.

The time went much faster when working at one of the prison industries and once again, McFarlane kept his nose clean and served his time. With good behavior, he was released early on June 6, 1908, and returned to Merced County.

There had been few changes in Merced since he had been away. The new automobiles, which had basically been buggies with a motor a few years earlier, now were larger and had convertible tops and

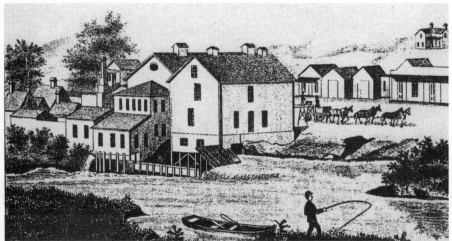

With a flour and woolen mill, several saloons, a hotel, and various shops, Merced Falls could be a very lively place. *Elliott's History of Merced County*

were becoming quite popular. Bob's mother, Hannah, had died the previous year, but his seventy-two-year-old father was still living on the farm northeast of Snelling. Perhaps Bob visited his aging parent, but chances are he had cut that tie long ago. Nothing was expected of him. What could they say to one another? Mothers never lose hope, despite the years of broken promises and heartache. Men can be more practical.

Riding over the yellowed, oak-studded hills above Snelling, Bob called on old friends and again enjoyed the surroundings of the local saloons. It was good to be home. There were those who considered the fifty-one-year-old badman something of a folk hero, now. Although quiet and genial enough when sober, Bob liked to tell of his adventures when his cronies gathered around, and occasional drinking sprees seemed unavoidable. Roaming the hills of Merced and Mariposa counties, it was easy enough to find work on the stock and sheep ranches of the area. Jails and prisons were no longer an option in his life and there seemed to be little incentive for trouble in these lonely hills, unless you were born to be bad.

Bob McFarlane's long-awaited fate was announced in newspapers around the state. *Merced County Sun, November 6, 1915*

Bob was employed at various jobs in both Merced and Mariposa counties. He was working on the ranch of a Dr. Frank Henderson in the fall of 1915, and he lived in a cabin on some land near Mariposa on which he had recently filed. When a second cousin named Frank Dickinson asked to stay with him, McFarlane agreed and the two men began bunking at the cabin. It was not to be a harmonious relationship.

Sheriff Walter Farnsworth. *Mariposa County Sheriff's Office*

Dickinson was a fifty-year-old gambler whose father had been a logging superintendent at a Fresno County mill. Roving between Fresno and Merced, Dickinson's lifestyle was much like McFarlane's and he too had done time in local jails. Perhaps both men were loners to the extent that living with someone gradually became an irritant to one or the other. They got along for a time, but after a prolonged drinking bout, trouble erupted. Bob returned to the cabin one day to find Dickinson sleeping off a drunken stupor. Perhaps McFarlane had told his relative to clean up the place and he was furious at noticing nothing had been done. Whatever the cause of Bob's fury, there was a shouting match and McFarlane gave his cousin a bad beating before stomping out the

door.

Dickinson would later state that after his cousin had shot at him several times in the following days, he took to carrying a shotgun for protection.

Bob was riding over to Merced Falls on Friday, November 12, 1915, and as he approached the Cliff House Saloon he saw Dickinson walking along carrying his shotgun. Riding over and confronting him, McFarlane swung down from his horse saying:

"Well, I suppose you are out hunting for me, so I'll take that gun away from you."

Stepping back as McFarlane lunged at him, Dickinson fired both barrels of his scattergun, the buckshot ripping into the badman's body and arm. Death was almost instantaneous. Residents ran out of their buildings and saw the cloud of gunsmoke. The killing had taken place in Mariposa County and Sheriff Walter Farnsworth was called and informed of what had happened. Dickinson was soon deposited in the Mariposa County jail. At a preliminary hearing in Hornitos on November 15, Justice William Adams dismissed the charges on a plea of self-defense. Dickinson walked away a free man.

McFarlane's Merced funeral was well attended by old-timers and friends of the family. Many attended out of respect for Bob's father, who had died in 1911. Ex-sheriff Bob Prouty came down from Mariposa and stared at the corpse of the man who had caused so much grief to so many people. As a young sheep rancher, Prouty had been one of those who had accompanied Bob McFarlane back to town after the Enos shooting. The two men had been so similar in their youth, but despite their friendship they had gone in different directions. Now it was over and no one was surprised.

A cold wind and black clouds blew through the city that afternoon as roaring thunder, crackling lightning, and fierce hail heralded the first big storm of the season. The tempest was just in time to commemorate Bob McFarlane's descent into hell, the final destination of a desperado who had outlived his time. Few would argue that he was a man born to be bad.

CHAPTER 6 SOURCES

Guinn, Prof. J. M. *History of the State of California and Biographical Record of the San Joaquin Valley, California.* Chicago: The Chapman Publishing Co., 1905.

No author given. *History of Merced County, etc.* San Francisco: Elliott & Moore, 1881.

No author given. *A Memorial and Biographical History of the Counties of Merced, Stanislaus, Calaveras, Tuolumne and Mariposa, California.* Chicago: Lewis Publishing Company, 1892.

Albuquerque Democrat, July 7, 1892.

Fresno *Daily Evening Expositor*, June 21, 1884.

Fresno Morning Republican, November 7, 1915.

Mariposa Gazette, February 6, September 12, November 7, 21, 28, December 20, 1896; November 13, 20, 1915; June 15, 1928; January 17, 1930.

Merced County Sun, November 8, 12, 16, 1915.

Merced Express, August 9, 1884; April 4, 1885; February 25, 1888; November 13, 1915; March 1, 22, 29, April 12, May 3, 10, 24, June 28, 1901.

Modesto *Daily Evening News*, March 4, 1891.

Porterville Enterprise, November 30, 1889; January 11, 25, 1890.

San Joaquin Valley Argus, January 11, February 15, March 8, 1879; October 13, November 10, December 15, 1883; June 21, 28, August 9, September 6, October 18, November 15, 1884; February 14, March 21, 28, April 25, June 27, 1885; December 4, 1886; May 31, 1890.

Socorro Chieftan, July 15, 1892.

Tulare County Times, November 28, 1889.

Visalia Weekly Delta, May 10, 1888; January 23, February 6, 1890.

Edwards, Harold L. "No Monument for Robert McFarlane," *Old West*, Winter 1989.

_____. "Gunfighters and Lawmen," *Wild West*, August 2004.

Report of the Penitentiary Committee of the House of Representatives of the Thirtieth Legislative Assembly, Territory of New Mexico, Santa Fe, February, 1893.

Biennial Report of the Board of Commissioners and Superintendent of The New Mexico Penitentiary to the Governor of New Mexico for the two years ending December 31, 1896.

Record of Convicts, New Mexico Penitentiary; State Records Center and Archives, Santa Fe, New Mexico.

List of Prisoners on the Register of State Prison at San Quentin, Marin County, California; California State Archives, Sacramento, California.

Documents, Socorro County District Court Records; State Records Center and Archives, Santa Fe, New Mexico.

Governor William T. Thornton Papers-Penal Papers-Respites; State Records Center and Archives, Santa Fe, New Mexico.

U.S. Federal Census, 1870, Merced County, California.

U.S. Federal Census, 1870, Mariposa County, California.

U.S. Federal Census, 1880, Mariposa County, California.

U.S. Federal Census, 1900, Mariposa County, California.

Index

Coronel family 87
Cosmopolitan Saloon 193, 219
Cosner, Robert 68, 71
Costo, Rose 1210, 111
Costo, Rupert 112
Coulterville 194
Couts family 87
Coyote Hill Diggings 7
Cozear. *See* Sarah Cazier
Crane, L. 104
Crawford, Dr. 183
Cremony, John C. 25
Crescent City. *See* New Orleans
Cross, Constable 67
Crow, H. J. 167, 169, 171-173, 177
Crowe, John 30
Cruikshak, Dr. 204
Crumely 9
Crystal Springs 26, 27
Cucamonga Rancho 156
Cumberland Gap 139
Curtis, James D. 125
Cusick, James 40, 41

D

Daily Alta California 8, 10, 11, 13, 14, 19, 43, 55, 59, 80, 82, 83
Daily Evening Bulletin 21, 22, 24, 25, 27, 33, 34
Daily Herald 15
Daily Morning Call 50
Daily Morning Republican 210
Daily News 150, 151, 152, 158, 161
Daily Picayune 9
Dallas 141, 142
Dallas County 141, 142
Daney 39
Davis 9
Davis, Sam 180
Davisville 127
Dead Rabbits (club) 2
Del Valle family 87
Delano 132
Democratic newspapers 17
Democratic Party 1, 2, 8, 14, 19, 25, 47, 51
Democratic primaries 18, 190
Democratic State Convention 19
Democrats 1, 13, 17, 29
Desert Queen gold mine 106
Diamond Valley 105
Dickinson, Frank 217, 218
Diego, Condino 111
Diego, Juan 89, 91, 95-100, 102, 103, 105, 109, 111, 112
Diego, Lupo 97
Diego, Mary 97
Diego, Matilda 97
Diego, Ramona. *See* Ramona Lubo
Dixon, Al 144

Dobson, Officer 152
Dodge 12
Donner Pass 202
Dooley, John 47, 48
Dooley, M. T. 212
Dooling, Judge 213
Doten, Alfred 72
Douglass, Jimmy 7
Dowdigan, Christopher 17
Downey, John G. 148
Drake, Henry 11
Dry Creek 66
Drytown 67, 68, 71-74, 79
Duane, Charley 4, 11, 16, 17, 18, 21, 29, 30-32, 35, 51
Duane, John 51
Duncan, Captain 54
Dupont Street 10, 11, 56
Durham, George 66, 78, 79, 82
Dutch Charley. *See* Charles Duane
Dye, Adelaide 139, 141
Dye, Amos 140
Dye, Benjamin 139, 140, 141
Dye, Benjamin Jr. 142
Dye brothers 142
Dye, Ennis 139
Dye, Enoch 139, 141
Dye, Francisca 155, 164, 165, 168
Dye, George 139
Dye, Grace 166, 169, 172, 175
Dye, Gracie (daughter) 167, 169
Dye, Jane 139
Dye, Joe 138-184
Dye, Martha Eunice 142
Dye, Miranda 139
Dye, Sarah "Sally" Cazier 139
Dye, William 139, 142
Dynan family 81
Dynan Hotel 70
Dynan, Mike 69
Dynan, Mrs. Mary 69-71, 73, 74, 78

E

Eighth Ward Station 49
El Dorado 5, 14, 15, 16
El Dorado County 64
El Monte 147
Elk Grove 125
Empire City Regiment 1
Empire House 5
England 85
Enos, Antone 191, 192, 193, 194
Enos shooting 205, 218
Escobar, Rafael 78, 79, 80
Estudillo land grant 94
Evergreen Cemetery 183
Ewing, Sarah 11, 12

Tibbet, Bert 215
Tibbet, William 215
Ticknor, Mary 98
Tombs, the 2, 42, 43
Towle, James 14, 15
Trafford, Thomas 153, 154, 163
Trinity County 126
Trinity River 126
Trinity River, Texas 140
Tripp, Samuel V. 98, 99, 101
Tripp, Will 101
Truckee 127
True Californian 31
Tucker, Ida 209-211
Tucker, Jim 209-211, 213
Tucker's Blue Wing Saloon 209
Tulare County 127, 132, 195, 200, 208, 209
Tulare County Courthouse 198, 199
Tulare County jail 199
Tulare County Times 200
Tuolumne 77, 201
Tuolumne camps 6
Tuolumne County 5, 17, 144
Turlock 202, 203
Turner, Jim 15
Tyson's Exchange 20

U
Udall, J. C. 165, 174, 184
Uncle Tom's Cabin 87
Union 45
Union County, Kentucky 139
Union Hotel 9, 18
Union Oil Company 165
Union Pacific Railroad 201
Upper Rancheria 66

V
Vallejo 121
Vallejo, Mariano 118
Vance, Robert 65, 70
Vance's store 72
Ventura 129, 152, 171, 172, 175
Ventura County 87, 138, 160, 163, 165, 166, 178
Ventura *Daily Free Press* 127, 170, 173
Ventura mountains 164
Ventura *Signal* 160
Vera Cruz 2
Vesques, Tomas 203
vigilance committee 29, 36. 38, 49, 158
vigilantes 1, 8, 23, 30, 31, 34, 35, 37, 52, 57, 144, 157, 161
Virginia 139, 140
Virginia City 52
Visalia 128, 129, 143, 195, 198, 199, 202
Visalia *Weekly Delta* 129, 132, 145, 198, 201
Volcano 72

W
Waite, Joe 105
Wall Street 49
Walsh, James W. 25
Ward, John 77
Ward, R. H. 192, 193, 194
Warner, James 35-37
Warren, Juana Lopez 160
Warren, William 148, 150-153, 155, 158, 167, 179
Washington 47
Washington Street 8
Washington Territory 133
Watkins, Carleton 87
Watson, John 18
Webb assault case 38
Webb, Billy 196
Webb, Hiram 35, 36
Webster, Will 99, 101, 102
Wellman, Frank 99, 100
Wells, Alexander 15, 16
Wells, Justice 55
West Coast 3
Wheeler, Lee 199
Whigs 13
White Hotel 181
White River 129
White, Stephen M. 170, 171, 175, 177, 183
Widney, Joseph P. 155, 156
Wilke, George 40
Wilkes, George 40, 41, 47-50, 54
Williams, Alex 10
Williams, Judge 177
Wilson, Jim (alias of Bob McFarlane) 203
Wilson, Sam 69
Wilson's Creek 46, 47
Winston, James B. 161
Winters, Elizabeth 104
Wood County, Virginia 139
Wooden Valley 119, 121, 124, 125, 135
Woodland 120, 124
Workman, William 162
World Fairs 109
Wylie, Mr. 124
Wyoming 208, 215

Y
Yankee (ship) 31
Yerba Buena 5, 118
Yolo County 120, 125
Yolo Mail 127
Young, Loretta 112
Yount, George 117, 118
Yountville 118, 119, 123, 124
Yountville cemetery 124
Yountville Register 123
Yuma 110

Born in Fresno, California, in March of 1930, William B. Secrest grew up in the great San Joaquin Valley. After high school he joined the Marine Corps where he served in a guard detachment and in a rifle company in the early years of the Korean War. Returning to college, he obtained a BA in education, but for many years he served as an art director for a Fresno advertising firm.

Secrest has been interested in history since his youth and early began comparing Western films to what really happened in the West. A hobby at first, this avocation quickly developed into correspondence with noted writers and more serious research. Not satisfied in a collaboration with friend and Western writer Ray Thorp, Secrest began researching and writing his own articles in the early 1960s.

Although at first he wrote on many general Western subjects, some years ago Secrest realized how his home state has consistently been neglected in the Western genre and concentrated almost exclusively on early California subjects. He has produced hundreds of articles for such publications as *Westways, Montana, True West*, and the *American West*, while publishing seven monographs on early California themes. His book *I Buried Hickok* (Early West Publishing Co.) appeared in 1980, followed by *Lawmen & Desperadoes* (The Arthur H. Clark Co.) in 1994; *Dangerous Trails* (Barbed Wire Press) in 1995; *Dark and Tangled Threads of Crime*, the biography of noted San Francisco police detective Isaiah Lees (Quill Driver Books) in 2004); and a biography of Harry Love, the leader of the rangers who tracked down Joaquin Murrieta, *The Man from the Rio Grande* (The Arthur H. Clark Co.) in 2005.